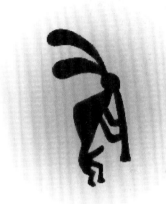

KOKOPELLI

A must for your library, Kokopelli: The Magic, Mirth and Mischief of an Ancient Symbol *is much more than another book about Kokopelli, one of the favorite images to adorn cliffs throughout the American Southwest. Throughout this book, Dennis Slifer provides numerous examples of flute players; explores the prevalence of the flute player imagery throughout the American Southwest and beyond; presents new and intriguing interpretations about its significance and origin; and examines the flute as an instrument of love and seduction in the Southwest and around the world. The book, complete with its sharp black-and-white photos and drawings of selected petroglyph sites and figures, is well written, clear, and free of jargon—a wonderful volume for nonacademics wishing to learn more about this captivating icon.*

—ORIT TAMIR, PhD
Associate Professor of Anthropology,
New Mexico Highlands University

Slifer is knowledgeable and passionate about his subject. He places flute player images in context over time and space, dispelling misconceptions and adding new information and astute insights on the topic. The book is thoroughly engaging—a rewarding reading and learning experience.

—DR. EMILY BROWN
Aspen Cultural Resources Management Solutions

The image of the flute player has become an icon throughout the Southwest. It appears on T-shirts, lampshades, metal sculptures, and on other tourist items. However, just who or what this flute player represents is not well known. Dennis Slifer, in this book explores the prehistoric appearance and distribution of this image in the Southwest. He also delves into the meaning of the flute player for traditional cultures in the region and throughout the world. For anyone who wants to know more about the flute player, this is the book to read. It is well researched and the illustrations are outstanding.

—DONALD N. BROWN, PhD
Research Associate,
Laboratory of Anthropology
Santa Fe, New Mexico

KOKOPELLI

*The Magic, Mirth, and Mischief
of an Ancient Symbol*

Dennis Slifer

Foreword by R. Carlos Nakai
Introduction by Robert Wayne Mirabal

Gibbs Smith, Publisher

TO ENRICH AND INSPIRE HUMANKIND

Salt Lake City | Charleston | Santa Fe | Santa Barbara

First Edition
11 10 09 08 07 5 4 3 2 1

Published by
Gibbs Smith, Publisher
P.O. Box 667
Layton, Utah 84041

1.800.748.5439 orders
www.gibbs-smith.com

Designed and produced by Rudy Ramos
Printed and bound in Canada

Library of Congress Cataloging-in-Publication Data

Slifer, Dennis.
Kokopelli : the magic, mirth, and mischief of an ancient symbol /
Dennis Slifer. — 1st ed.
p. cm.
Includes bibliographical references and index.
ISBN-13: 978-1-4236-0174-6
ISBN-10: 1-4236-0174-2
1. Kokopelli (Pueblo deity) 2. Pueblo Indians—Folklore. 3. Pueblo mythology.
4. Pueblo Indians—Antiquities. 5. Rock paintings—Southwest, New.
6. Southwest, New—Antiquities. I. Title.

E99.P9.S585 2007
709.01'13089974—dc22 2006028148

Contents

Foreword
by R. Carlos Nakai

In this treatise, Dennis Slifer offers an insightful look at the rock art images of the American Southwest as well as of international locales. In this clearly defined approach to the ancient flute player deity, he has assembled a thorough collection of stories, images, and research. He addresses the many curious forms of this entity, such as an insect or odd-shaped creature with a hump forming the curved shell of a cicada, antenna streaming behind, and arms shortened into an insect's legs. Many questions are brought to mind about this figure. This new collection of images and information will encourage one to speculate once again about Kokopelli, whose enigmatic guise is etched in such varied depictions upon the rocks.

Beginning with the flute-playing traditions of ancient and contemporary indigenous tribes of the Southwest, Dennis explores the social and cultural motivations that are expressed in ancient depictions of flute-playing figures. These visual art forms, sometimes in juxtaposed combinations, allude to behaviors and mores in the ceremonial, ritual, and social interactions of these peoples. The interpersonal responsibilities observed in gender issues and expectations of these tribal peoples may also be a focus of such depictions.

Comparative insights into the worldwide images of flute players are given in the section that includes such archetypes as Orpheus, Pan, Krishna, and the Earth Mother goddess at sites as far-flung as Africa, Australia, and Central and South

America. Similarly, among the North American Plains and woodland Indians, many stories exist in varied contexts about young girls being enticed and entranced by the inveigling flute players. In fact, among the indigenous North Americans, the end-blown block flutes with four to six finger stops are regarded primarily as courting instruments to be used only by bachelors to signal their intentions with unique melodies devised for love magic. Other whistles and aerophones crafted for specific purposes are not considered in the same category as the block flute. The specific names for this type of flute bespeak the antics of elk, crane, loon, dove, grouse, and other birds and animals whose courting dances and songs are part and parcel of traditional flute technique. Even in today's performances near Indian reservations, I've been informed that young ladies have been prevented from attending native flute concerts because of the possibility of sorcery, witchcraft, and spell-casting by the performer. I dare say that, yes, the art form does encourage spell-binding performances, with the understanding that this is one of many examples by a masterful and self-aware musician to "make the ladies in the front row cry."

Are these rock images "honorific" depictions of the human condition? Could some of these exaggerated depictions be caricatures or cartoonish graffiti that comment on the foible and pretense of our all-too-human daily interactions? Now, with the commercialization of this important icon, the perspective of "the sexy flute guy" is relegated to an emasculated "sacred scatterer of corn and love." The ancient hunter-gatherer peoples had socially and politically organized communities that were primarily matrilineal. In that sense, could these phallic flute player depictions be a way to remind people through varied condescending jibes of the male propensity for indiscriminate sexual adventures? Curiously, there are few depictions of female flute players, and the stories, too, cover the whole gamut of male sexual behavior. The images remain etched in stone, but the all-too-real story may be covertly shared among elder matrons and their young charges during specific ceremonies that males will never be privy to. Perhaps these pictographs and petroglyphs are similar to the quips and images we experience today that comment upon our human foibles.

Dennis hints at our deep-seated fears about looking into the mirror of our human/animal nature. He finds that the new-age commercialized treatments of this phallic procreative archetype have been emasculated and sanitized. Such trivialized symbols are now trendy populist sentiments and safe for all ages, devaluing such

an important icon with their bumper-sticker reductionist sensibility. Psychological research in a recent *Scientific American* article revealed the propensity for over-exaggeration and codification of one's body image. In this study, the majority of males interviewed selected their genitals as most important in all cases. This same mind-set may be at the root of ancient shamans' portrayals of apparent male hyperbole, or perhaps dysfunction. Their prescriptions for the dilemma, like ancient Viagra commercials, have been indelibly inscribed far and wide for all to see and ruminate upon, or to offer their own personally embellished conclusions for the enjoyment of others. Perhaps Kokopelli was intended as a social control mechanism for keeping males in their place.

Finally, locations are described within the Four Corners region that encourage the reader to explore these places and to speculate about the messages contained in these depictions from ages past. Inquiry among the locals or one's guide will always be met with disguised humor or another story to be added to the cornucopia of oral tradition among the indigenous folks. Kokopelli remains an enigma, and Dennis Slifer has opened another doorway into this enduring mystery.

R. Carlos Nakai
native American flutist
Montrose, Colorado
September 2006

Introduction

by Robert Wayne Mirabal

Ancient images of flute players appear on rocks from the Four Corners of the barren Southwest to the far corners of the world. In the realm of the mind, the flute player icon, like a sailor at sea, spreads his knowledge and seed. Variations of this archetypal figure came not only to the Anasazi people but also to the Hohokam, Africans, ancient Peruvians, Australian Aborigines, and many other indigenous cultures. The flute player, in his many guises, came to remind our ancestors of prayer, laughter, and happiness, and of their connection with one another. I believe that is why he has come back into our lives, where we accept him with a naughty grin. Ultimately and intimately there is a bit of Kokopelli in us all.

The message of Kokopelli is like a beautiful love letter written to us a thousand years ago. More than twenty years ago, I saw my future unfold in a trance vision in a Chaco Canyon cave where the Milky Way was etched in sandstone. I opened my letter. "Play my music of love for the people" was all it said, and as I read and contemplated these words, though I didn't make a deal with the devil at the crossroads, I did make a covenant with Kokopelli in a cave where the ancients looked on and where four states meet, forming an invisible cross in the heart of the Southwest.

When I started playing the flute, Kokopelli was known by the Pueblo people but few others, and his power was rare. Still, I never understood why I had chosen to play this instrument until it dawned on me that afternoon in the cave that the flute

had chosen me. I had been hiking for days from one ancient ruin to the next. On the evening of the last day, I had a vision: my skin and mind were imprinted like petroglyphs on sandstone and then branded by the sounds of the flute and the mysterious rock carvings of the ancients. I searched for the mythical being I had heard about, the man/creature that haunted my dreams. Etched on rocks, he could hear your dreams if you played the right notes on the flute—an ability that impressed me enormously.

Today's world needs a hero, someone to connect us all, I told myself. Suddenly I realized that the object of my quest, the "rock" star depicted in the ancient petroglyphs—archetype of fierce glory whose music illuminates and empowers—may in fact be a hero for our times, however unusual and unpredictable he might be.

Recalling these events after emerging from the vision, I laid my sunburnt body on top of a cliff in the waning heat of the day. It was summer solstice, and as the longest day of the year subsided, evening insects were chased by the flying fish of the sky—swallows dipping in and out, limitless in their universe and perfect creatures of flight. I watched for a while as the sun set, stretching its brilliance for miles across the desert. Then from my pack I pulled out an old cedar flute that had been given to me by an elder from Taos Pueblo. In quiet exhaustion and with burnt skin, I stretched out on the floor of the world, closed my eyes, and played until gigantic rain clouds danced and began teasing the earth with moisture.

I played on, the enchanting music echoing in and out of the open hollowness of canyon corridors. I thought the only audience was the sweeping sneaky night that engulfed the canyon floor, pulling down shadows from the cliff tops to cover the red earth. But as the theater of my mind opened, thunderclouds flowed to the north and the star people entered. It was as if the spine of the heavens had furrowed rows of luminosity into the blackness. I stopped playing and, opening my eyes, noticed many people listening and watching, their shadows tucked into crevices.

Just when I thought he had faded away, the ancient flute player began to move and sway again within me like a summer storm that, lingering, suddenly becomes so powerful it washes away the dusty remnants of a cold winter and rejuvenates dried-up springs. The downpour uncovered hidden treasures and blossoms of truth that only expose themselves when we are willing to dance with the rain. Thus, my life bears witness to the fact that Kokopelli is alive and giving birth to a new generation

of seekers eager to know more about the humpbacked warrior-king, the Dionysian archetype, the Quetzalcoatl who destroys life and gives it back again.

This book is not only for the seekers but also for anyone wishing to be reminded of our ancestral teachings and their enduring importance in a world of technology and fear. After all, amidst the daily grind of our industrial lives, what teachings etched into canyon walls today might have relevance in a thousand years? Surely we can depict cell phones and the meandering lines of fiber optics. As for me, I choose to continue what my forebears started, to chisel away at the humpbacked flute-playing Romeo, the Anasazi Don Juan.

The detailed research presented in this book offers information that has not been brought to light before. It reveals new perspectives on the flute player's relation to such things as wind and breath, animals, twins, spirals, and the insect world. It suggests how the flute may have been thought to open portals to other realms. In "back to the future" descriptions of the way of seeds, it also intimates why areas with little rainfall could spawn crops in abundance. Included is a trail guide to public access sites in the Four Corners region where Kokopelli still reigns supreme.

In addition to new findings, the chapters contain colorful stories and hundreds of images illustrating various roles of the ancient flute player. As the preeminent god of fertility for my ancestors, he continually awakens a memory within me of how everything is connected—seeds, plants, animals, rain, and human sexuality. The music of our coming together announces the beginning and end of the world. I become an animal, and you the clouds. I follow you into the lightning and we fall together with millions of others, intertwined in drops of moisture descending onto the desert, collecting on rows of sweet blue corn, dripping on the brown skin of beautiful dancers and singers. I lie on the pollen of life, exhausted and happy, listening to the pounding of the earth as it gives birth to a new harvest.

Blessings, dear reader, as you go headlong into the world of Kokopelli. May you become a rain cloud bringing moisture to seeds and awakening others to answers the ancestors had all along.

ROBERT WAYNE MIRABAL
Taos Pueblo, New Mexico

Preface

by Dennis Slifer

There continues to be keen interest in the ancient symbol of the humpbacked flute player, which has become the Southwest's most recognizable and popular icon. Presented here for the first time are more than 300 flute player images from rock art that have never been published, along with new information about their occurrence and significance. This new collection of images expands the flute player's geographic range in four directions—south into Mexico, north into Canada, west into Nevada, and east into the plains of Colorado, Texas, and Oklahoma. Some of these new illustrations reinforce certain interpretations about the meaning and origin of this figure, while others challenge our understanding. Also shown are examples of flute players in the rock art of other parts of the world to provide cultural comparisons of this archetypal motif. A discussion of flute lore underscores the special role of the instrument among many indigenous peoples and its near-universal association with courtship, love, and seduction. Some of these new images increase our knowledge about the role of flute playing in shamanism, ancient creation myths, and fertility rituals. The final chapter provides information about visiting public rock art sites in the Southwest where examples of the flute player motif can be seen. Thus, in *Kokopelli: The Magic, Mirth, and Mischief of an Ancient Symbol,* I update and expand upon my earlier work. This new volume brims with vital, compelling images and fascinating information, showing that we still have much to learn and appreciate about this charismatic ancient figure.

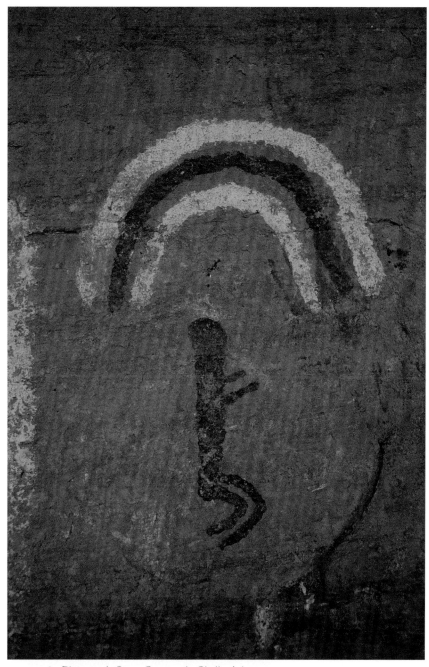

PLATE 1: Pictograph Cave, Canyon de Chelly, Arizona.
From the early Ancestral Pueblo period, this colorful pictograph of a flute player
beneath a rainbow illustrates the link between flute-playing and rainmaking magic.

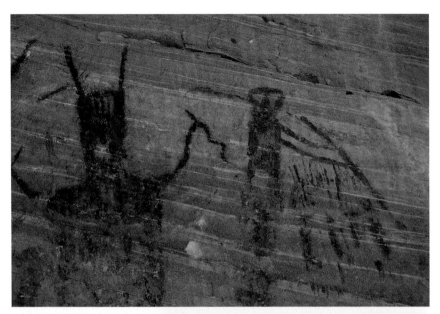

PLATE 2: Prickly Pear
Canyon, Southeastern Utah.
The earliest known depic-
tions of flute players in the
Southwest are from Barrier
Canyon Style pictographs.

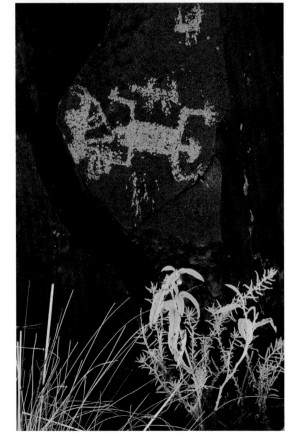

PLATE 3: La Cieneguilla,
near Santa Fe, New Mexico.
In his role as a major
fertility deity, the hump-
backed flute player is
sometimes shown having
sexual intercourse with a
female, as in this Ancestral
Pueblo petroglyph.

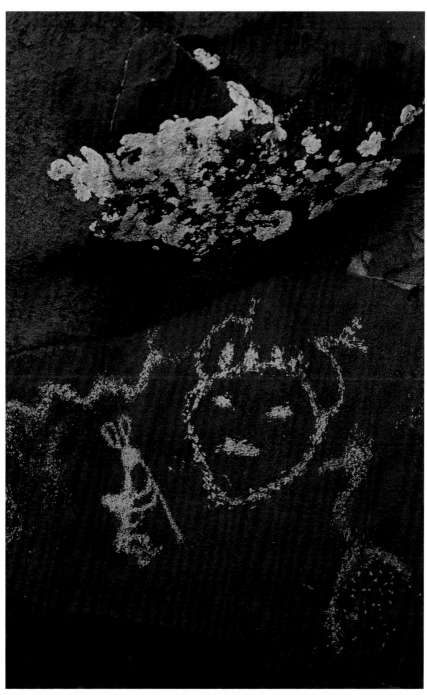

PLATE 4: La Cieneguilla, near Santa Fe, New Mexico.
Ancestral Pueblo depictions of flute players are often accompanied by images of birds,
snakes, and katsina masks.

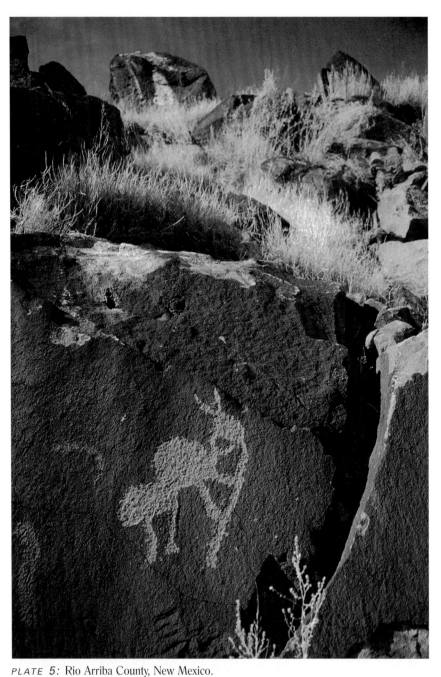

PLATE 5: Rio Arriba County, New Mexico.
Flute players resembling insects may illustrate ancient stories and creation myths
about the first people coming up from the underworld and the warming of the earth
to make corn grow.

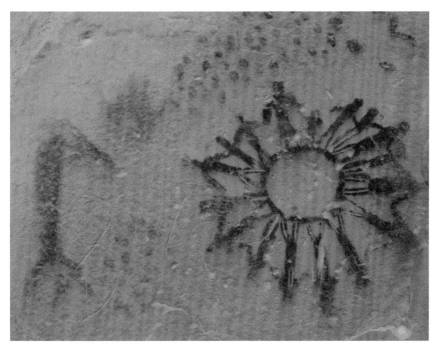

PLATE 6: Birch Creek, Escalante, Utah.
A flute player is shown in this pictograph with dancers and ceremonial participants.

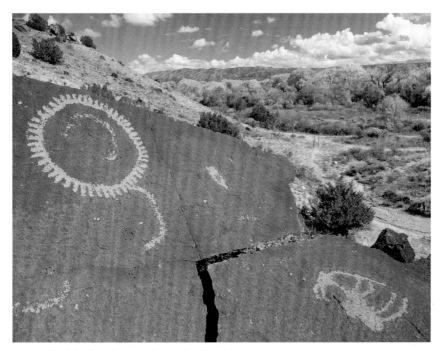

PLATE 7: Rio Grande, near Espanola, New Mexico.
This insect-like flute player next to a possible sun symbol adorns a basalt boulder. In some myths, the flute is played to bring the sun's warmth and cause plants to grow.

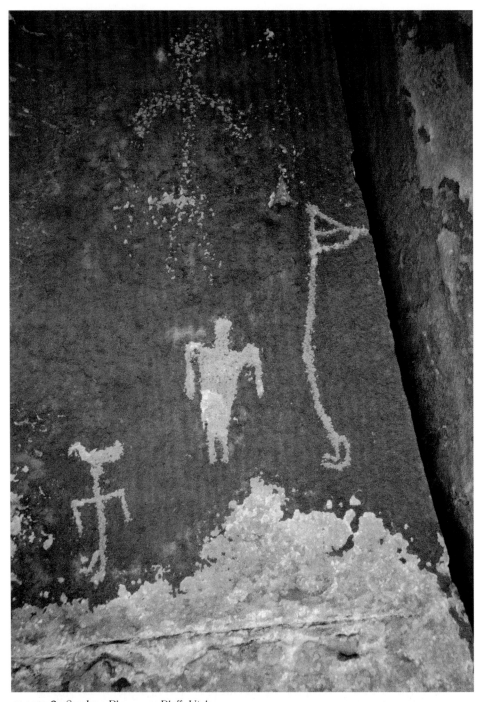

PLATE 8: San Juan River, near Bluff, Utah.
This elongated, highly stylized flute player points his flute into a crack in the cliff face, as if calling spirits from the underworld. Such Basketmaker Period petroglyphs often feature bird-headed human figures that suggest shamanic roots for these ancient symbols; the bird as a spirit helper.

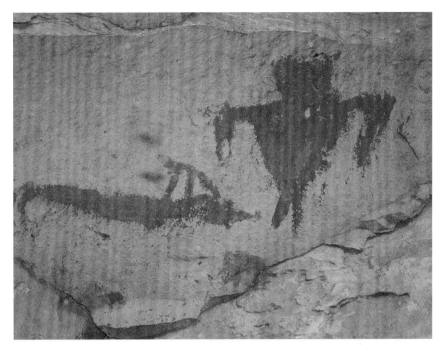

PLATE *9:* Snake Gulch, Northwestern Arizona.
Reclining flute players are often shown in early Ancestral Pueblo pictographs.

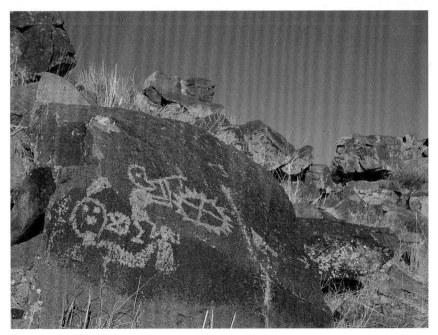

PLATE *10:* Galisteo Basin, south of Santa Fe, New Mexico.
This flute player accompanies a sun symbol or shield design and a katsina at a major
Southern Tewa (Ancestral Pueblo) petroglyph site.

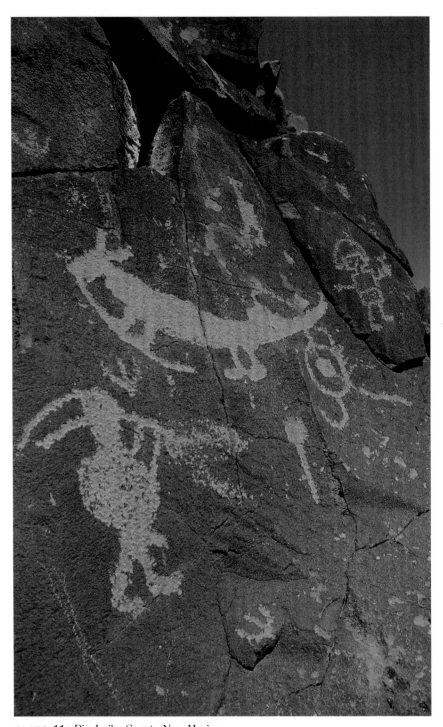

PLATE *11:* Rio Arriba County, New Mexico.
These Ancestral Pueblo petroglyphs depict a rotund human flute player and a flute-playing animal, along with bird tracks and other symbols.

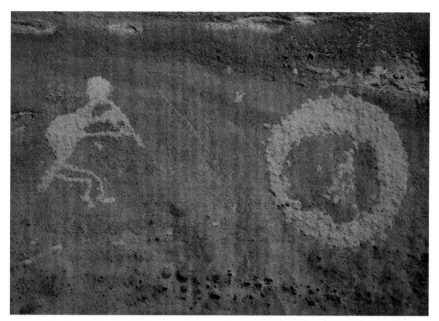

PLATE *12:* Little Colorado River drainage, near Petrified Forest National Park, Arizona.
A curiously shaped humpbacked flute player seems to direct his music or magic toward a
circular object.

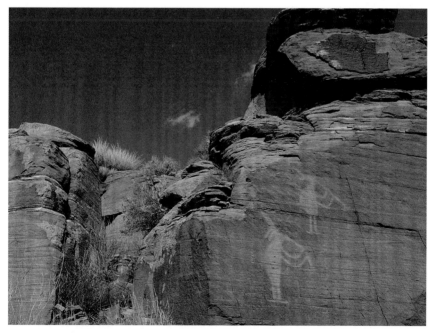

PLATE *13:* McKinley County, New Mexico.
A pair of similar flute players may illustrate the association between twins and flute playing
in some native cultures.

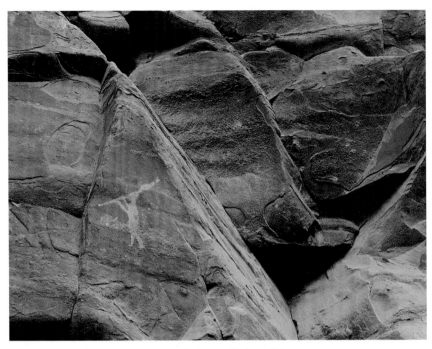

PLATE *14:* Honanki Cultural Heritage Site, near Sedona, Arizona.
This white pictograph of a flute player is probably from the Sinagua people.

PLATE *15:* Tompiro Culture Area, near Mountainair, New Mexico.
These unique petroglyphs depict a person playing two flutes next to human footprints.

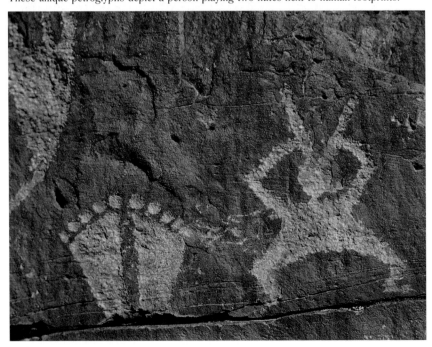

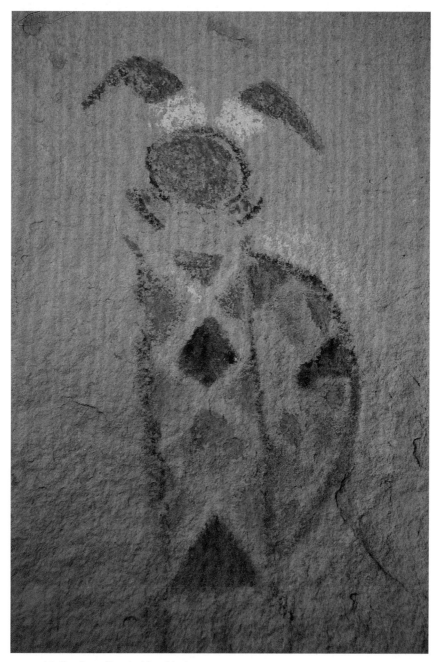

PLATE 16: San Juan County, New Mexico.
This multicolored Navajo pictograph portrays a humpbacked relative of
Kokopelli known as Ghanaskidi, who carries mist and seeds in his hump.

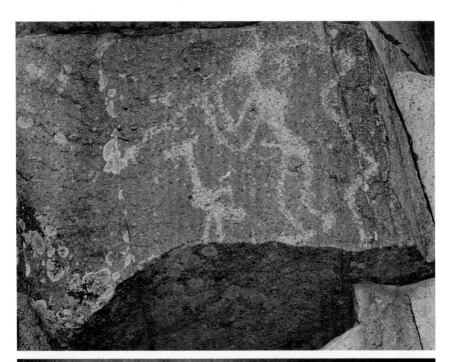

PLATE 17: Galisteo Basin, south of Santa Fe, New Mexico.
This is another example of how images of birds and snakes are the most common symbols associated with flute players in Ancestral Pueblo rock art.

PLATE 18: Montezuma Canyon, Utah.
These Ancestral Pueblo images include a white pictograph of an insect-like flute player hovering above a red pictograph of a long serpent-like image.

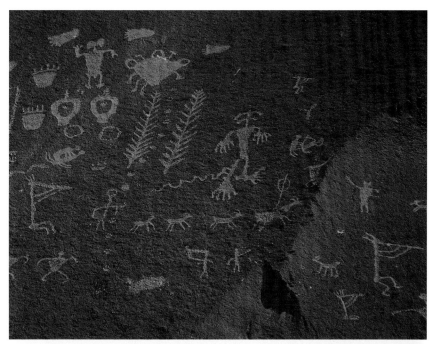

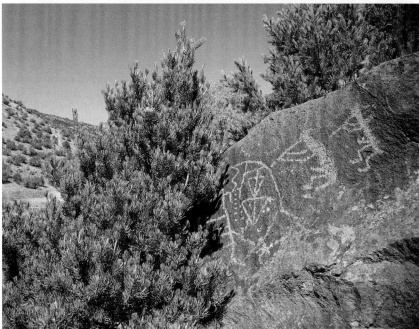

PLATE *19:* Monument Valley, Utah.
Basketmaker (early Ancestral Pueblo) petroglyphs include early flute player images lacking humped backs. Shown here are plants, animals, a sex scene, and a human figure being bitten on the leg by a snake.

PLATE *20:* Kokopelli Rock (near Rio Grande), Rio Arriba County, New Mexico.
Included are examples of Ancestral Pueblo petroglyphs of flute players and shield motifs.

PLATE 21: Upper Calf Canyon, Southeastern Utah.
The oldest known flute player images in the Southwest are pictographs in
the Barrier Canyon Style.

PLATE 22: Loy Canyon, near Sedona, Arizona.
This pictograph of a flute player with a very long flute is attributed to the
Sinagua people. Photo by Chris Larsen.

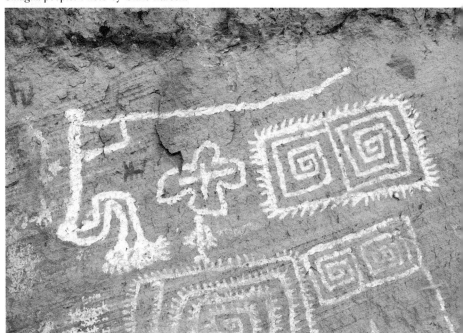

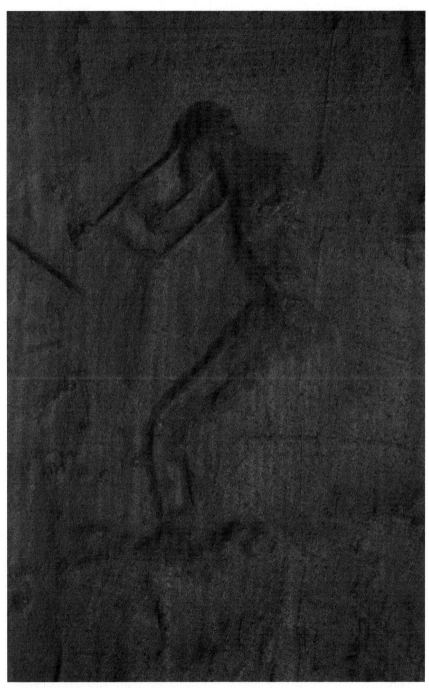

PLATE 23: Gallup, New Mexico.
Here is an Ancestral Pueblo petroglyph of a humpbacked flute player.

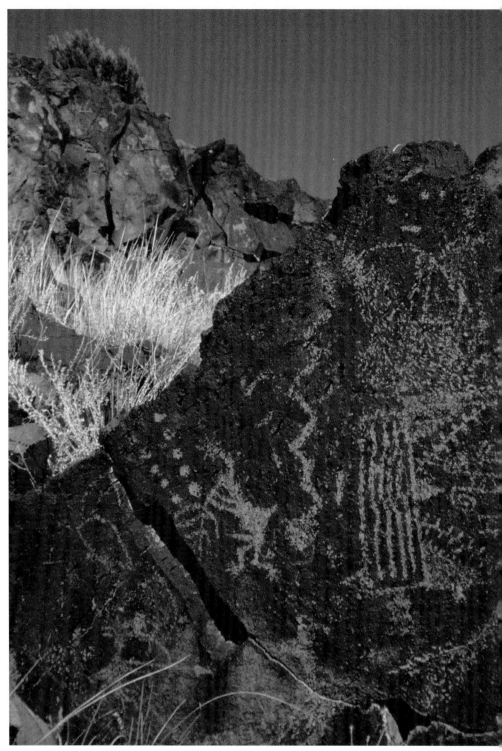

PLATE 24: La Cieneguilla, south of Santa Fe, New Mexico.
This panel of Ancestral Pueblo petroglyphs shows a humpbacked phallic flute
player who appears to play a tree-like flute with dots emanating from it.

I was alone and the flute player came upon me suddenly, unsought and unplanned. . . . in the canyon behind me wind whistled through scrub oak and smoothed the fractured surface of pink stone. . . . this particular flute player could well be a thousand years old, an age that hovered outside my range of belief. Here, drawn on a flat rock twenty miles from my home, the flute player was caught in one of his many transformations into a bug or odd-shaped creature. Already his hump had formed the curved shell of a cicada and his antenna streamed behind him as his arms shortened into an insect's legs. . . . he had the power to repel and slightly frighten. He had the reek of that which is half-human and half-beast, a cunning, scrabbling magic that, like a man with a giant penis, was alien to me. . . . Since then I have seen other Kokopellis, many of them, tootling under a high ledge at Canyon de Chelly or dancing among the ruins of Chaco Canyon.

—SHARMAN APT RUSSELL
Songs of the Flute Player

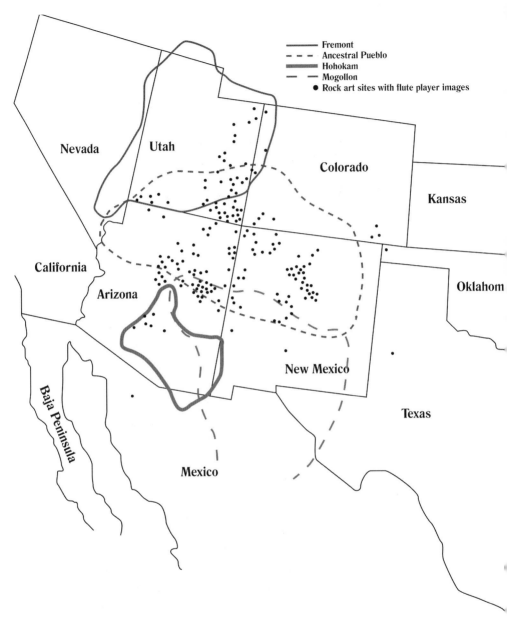

FIGURE 1.01: Map of the greater Southwest showing distribution of flute player images in rock art, and areas of prehistoric cultural traditions. Images of flute players are widely dispersed over the Colorado Plateau, upper Rio Grande, and surrounding areas.

The Magic of the Flute Player
Enduring Icon of the Southwest

One of the most enduring and ubiquitous figures in rock art of the Four Corners region is the flute player, which usually occurs in contexts related to fertility and abundance. Often phallic, sometimes humpbacked, these curious images occur in prehistoric rock art, as well as ceramics and kiva murals, over a large area of the American Southwest (fig. 1.01).[1] That this symbol is prevalent within such a large area and for more than a thousand years suggests that the flute player character was very important in prehistoric times. More than 500 flute player images have been recorded in the research for this book.

In recent years, this figure with the misnomer of Kokopelli has become an extremely popular icon of the Southwest. Kokopelli is the name of a Hopi *katsina* ("respected spirit") associated with fertility and rain. Although the Kokopelli katsina never plays a flute, he has a humped back and an erect penis; he is notorious for his libido. His name has come to be associated with the prehistoric flute players depicted in rock art throughout the Southwest. This may be appropriate for some rock art images, but by no means all. The flute player depicted in rock art is probably a complex merging of various myths, deities, personalities, and traits that evolved over a period of at least a thousand years in the Ancestral Pueblo world. The Hopi never identify the flute player figure in rock art as Kokopelli, preferring the traditional term *Maahu* (cicada) or *Lahlanhoya* (a symbol of the Flute Clan).[2] Other Pueblos as well have different names for the flute player figure—at Zuni he is called *Chu'lu'laneh*, the name for the type of flute used by the rain priests.[3] The modern Kokopelli katsina

may have evolved from the prehistoric lineage of diverse flute players portrayed in rock art and pottery throughout the Southwest.

There is something archetypal and universally appealing about the flute player character. The widely held beliefs that he was a fertility symbol, roving minstrel or trader, rain priest, shaman, hunting magician, trickster, and seducer of maidens have contributed to his popularity. He is one of the few prehistoric deities to have survived in recognizable form from ancient times into the present. There are thousands of flute player images found at hundreds of rock art sites throughout the Southwest, ranging from crude stick figures to sophisticated and elaborately rendered designs. His image occurs as a lone figure, in pairs, and in groups. He is shown standing, sitting, lying on his back, kneeling, dancing to his flute music, being carried, hunting, and making love (fig.1.02). These images share a number of interrelated attributes. The flute player has been interpreted as a deity, a clan symbol, a shaman or medicine man, a trader, an insect- or animal-like being, and an individual with a spinal deformity. He often has feathers or antenna-like appendages on his head and may appear as a flute-playing insect or animal (fig. 1.03).

THE LURE OF THE FLUTE

So the flutes did all the talking. At night, lying on her buffalo robe in her parent's tipi, the girl would hear that moaning, crying sound of the siyo tanka. By the way it was played, she would know that it was her lover who was out there someplace. And if the elk medicine was very strong in him and her, maybe she would sneak out to follow that sound and meet him without anybody noticing it.[4]

In many tribes, especially among Plains Indians, the flute was used for love magic and courting by young men, either as a signal or as a serenade.[5] Its sound resembled birds or the elk's call—a powerful medicine that made a man irresistible. Sometimes the courting flutes were called elk whistles and some had elk heads carved on their ends.[6] There are tales of men whose flute melodies were so powerful that women could not resist the call and would come to them. The Sioux told of women who became so excited by their lover's seductive flute music that their noses sometimes bled.[7] This same power of the flute was described by a Jicarilla Apache as follows: "The flute is used in love magic. It makes a girl come to you. We do not use the flute very often. It is dangerous. Sometimes it makes the girl crazy. Some flutes have a butterfly design on them."[8]

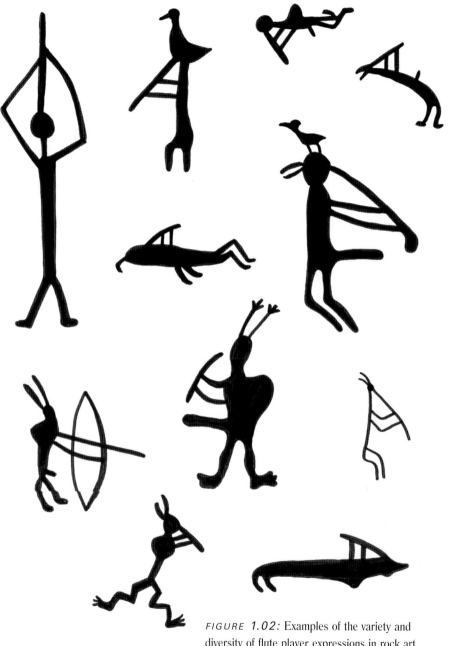

FIGURE 1.02: Examples of the variety and diversity of flute player expressions in rock art of the Southwest.

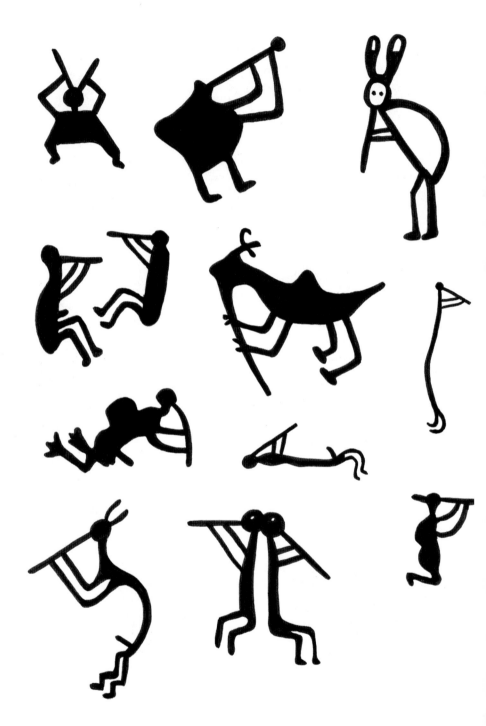

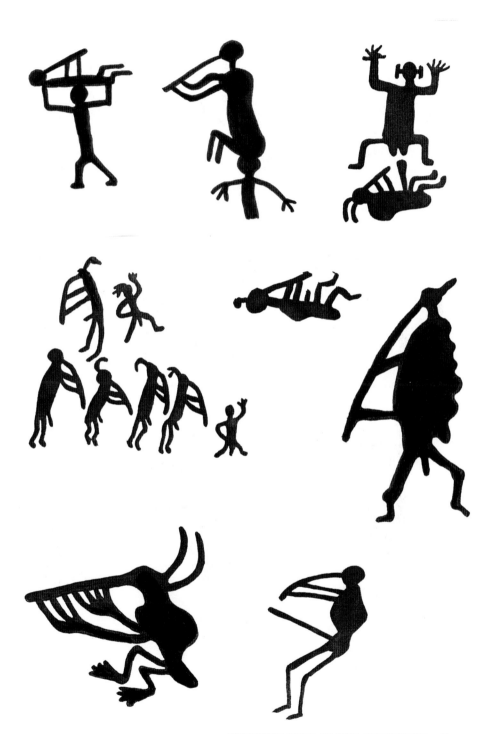

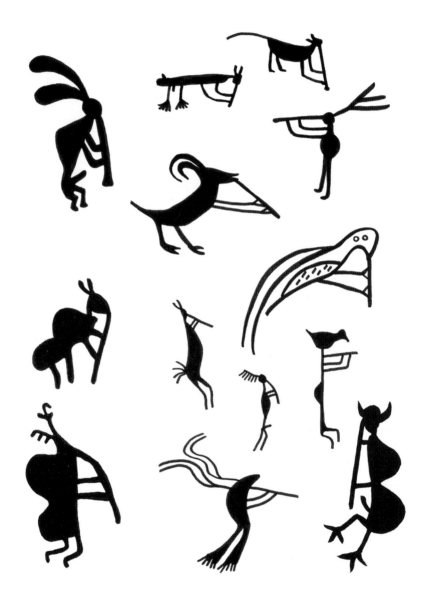

FIGURE 1.03: Examples of flute players
depicted as insect- or animal-like shapes.

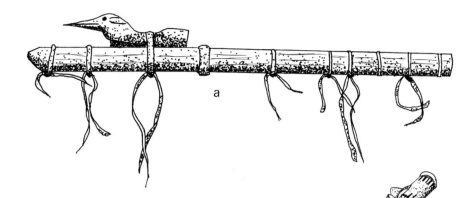

A legend of the origin of the courting flute was obtained from the Santee Sioux. It recounts how a poor boy was rebuffed in courting the daughter of a chief. In a dream, he was visited by two elk in the form of handsome young men. They gave him a flute made like a gar, from which came a sweet piercing sound. They showed him how to play it. He then walked among the lodges at night playing his flute. The women all arose from their beds and, dragging their blankets, followed him.[9]

Usually, each young man created his own special courting song to be used for love magic—a unique melody or signal that revealed his

FIGURE *1.04:* Wooden flutes with bird fetish designs: a. Kiowa flute collected in 1911 (after Ewers, 1986: 165); b. Lakota bird-headed courting flute (after Conn, 1982: 101).

identity to the woman he courted. Often such melodies were haunting and mournful for the purpose of making the courted woman feel lonely. If the magic worked, she would be drawn irresistibly into his arms. Some courting songs imitated crying. The player of a Yuchi flute melody exclaimed: "Oh, if some girls were only here! When they hear that, they cry, and then you can fondle them. It makes them feel lonesome. I wish some were here now. I feel badly myself."[10] A Pima song that imitated the sound of a flute had a hypnotic quality and was intended to induce a sort of trance—to shake the woman's heart as the song bloomed. Some tribes made special courting flutes that were carved with animals and birds known for their showy courtship dances and displays (fig. 1.04). Some rock art depictions show flutes with animals and birds attached (fig. 1.05).

Some of the bird-head flutes were actually whistles that could play only a single note; but this note, if played in accordance with magical instructions, was believed to

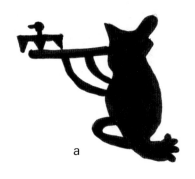

a

b

FIGURE *1.05:* Petroglyph depictions of flutes with birds or animals attached: a. Inscription Point, Arizona; b. Aztec Canyon, Arizona.

have influence over women.[11] Courting flutes with bird heads were known to the Lakotas as *siyo tanka* (the big prairie chicken), and were said to attract even the most indifferent girl if played skillfully. Still, some men had their flutes blessed by a holy man to ensure success. Other courting flutes among Plains tribes had horses' heads carved on them to aid the suitor by invoking the ardency of the horses' mating.[12]

While some tribes used the flute solely for love magic, others used it for different purposes and sacred rituals. For example, Pueblo attitudes toward the flute reflected past and current aspects of their culture such as community concerns, rainmaking, and the value of tradition. The Apache, by contrast, used the flute primarily for love magic, which reflects on the importance of the individual and personal ritual.[13]

The flute evidently had a special role in the prehistoric Southwest, where flutes and whistles made of bone and wood have been found among other artifacts.[14] In many Native American cultures as well as in other parts of the world, flute lore was often associated with sex as well as fertility in an overarching sense. The flute was seen as stimulating growth, abundance, and reproductive energy, and was played to encourage rain and the healthy growth of plants and animals (fig. 1.06). At some Pueblos, flutes themselves symbolized summer warmth, rain, and flowering plants.

One way in which the playing of flutes was related to fertility was in the symbolic linking of breath and wind. In the ancient Southwest and Mesoamerica, wind was considered an essential pathway for life forces from which rain, maize, and human life were derived. Wind was the origin of rain-bringing clouds and played a role in the complex rituals that evolved to link the terrestrial source of water to rain that fell from

FIGURE 1.06: Basketmaker petroglyphs showing flute player with plants and bighorn sheep, Johns Canyon, Utah.

the sky. Wind and breath were connected with the idea of the breath-spirit, which was instilled in a person at birth and leaves at death.[15] As an archetypal symbol, the spiral sometimes represented the wind or the breath-spirit in rock art depictions.

The creation of clouds and invocation of life forces was often simulated by feathers—in particular the breath-feather, which was blown from the mouth in rituals or tied to the end of sacred flutes. At certain Hopi rituals, sacred flutes had such feathers tied to them; these were known as *len hi'ksi,* meaning "flute breath."[16] Similar flutes with feathers attached were also known in the Zuni Pueblo. Because breath symbolized life and a spiritual medium, a strong link developed between flute-playing and notions about fertility and creation.

In ancient Mesoamerica, music itself was related to rain and water. In Aztec myth, the wind deity crossed the sea to the house of the sun to obtain music for humans. From a sacred bundle taken from the night sun, the wind unveiled flutes, rattles, drums, birds, and butterflies. Rain as well as ancestor spirits were thus conjured through music—a ritual complex that seems analogous to the katsina rain spirit cult of the Southwest, where breath symbolizes cloud-bearing wind.[17]

In the archaeological record of the Southwest, flutes are relatively common. These

artifacts suggest flute making is at least a 2,000-year-old tradition in the Four Corners region. Some of the earliest wooden flutes recovered in the Southwest are from the Basketmaker period and may have been linked to shamanic ceremonialism.[18] Some of these have been dated as prior to AD 450, and they show sophistication that implies the existence of even earlier flutes.[19] Many flutes have been recovered from early Ancestral Pueblo sites, such as Chaco Canyon. A collection was excavated from burial rooms in Pueblo Bonito, where they were associated with crook-necked staffs and other ceremonial objects.[20] One flute was painted in black, orange, and green patterns of circles, bands, and cloud terrace symbols (fig. 1.07). Two others had small animal figures carved in relief. The context of these flutes with ceremonial objects and grave goods suggests they were seen as ceremonial objects too.

In addition to bone and wood flutes, others were fashioned from hollow reeds. Bone flutes were more widespread than wooden ones in the upper Rio Grande in late Pueblo times (AD 1350 to 1700). Coronado's expedition into the Pueblo area of the upper Rio Grande in 1540 found widespread use of flutes in celebrations; to accompany singing; and, by men, to entertain women while they worked.[21] Among numerous Spanish references to Pueblo flute-playing is a description of how men would sit at the door, playing a flute

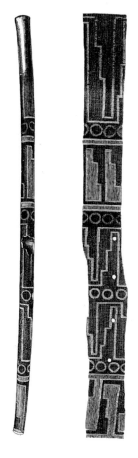

FIGURE *1.07:* Painted wooden flute from burial room in Pueblo Bonito, Chaco Canyon, New Mexico (from Pepper, 1909: 72).

while women inside would sing and grind corn, keeping time to the music with their grinding stones. Such cornmeal was used ceremonially.[22]

In a letter from the 1540 Coronado expedition is this description of the Zunis using flutes, probably at the village of Hawikuh:

The Indians hold their dances and songs with the aid of some flutes which have holes for the fingers. They make many tunes, singing jointly with those who play.

Those who sing clap their hands in the same manner as we do. I saw one of the Indians, who accompanied the negro Esteban and who was a captive there, play, since they had taught him how to do it there. Others were singing, as I said, although not very harmoniously. They say that five or six get together to play, and that the flutes are of different sizes.[23]

Other historical records indicate that the sounds made by flutes were not always appreciated by non-Native listeners. These remarks were made by Alexander Stephen in his Hopi Journal of 1894:

The Sand Chief makes vile noises on a flute. He is keen to learn, but one would think he would choose some other time than a ceremony for practice. His discordant screeching is complacently listened to . . . Damn 'em, they make vile screeching noises. No one remarks the vile sounds but myself.[24]

Today, flutes are used among the Hopi, Zuni, Acoma, Laguna, Jemez, and Rio Grande Pueblos. The most elaborate flute ceremonies are found with the Hopi and Zuni. The Rio Grande Pueblos use the flute mainly for summer rain ceremonies. At Santo Domingo, Pueblo flutes are played to accompany the planting of crops in order to "make everything grow better." Such applications show that the flute is a ritualistic object among the Pueblos. Even in such seemingly mundane activities as corn-grinding, flute-playing accompanies prayers for warm weather. Flutes are not only sacred but are owned by groups or societies that relate their ownership to mythological events. Flute-playing in the Pueblos is therefore for the benefit of the group rather than the individual. Such events as rain and solstice ceremonies, and planting rites, all involve community welfare.[25]

Moreover, in some cultures flutes were made by shamans, or holy men, and were thought to produce powerful magic notes that would attract a woman anywhere.[26] Some petroglyphs show flute players with dots or circles that may symbolize musical notes or the magic power associated with the flute (fig. 1.08); others show women being serenaded, charmed, and drawn to the flute player (figs. 1.09 and 1.10).

Flutes were used for even more powerful applications dealing with the supernatural activities of the shaman. The altered state of consciousness that shamans experience in a trance often begins with aural hallucinations before proceeding to mental and visual ones. In the ethnography of far western North America, these aural hallucinations were often described as whistling, buzzing, whirring, and ringing, and were often related to the sounds of flutes and bullroarers; these instruments were used by

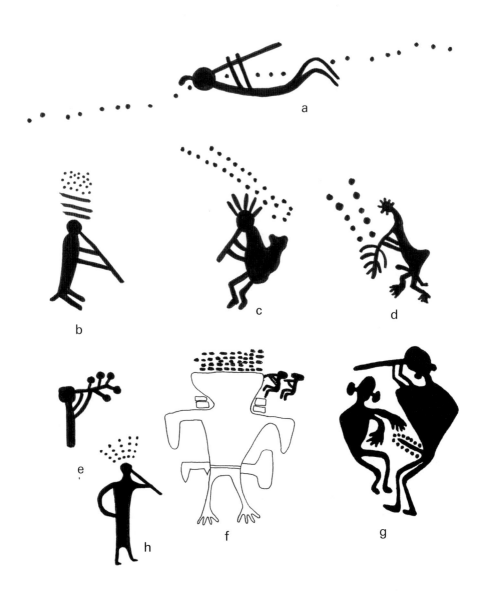

FIGURE 1.08: Flute player images with dots that may represent music or magic power associated with the flute: a. Butler Wash, Utah; b. and e. south of Black Mesa, Arizona; c. and d. La Cieneguilla, New Mexico; f. Zion National Park, Utah; g. ceramic design, Anasazi Heritage Center, Dolores, Colorado; h. Los Pinos River, New Mexico.

shamans at the start of rituals to make the transition to sacred time.[27] In the mythology of the San Carlos Apaches, the flute was used to suddenly transport the player to a distant place.[28]

In some cultures, the flute was used to open the portal to the supernatural and to lure the rattlesnake (often a spirit guardian of the supernatural realm) out of his supernatural lair (fig. 1.11). Like the buzzing of the rattlesnake, the whirring sound made by a covey of quail simulates the aural hallucinations of the shaman. Quails were therefore said to play the flute to open the supernatural portal for Yokuts shamans in southern California.[29] Some shamans wore headdresses of the quail's top-knot feathers, and some flute players in rock art seem to sport similar headgear.

Preserved in the ice age caves of Europe, flutes, bullroarers, and heel marks in clay suggest an ancient ceremonial importance for the instrument—perhaps in ritualized sacred dancing related to the regenerative magic of the cave paintings. In fact, the flute is probably the oldest recognizable musical instrument; archaeologists have found a 53,000-year-old flute made from the thighbone of a cave bear in a Neanderthal cave in Slovenia.[30]

As a measure of cultural complexity, the fact that music making is found in all cultures suggests a deep human need for it. The flute was played for many purposes, including ritual, courtship, entertainment, and dancing, and as a signaling and communication device. In ancient times, the flute probably evolved from the whistle—a sacred object used in specific rituals to call spirits, even during hunting and warfare. Some images of flute players with short instruments may actually be depicting whistles (fig. 1.12). Kokopelli the katsina is said in some accounts to play a "nose whistle stick."[31]

Recent excavation of an early Neolithic site in China uncovered six remarkably well-preserved flutes made from wing bones of cranes. Dated between 7,000 and 9,000 years old, some are in perfect condition and can still be played; their tone scale is similar to the Western eight-note scale that begins "do, re, mi," suggesting that ancient musicians of the seventh millennium BC could play not just single notes but music.[32] Evidence of more than thirty of these flutes was found at the site; all were within graves among human burials. An ancient Chinese legend tells that the flute's music was so mesmerizing that large cranes flocked from the sky and gathered around the flute player. It is interesting that so many Southwestern flute players are depicted with birds, some of which resemble cranes (figs. 1.13 and 1.14).

Many ancient flutes and other wind instruments such as clay whistles and ocarinas have also been unearthed in Central and South America. Researchers believe these were vital to the life of the Inca, Maya, and other peoples. These musical instruments

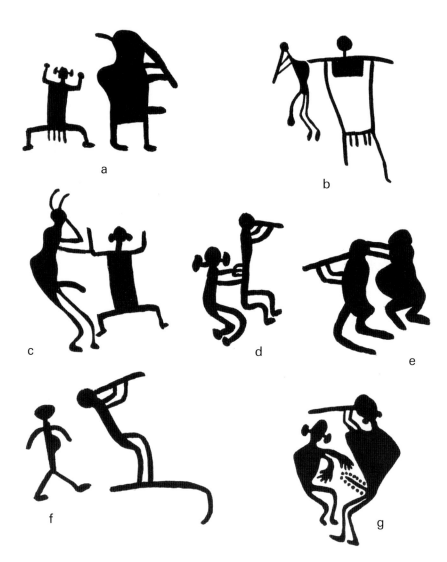

FIGURE 1.09: Portrayals of women being serenaded, charmed, and drawn to the flute player: a. and h. Rio Arriba County, New Mexico; b. Sand Island, Utah; c. and i. La Cieneguilla, New Mexico; d. Little Colorado River, Arizona; e. Kanab, Utah; f. Comb Ridge, Utah; g. ceramic bowl from Four Corners region; j. White Rock Canyon, New Mexico; k. South Mountains, Arizona.

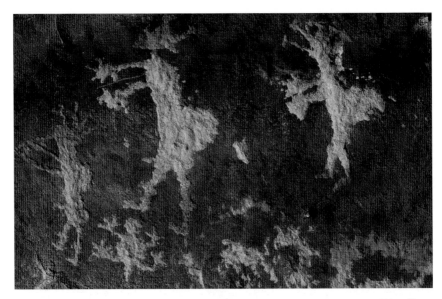

FIGURE *1.10:* Petroglyph of flute player seeming to charm or attract women, Waterflow, New Mexico.

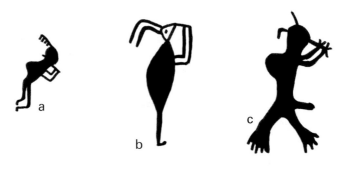

FIGURE *1.12:* Petroglyphs of figures that may be playing whistles: a. Chaco Canyon, New Mexico; b. Three Rivers, New Mexico; c. West Mesa, New Mexico; d. Mesa Verde, Colorado.

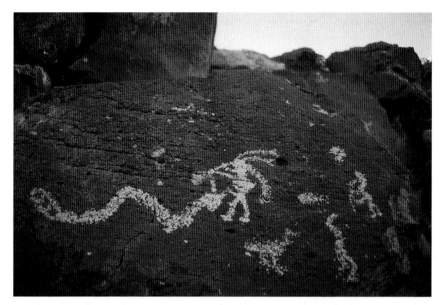

FIGURE *1.11:* Petroglyph of flute player and rattlesnake, La Cieneguilla, New Mexico.

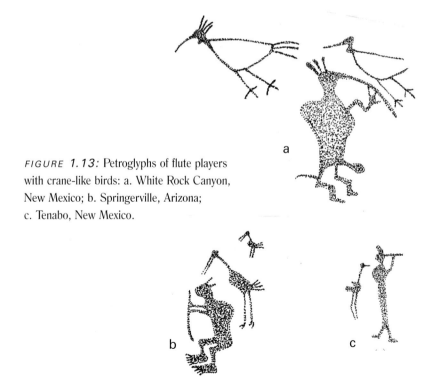

FIGURE *1.13:* Petroglyphs of flute players with crane-like birds: a. White Rock Canyon, New Mexico; b. Springerville, Arizona; c. Tenabo, New Mexico.

FIGURE 1.14: Petroglyph of flute player with crane, Tenabo, New Mexico.

were used for pleasure and ritual, perhaps including funeral processions and conjuring up the supernatural.

As an example from South America of the nearly universal importance of the flute and its sexual or fertility context, consider the mythical background for an important ceremony of the Desana people in the Amazon.[33] When the Sun Father's incestuous sin of violating his daughter was witnessed by a mantis-like insect, the creature transformed into a person and used a flute to publicly denounce the crime. On the rocks where this happened can still be seen petroglyphs symbolizing these mythic events: a spiral marking the spot where he put the mouthpiece of the flute, as well as an impression of the girl's buttocks, spots of blood, and small holes where she urinated.

This instrument produced a sad sound, and it smelled like the *bari* fruit, having the odor of the genitals of the Daughter of the Sun. This mythic event introduced flutes and their ceremonial playing to the Desana people. Afterward, some women observed where the men hid their flutes. After the women handled the flutes, their bodies suddenly grew pubic hair. When the men returned, the women seduced them, even though they belonged to the same family groups. Order was restored after supernatural punishments took place. This myth illustrates how creation passes to chaos because of forbidden sexual acts, and how flutes are played as a reminder of these sins. There are male and female flutes, with different sounds and erotic meanings to the Desana. The name given to men who play these flutes translates as a conflation of

the phrases "to be drowned, or sink" and "pubic hair." This alludes to the metaphor of "submerging oneself in water" for the sexual act; the flute players represent those who are "drowned."

ORIGINS AND INTERPRETATIONS OF THE SOUTHWESTERN FLUTE PLAYER

Widespread as the figure is, the origin of the Southwestern flute player and the evolution of his role as an important symbol are difficult to determine. Exactly when they first appeared is uncertain, but at least five examples of flute players are known from the Archaic Barrier Canyon Style of southeastern Utah, which is dated between 4000 BC and 500 BC.[34] Flute players are more numerous in Basketmaker rock art dating back to at least AD 500, particularly around Canyon de Chelly and northwest of the Hopi mesas.[35] After AD 1000, they are present with humped back in Ancestral Pueblo rock art, pottery, and wall paintings. They also appear on ceramics of the Hohokam and Mogollon in southern Arizona and New Mexico around AD 1000–1150.

Flute players lacking humps may simply represent normal human musicians. Although some of these are phallic and therefore imply an early role as a fertility symbol, normal-looking flute players seem to predate the mythical and intriguing humpbacked ones. The evolution of the normal-looking flute players into the humpbacked phallic figures took place in the San Juan Basin and the upper Rio Grande region. The humpbacked phallic flute player appears as a ceramic design from Chaco Canyon dated to the Pueblo I Period (AD 750–900).[36] The humpbacked flute player is quite common in petroglyphs throughout the upper Rio Grande region after AD 1300, with definite sexual attributes (fig. 1.15). As the image diffused throughout the Southwest, regional variations undoubtedly developed, explaining the diverse guises and associations such as insect or animal shapes, distorted appendages, bird heads, rabbit ears, and hunting themes.

The flute player has been identified with the character of several insects, including the cicada and the robber fly. The transformation of the flute player into an insect-like being is illustrated in rock art (fig. 1.16) and has been described in ethnographic records.[37] At Hopi Pueblo, the humpbacked flute player and the robber fly or cicada evidently integrated and evolved into the Kokopelli katsina—still phallic and humpbacked but with a long, insect-like snout to replace the flute.[38] Another explanation for the katsina's snout is that it may represent a "nose whistle stick," a type of flute played by katsinas at certain pueblos.[39]

The robber fly has a pronounced hump on its back and is notorious for its persistent copulation.[40] This insect symbolizes life for the Hopi, who gain beneficial

FIGURE 1.15: Rio Grande Style petroglyph of phallic, rabbit-eared flute player, Galisteo Basin, New Mexico.

FIGURE 1.16: Petroglyphs showing transformation of flute player into an insect.

power from it. For example, women who cannot conceive sometimes pray to these insects to ask for children.[41]

The cicada is one of the most revered insects at Hopi, where it is venerated and accorded divine status as a katsina. *Maahu,* the cicada, is a patron of the Hopi Flute Society. In the Hopi emergence myth, the cicada was sent from the lower world to seek an exit for man. When the clouds shot their lightning bolts through him, he went on playing his flute. The Hopi describe the cicada's sound as "fluting." The flute societies use cicada medicine to dream the future, and pieces of cicadas are thrown on the fire to hasten the return of warm weather. The cicada embodies magical heat power, with which it brings hot weather so vital for successful crops.[42] In stories, cicada plays the flute to melt the snow when appealed to by the sun-loving snakes (fig. 1.17). This helps explain some of the flute players that resemble insects, as well as the common association of flute players with snakes in rock art (figs. 1.18, 1.19).

Creation stories of the Hopi, Zuni, and Navajo all feature the cicada. The first people came up through a great hollow reed, aided by cicada and wind. Moreover, the reed of emergence is a great flute, whose music is the breath-wind of the ancestors. At Hopi, there are depictions from the flute ceremony showing cicada playing his flute over the reed to make it grow.[43] The ancient Flute Clan ceremony (fig. 1.20) is still practiced at Hopi. It reenacts their departure from Tawtoykya (Mesa Verde) and tells of ancient ties to ancestral sites throughout the Southwest. They completed their migrations at Walpi on the present-day Hopi Mesa in Arizona.

The sound of a similar insect—the katydid—is also associated with that of the flute by the Jicarilla Apache, who use this insect in their love magic.

These insects make a noise like a flute. When one is caught, it is put in pollen alive. Sometimes it is taken out then; sometimes it is left in the pollen. Then this pollen is put in the flute, and the flute is blown near the girl's home. It is

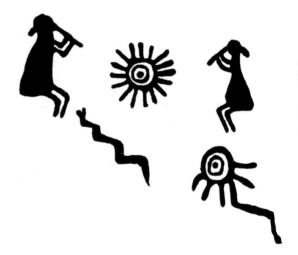

FIGURE *1.17:* Ancestral Pueblo petroglyphs depicting flute players with snakes and sun-like symbols, Moss Back Butte, Utah.

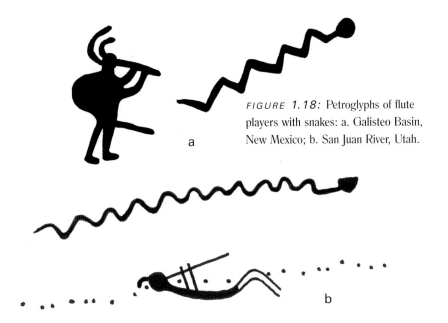

FIGURE *1.18:* Petroglyphs of flute players with snakes: a. Galisteo Basin, New Mexico; b. San Juan River, Utah.

a

b

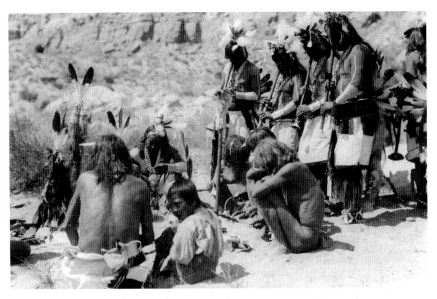

FIGURE *1.20:* Flute ceremony, Hopi, Arizona. Photographer and date unknown. Courtesy Museum of New Mexico, negative no. 177956.

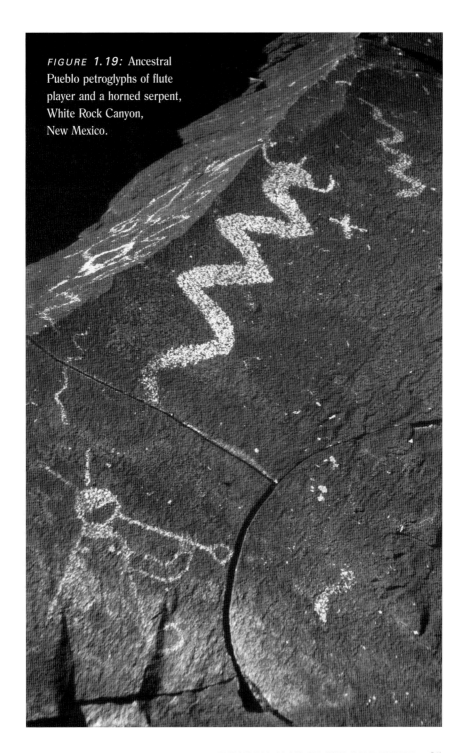

FIGURE 1.19: Ancestral Pueblo petroglyphs of flute player and a horned serpent, White Rock Canyon, New Mexico.

FIGURE 1.21: Flute ceremony at Mishongnovi Pueblo, Hopi, Arizona, ca. 1907. Frederick Monsen, photographer. Courtesy Museum of New Mexico, negative no. 74527.

pointed in that direction. When the girl hears this music, she begins to like the boy who is playing.[44]

The flute player has also been interpreted as a rain priest who calls the clouds with his flute. The flute societies at Hopi play the flute over springs to bring rain (fig. 1.21). At the Hopi village of Walpi, the summer flute ceremony involved blowing the sacred flutes in springs to create bubbles as part of their rainmaking act. At other Pueblos, such as Zuni, sacred flutes were played over medicine bowls filled with water, which represents symbolic springs (fig. 1.22). Such flutes often had bell-shaped gourd ornaments and feathers attached to the lower ends. These gourd ornaments were frequently decorated with cloud motifs and have been described as flowers.[45] This type of flute at Zuni was described as follows:

The flutes are about 27 inches long. The gourd cup at the end of each is decorated on the outer side with yellow, blue, red, black and white cloud symbols. The concave or inner side has a ground color of white or blue-green, upon which butterflies and dragonflies are painted. The edges of the cups are scalloped, each scallop being tipped with a fluffy white eagle feather.[46]

Moreover, gourds for carrying water are sometimes attached to the ends of the Hopi flutes. Some rock art depictions show a bulbous shape at the end of the flute, representing these gourd features (fig. 1.23). In other examples of the flute player's rainmaking, he is often portrayed along with moisture-loving creatures such as toads, lizards, snakes, and insects in rock art. The Zuni claim this association aids the magic in attracting moisture to that locale.

In Pueblo myths, the flute player carries seeds, food, babies, and other good things in his hump to offer maidens whom he seduces. According to stories in the upper Rio Grande pueblos, he wandered between villages with a bag of songs on his back. As a fertility symbol, he was welcome during corn-planting season, was sought after by barren wives, and was avoided by shy maidens. Examples of flute players associated with females, some pregnant or giving birth, are shown in figure 1.24.

Rock art images that also depict the flute player in the shape of various creatures, perhaps suggesting animal or spirit-helper shapes, are assumed by the flute player (figs. 1.25, 1.26). Among the lore of various Pueblo groups, the flute's magical power could transform creatures from one shape to another, such as a man into a butterfly or an ear of corn into a beautiful maiden.[47] Whatever label we may attach to him—deity, priest, shaman, medicine man, healer, or magician, the flute player's function was undoubtedly interrelated with creatures of the natural and supernatural worlds.

Although the humpbacked flute player's origin is lost in time, some believe the tradition may have come north from ancient Mexico or South America with itinerant

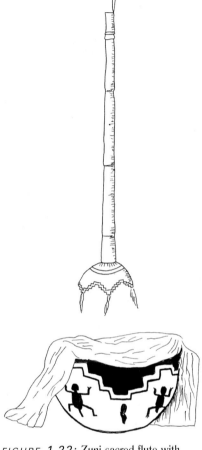

FIGURE 1.22: Zuni sacred flute with feathers attached and medicine bowl with water representing a sacred spring (after Cushing, 1920: 385–86).

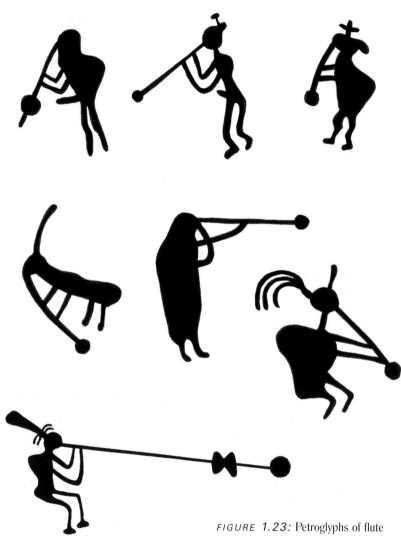

FIGURE 1.23: Petroglyphs of flute players with flutes having gourd-like ends, all from the upper Rio Grande, New Mexico.

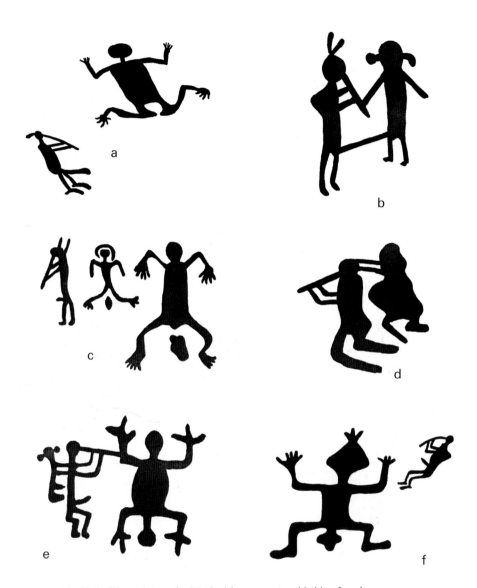

FIGURE 1.24: Flute players depicted with pregnant or birthing females:
a. San Juan River, Utah; b. La Cienega, New Mexico; c. Chaco Canyon,
New Mexico; d. Kanab, Utah; e. Inscription Point, Arizona; f. Abiquiu Dam,
New Mexico.

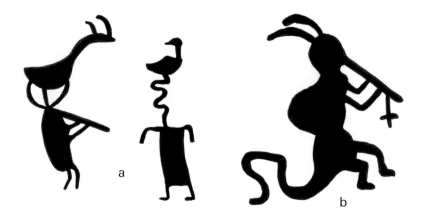

FIGURE 1.25: Depictions of flute players in various animal or spirit-helper shapes that suggest shamanic influence: a. Canyon de Chelly, Arizona; b. Rio Arriba County, New Mexico.

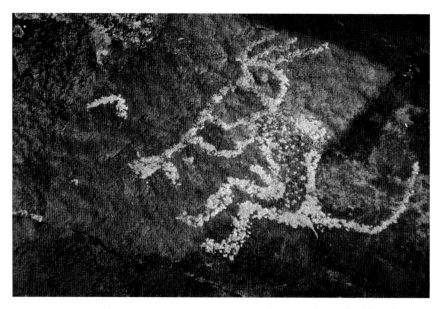

FIGURE 1.26: Petroglyph of a flute player with animal-like features, Rio Arriba County, New Mexico.

traders carrying their goods in sacks (humps) on their backs. These southern traders, known as *pochtecas* (fig. 1.27), were an ancient merchant guild that operated at Casas Grandes (Sonora, Mexico) and throughout the Chihuahuan desert from about AD 1200 to AD 1400, and were at the nexus of relationships between the Southwest and ancient Mexico. In addition to packs, these traders carried walking sticks, or canes, which they venerated. Canes and crook-staffs are portrayed in rock art of the

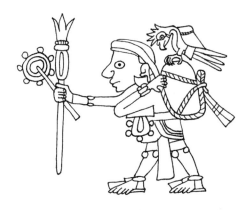

FIGURE 1.27: Drawing of a pochteca merchant from ancient Mexico as depicted in the Codex Fejervary-Mayer (after Nicholson, 1967: 92).

Mogollon, Hohokam, and Ancestral Pueblo (fig. 1.28), and also figure prominently in modern Pueblo ceremony as badges of office, prayer stick bundles, and altarpieces; in many contexts they symbolize fertility and long life (the fertility symbolism of crook-staffs is discussed further in Chapter 3).

Being carriers of ideas as well as goods, the long-distance trade networks of the Pochtecas probably helped spread cultural and religious elements between Mexico and the Southwest. In the Andes of South America, medicine men still wander between villages with flutes and sacks of corn.[48] Although there is no archaeological evidence for it, the theory has been proposed that the ancient flute player prototype may have been responsible for carrying maize to the American Southwest and introducing it to the local cultures. Ek Chuah, a prehistoric Mayan deity, may have been ancestral to Southwestern flute players. He wears a backpack, carries a staff, and is patron of hunters, traveling merchants, and beekeepers.[49] Also from Mesoamerica, the complex Aztec deities Quetzalcoatl (creator sky-god as well as a god of wind, water, and fertility, represented as a feathered serpent) and Xochipilli (the prince of music) play flutes in certain stories and manifestations related to creation, emergence, and water.[50]

Given the diversity of figures, there is no single interpretation for all flute player images, but there are groups that seem to fit certain explanations. For example, a subset of images appears to depict Maahu (the cicada) from Hopi, and another depicts Lahlanhoya (the clan symbol). Another group of images appears to be related to shamanism or altered states. Still others may be from the mythological realm. While seemingly different, these figures seem to share an association with fertility, moisture, and warmth.

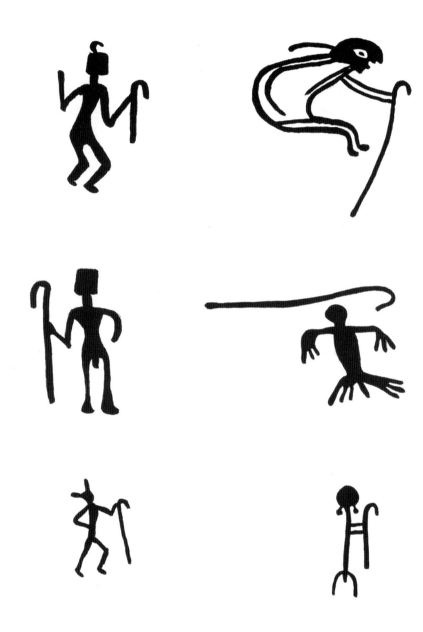

FIGURE 1.28: Rock art images of figures holding crook-necked staffs or canes.

DISTRIBUTION OF FLUTE PLAYER IMAGES IN ROCK ART

The distribution of flute player images, whether in rock art, pottery, or kiva murals, corresponds primarily to a limited area of the Southwest. This is essentially the Ancestral Pueblo region of the Colorado Plateau and upper Rio Grande, and includes, to a lesser extent, the Mogollon, Hohokam, and Fremont culture areas (fig. 1.01). This area correlates well to the distribution of flutes in the archaeological record.[51] Over the years, flute player portrayals changed considerably. There are regional variations in style and concept—phallic versus non-phallic, humpbacked versus straight backed, recumbent versus upright depictions.

Flute player images occur throughout Utah, from the southwestern corner near St. George, extending north to Dinosaur National Monument and southeast to the Four Corners region, where there are major concentrations along the San Juan River. In New Mexico, flute player portrayals are plentiful along the upper Rio Grande and its tributaries, and in the canyons draining to the San Juan River in the northwestern part of the state. The greatest concentration in Arizona occurs in the northeastern region, particularly around Canyon de Chelly and north of Hopi Pueblo, but also extends south into the Little Colorado River area and as far as the Verde Valley. The flute player image is sparse in Colorado, appearing primarily in the southwestern corner of the state.

Two petroglyph sites stand out as having unusually great concentrations of flute players. A petroglyph site located in an area south of Black Mesa in northeastern Arizona contains more than 175 flute player images—probably the largest such concentration.[52] Many interesting and unusual depictions of flute players are found at this site—examples of which are shown in figure 1.29. In New Mexico, a rock art site along the Santa Fe River near La Cieneguilla has nearly as many depictions of flute players—at least 130 have been tallied.[53] Examples from this site are shown in figure 1.30. The reason why these two locales have so many flute player images is unknown.

The geographical distribution of known flute player images has been discussed in detail.[54] However, in considering the outlying images around the core area of flute player images, it is important to bear in mind that many native cultures played the flute, and that not all of these depictions may be symbolically related to the same ideas expressed by the classic Southwestern flute player being discussed here.

The eastern limit for flute player images extends to the Great Plains of Texas, Oklahoma, and southeastern Colorado. A flute player, seemingly humpbacked, is documented from a cave located on a tributary of the Brazos River in Garza County, Texas, about a hundred miles east of the New Mexico border (fig. 1.31).[55] In this

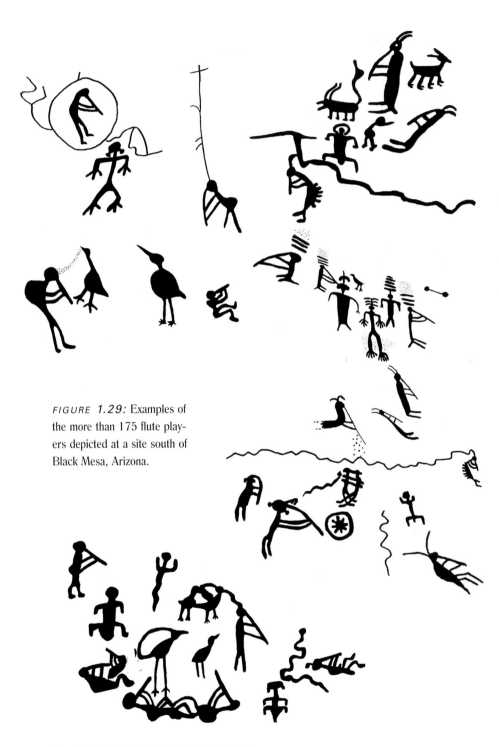

FIGURE 1.29: Examples of the more than 175 flute players depicted at a site south of Black Mesa, Arizona.

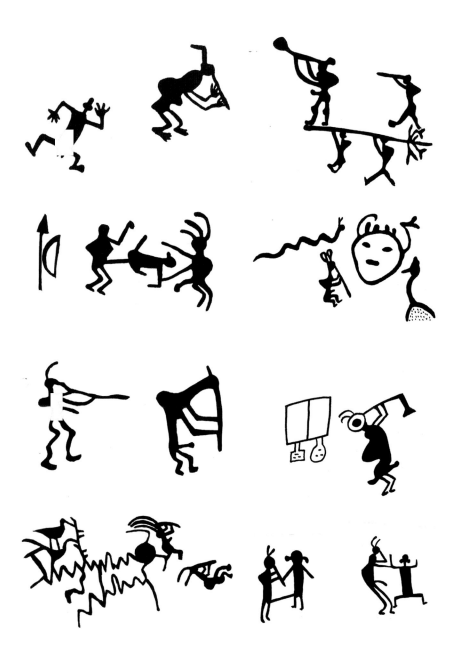

FIGURE 1.30: Examples of the more than 130 flute players, La Cieneguilla, New Mexico.

FIGURE *1.31:* The eastern-most known flute player image, from the Brazos River, Garza County, Texas (after Riggs, 1969).

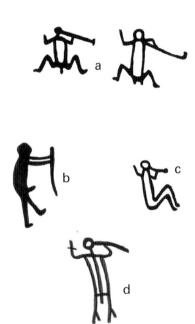

FIGURE *1.32:* Flute player images from sites in southeastern Colorado and the panhandle of Oklahoma (all are after McGlone, et al., 1994): a. Purgatoire River, Colorado; b. Canadian River drainage, Colorado; c. Picture Canyon, Colorado; d. southeast Colorado.

incised petroglyph, the hump could perhaps be interpreted as an arm, but the presence of a tail, the bulbous end of the flute, and a nearby image of a woman carrying a child suggest this may indeed be related to the fertility symbol of the Pueblos. Other images from the plains of southeastern Colorado and the Oklahoma panhandle are shown in figure 1.32. Most of these petroglyphs are also incised, suggesting a Plains Indian source. Among them are a pair of seated figures that appear to represent a male and female. The upturned object held by the female may portray a pipe, although women are not typically associated with the Plains cultural habit of pipe smoking. Another of these figures is phallic but it is not obvious that he is holding a flute.

Elsewhere in Colorado, in the San Luis Valley near the Rio Grande headwaters, is the only image of flute players known from this region north of the Rio Grande pueblos. Although these pictographs are faded, it is possible to discern four flute players in black superimposed on a row of red anthropomorphs (fig. 1.33). The age and cultural affiliation of these flute players is unknown, but a panel of Ute pictographs occurs on the opposite wall of the canyon here.[56]

The most northerly known occurrence of the flute player is hundreds of miles away in Alberta, Canada.[57] In Grotto Canyon near Exshaw is a series of faded red pictographs of unknown age and affiliation, among which is a possible flute-playing figure in a stooping posture similar to many Southwest flute players (fig. 1.34). He is next to a group of three styl-

ized ceremonial anthropo-
morphs whose tapered bodies
resemble certain Southwest-
ern imagery such as that of
Basketmaker and Fremont
cultures. Although archaeo-
logical evidence is lacking, it
has been proposed that this
flute player image suggests
that Ancestral Pueblo people
may have visited the area in
the past. Hopi legends—
while not literal proof of a
Canadian connection—claim
that certain clans in their
migrations went north to a
land of ice and snow:

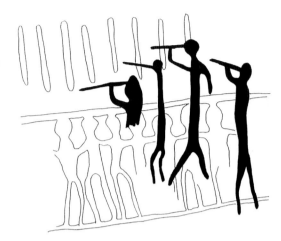

FIGURE *1.33:* Pictographs of flute players from the headwaters of the Rio Grande, near La Garita, Colorado.

When the Flute Clan set out on its migration, its members took the cicada along as their pet. This insect is their clan ancestor. Finally, they reached a place way in the northwest that was covered with snow. Since there was snow on the ground all the time, they failed to cope with it. The cicada, their pet, kept playing its flute constantly, but to no avail. It could not overpower the cold northwest wind. Meanwhile, the cicada, poor thing, was shivering with cold. Eventually it was frozen to a point that it could only produce some chirping sounds. The Flute Clan members claim that this truly happened. So, having arrived at that place they had to turn back again.[58]

Other Canadian examples of characters that may be related to the flute player are described from northwestern Ontario.[59] Ojibwa lore describes a mythic character known as Bebukowe—a bent man who sometimes wore a grasshopper's face. This presents intriguing parallels between grasshoppers and cicadas, and between hump-backs and bent-over figures. A depiction of this Ojibwa character is said to watch over a phallic male-fertility image among the petroglyphs at Peterborough, Ontario. The Ojibwa also tell stories about the Broken Back Man, who is a hunched-over mythic character who defeated an evil giant and who is a "dirty old fellow, but he has a way with the ladies."[60]

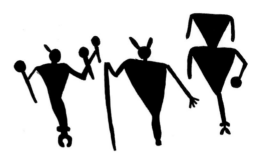

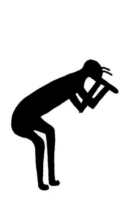

FIGURE *1.34:* The most northerly known flute player—a pictograph in Grotto Canyon, Exshaw, Alberta, Canada (after Magne and Klassen, 2002).

Moving far to the south, we find the southernmost North American depiction of a flute player in a petroglyph panel at Caborca, Sonora, Mexico (fig. 1.35). Although he is not phallic and lacks a hump, this flute player seems related to the Southwestern genre, with his curled head appendages and tail. To date, this is the only flute player image reported in Mexican rock art, but it is reasonable to expect that others exist.

The westernmost flute player images are found in southern Nevada, where he is depicted in three petroglyphs—two standing and one recumbent (fig. 1.36). These occur in the Ancestral Pueblo region associated with the Virgin River drainage in southwestern Utah. No flute player images are known to occur farther west in the Great Basin of Nevada or California, although several humpbacked figures occur there.

KOKOPELLI THE KATSINA: STORIES FROM THE PUEBLOS

There are interesting stories involving Kokopelli and other flute-playing figures from the various Pueblos. For example, the Hopi are the source of the Kokopelli katsina and most of our information about him. Likewise, there are counterparts from other pueblos, notably Acoma and Zuni. Katsinas are benevolent supernaturals, revered ancestor spirits associated with clouds, rain, and fertility. They bring rain and well-being to the people and are personified in the masked dancers at the Pueblos. Rock art studies indicate the katsina cult arrived in the pueblo area in the fourteenth century from the Jornada Mogollon region to the south.[61]

As a katsina, Kokopelli (Kookopölö in the Hopi language) varies somewhat in appearance between villages. According to some people at Hopi, he is concerned with increase and fertility among the people, animals, and plants. In his role as a god of human fertility, he heard the prayers of Hopi women desiring a child.[62] Moreover,

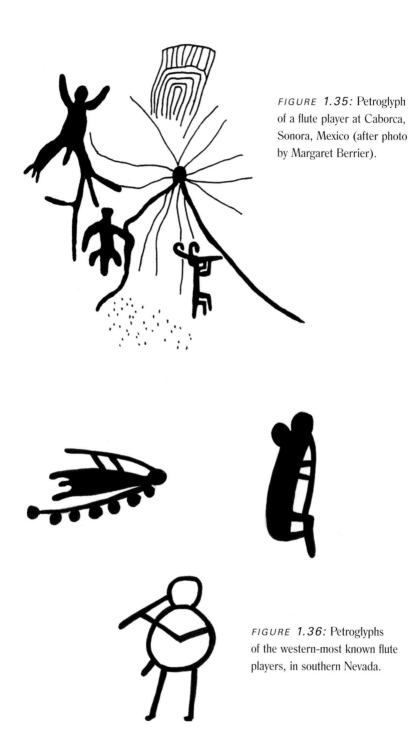

FIGURE *1.35:* Petroglyph of a flute player at Caborca, Sonora, Mexico (after photo by Margaret Berrier).

FIGURE *1.36:* Petroglyphs of the western-most known flute players, in southern Nevada.

his rainmaking power ensures good crops of corn and other food. However, other Hopi explanations of the Kokopelli katsina describe him as a lascivious troublemaker who reminds people about proper behavior. When he appears in dances, usually in the spring, he is erotic. He wears a black mask with a white stripe and has a long snout.[63] At dances in the past, he displayed his genitals, but this evolved into a costume involving an exaggerated false penis constructed from a gourd (fig. 1.37). This may be represented in the image from Petroglyph National Monument, New Mexico, shown in figure 1.38.

The Kokopelli katsina carries no flute, but it has been suggested that his snout may represent a nose whistle. He has a humped back or wears a bag on his back, and may carry a stick and rattle. His habit of chasing females, simulating copulation, and "humping" spectators was frowned upon as obscene by early anthropologists, tourists, and priests, but the Hopi do not look upon his behavior as lewd. Kokopelli used to figure more prominently in Hopi dances but is seen infrequently now, apparently having been suppressed for his ribald routine. An observer in 1939 commented that "the antics of the performers were lewd and obscene, and notoriously obnoxious to prudish white observers."[64] We have this description of a Kokopelli katsina dance in a kiva at Hopi Pueblo in 1934:

There were six Kokopele dancers. They wore dark gray masks, and suits of long

FIGURE *1.37:* A painting of the Kokopelli Katsina from the 1890s (after Fewkes, 1903: Plate XXV).

FIGURE *1.38*: Petroglyph of a possible katsina wearing what appears to be a strapped-on phallus as part of his costume, West Mesa, New Mexico.

underwear with a woman's belt tied at the back. Every performer had a hump fixed on his shoulders, and a large red "penis" [made of gourd?] strapped in position over the underwear. Each dancer carried a rattle in one hand and held his "penis" with the other throughout the performance. As they entered the kiva, the katsinas lunged at the spectators, particularly at the women. They sang and danced facing the audience, advancing in unison occasionally and singing a slow song. The spectators laughed hilariously. Afterwards a Hopi man told Dr. Eggan one should be friends with the Kokopele as they were the ones who sent babies.[65]

A story from Hopi called "The Man-Crazed Woman" is another example of how the Kokopelli figure evolved in their lore.[66] In this story, a man married a beautiful girl, but she made him miserable and depressed because he did not satisfy her, and she grew to dislike him and abuse him. Eventually he jumped off a cliff in despair, but he did not die and eventually revived to see a stranger sitting next to him. It was Badger, whose den was nearby. Badger told him that he was foolish and should have asked somebody for medicine for his problem. Badger said he could give him a remedy—stiffening medicine—which would allow the man to couple all he wanted. The man had a broken spine, and had to remain at the base of the cliff a long time to heal. His wife, meanwhile, did not miss him or search for him; instead, she continued to have sex with lots of men. When the man eventually recovered, he had a humped back. He took Badger's stiffening medicine and returned to his house, where he enticed his wife with flowers he had picked, and they had intercourse all day and all night until his wife was finally satiated. But the man also had another type of medicine that Badger had given him. To get revenge, he sprinkled some into his wife's vulva, causing her to go crazy and jump off a cliff, killing herself. Henceforth, he lived alone as an industrious farmer, but women flocked to him because of his potency. He became known as Kokopelli (Kookopölö) and impregnated many women. Eventually he married a beautiful young woman and they lived together peacefully.

Another explanation of the Kokopelli katsina comes from members of the Flute Clan at Hopi.[67] This tradition tells of a lecherous and promiscuous man who came from the far south and caused many problems as he traveled about the land as a trader, carrying his goods on his back. Upon entering a village, he displayed his items. As people gathered to see what he had to trade, he played his flute, which he used to entrance them. He then roamed about the village, committing lewd and mischievous acts upon some of the women. After he departed,

the people awakened and discovered his wrongdoings. This individual is today personified at Hopi as the Kokopelli Katsina to teach the people that promiscuous behavior is wrong.

Hopi katsinas are sometimes represented in both male and female forms. The female counterpart to Kokopelli is called Kokopelmana. This is a racing katsina and the role is played by strong runners who chase male spectators and simulate copulation with those who are caught. Several petroglyph sites have depictions of apparent female flute players or humpbacked figures. The image in figure 1.39 depicts a flute player incorporating a natural hole in the rock as a symbolic vulva; the petroglyph in figure 1.40 portrays a humpbacked female with breasts, holding a staff. From the same source as the dance description given above is this 1934 description of Kokopelmana at a Hopi ceremonial[68]:

> *Kokopelmana . . . appeared barefooted and barelegged, wearing a ragged manta, a shabby atà'u (small ceremonial blanket worn by women), and a mask comparable to that of Kokopeltiyo. As soon as this impersonator emerged from the kiva, all the men and boys in the vicinity began to scatter. At first the Kokopelmana merely feinted running after them, but suddenly "she" caught up with an unwary man, raised him high in "her" arms and pretended to copulate with him from behind. This done, "she" released him and handed him a few packets of somiviki (cornmeal cakes). From then on "she" ran far and wide in quest of "lovers," pre-*

FIGURE *1.39:* An apparent female flute player that incorporates a natural hole in the rock for a vulva, Cerro Indio, New Mexico.

FIGURE *1.40:* Petroglyph of a humpbacked female, Ferron, Utah

tended to lure men out of their houses, and argued in vigorous pantomime with all women and girls who tried to keep men away from "her." . . . the Oraibi people said that a man was "spoiled" (that is, rendered undesirable to other girls) if the Kokopelmana "got into him."

An interesting story of Kokopelli derives from the Hopi mesas, as follows:

*At the time when Oraibi was first inhabited, the katcina Kokopele was living nearby with his grandmother. Within the village there dwelt a good-looking girl who was so vain (*qwivi*) that she rejected the advances of all the young men. . . . Kokopele confided to his grandmother that he meant to try his luck with this pretty girl, but his grandmother laughed at him because he was humpbacked and far homelier than many of the Oraibi boys. . . . Kokopele had noticed that . . . the girl was in the habit of going to a particular spot at the edge of the mesa to perform her natural functions. . . . His first step was to dig a trench leading from his house to the exact spot which the girl was accustomed to visit. Then he cut and hollowed out a number of reeds, fashioned them into a continuous pipe, and laid it in the ditch . . . he filled in the trench and smoothed it over . . . the next day the girl came to the spot. . . . Hardly had she finished than she felt something stirring under her, and enjoying the sensation, made no effort to investigate. It was the penis of Kokopele that she felt, for so cleverly had he arranged his hollow tube that on inserting his organ into it at home he was enabled, thanks to its unusual length, to direct it into the girl's vagina. From then on Kokopele never failed to take advantage of his device nor did the girl abandon her customary visits to this spot. At last she found herself pregnant, but neither she nor any of the people in the village had the slightest idea of her lover's identity . . . when in due time a boy was born to her, his paternity was as much a mystery as ever.*[69]

The question of the child's paternity was resolved that spring when the village held a footrace for all the men and boys. They all picked and ran with a bouquet of flowers, which each presented to the baby as he finished the race. The baby would accept flowers only from the runner who was his father. The baby would not take the flowers from any of the runners until Kokopelli, who finished the race last, offered his bouquet. When the child accepted Kokopelli's flowers, the village knew he was the father. The villagers told the girl to take the katsina home and keep him for her husband. This she was happy to do, for as a katsina, Kokopelli was a good provider

FIGURE 1.41: Ancestral Pueblo petroglyph showing a flute player copulating with a female on the other side of a rock corner, Jemez Mountains, New Mexico.

and brought lots of rain. The critical portion of this myth (the act of impregnation) is apparently depicted in a petroglyph from the Jemez Mountains of New Mexico, which depicts a humpbacked flute player and a female joined in sexual intercourse by an unnaturally long penis that wraps around the corner of two rock faces (fig. 1.41).

A similar version of this Kokopelli story is recorded from Acoma Pueblo:

> *A long time ago two Dapopo brothers lived at Acoma near the house of Masewi, the elder of the twin war gods. The younger Dapopo asked the War Chief's daughter to let him sleep with her but she refused. Then the older Dapopo asked her the same thing but was also refused. In fact, the chief's daughter rejected the advances of all the boys at Acoma. The Dapopos were angry and kept thinking of how they could get the girl. At last the older brother advised the younger to dig a hole in the ground at the side of the mesa and hide there until the girl came to relieve herself in the evening. In this way the Dapopo got his girl. She did not realize exactly what had happened, but she liked the sensation so much that she repeatedly returned to the same spot. Then the older brother hid and he too got the girl.*
>
> *Soon the Acoma people noticed that she was going to have a baby. . . . When the time came two babies were born, one for each of the Dapopo. The War Chief decided to find out who had fathered his daughter's children so he announced a test. All the young men and boys of the village went out and gathered bunches of flowers. Then they lined up and offered them to the babies but*

they would not accept them. Finally the Dapopos, who were last in line, pre-sented their flowers and the children took them, thus acknowledging the Dapopos for their fathers.[70]

There are certain Zuni katsinas that share similarities with the Hopi's Kokopelli katsina and with the humpbacked flute players depicted in rock art of the Zuni area. Paiyatamu (fig. 1.42) is a flute-playing culture hero, but he is not humpbacked. Like Kokopelli, he is associated with fertility and rain. The katsina Owiwi is described by the Zunis as humpbacked or carrying a pack of fetishes on his back. There is also at Zuni a phallic katsina who has no hump, known as Ololowishkya. He is the central figure in a ceremony with flute-playing and corn-grinding by men dressed as women. This ceremony has been described by contemporary Zunis in the following way:

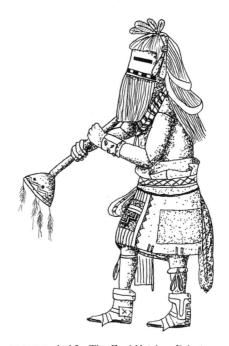

It's embarrassing, but it was for religious doings. Some males dressed like females and stretched out with grinding stones. There were flute players and rain dancers. Ololowishkya had a dinga-ling made out of a gourd. He peed a sweet syrup into a big pot that had sweet corn in it. He peed to the direc-tions of the earth six times. He made balls of the juice and corn and gave it to everyone. It tasted good. This ceremony was done so there wouldn't be any problem with men's urine. We don't do this now because white peo-ple watch.[71]

From the rich oral tradition at Zuni Pueblo, some narrative poems have been recorded and translated.[72] One performance relates a story about the flute-playing Paiyatamu and his medicine society kin. He was brought back to life by singing and drumming after being wrongly killed, and then led his brothers in revenge on his wrongdoers. When he blew on his

FIGURE *1.42:* The Zuni Katsina, Paiyatamu, plays a flute with a gourd trumpet on the end and "flute breath" feathers attached (after Wright, 1985: 72).

flute, a big swallowtail butterfly came out of it; when he sucked on his flute, the swallowtail went back into it (butterfly and moth are fertility symbols here and in many other Indian traditions).

He sent the butterfly to his enemies who were certain women, one of whom was responsible for his death. The swallowtail sprinkled the women with his wing powder when they tried to catch him in order to use his pattern in their basketry. This made the women go crazy, and he led them to Paiyatamu, who was perched up in a cottonwood tree. The women tried to catch the butterfly by throwing their clothes at him until eventually they were naked. When they lay down to rest in the shadow of the cottonwood tree, Paiyatamu spit on them and they went to sleep. He then summoned his grandfathers (ancestors) who came out of hiding and had pleasure with the sleeping women. When they awoke, they found Paiyatamu still sitting in the tree with his legs dangling down. He sucked the swallowtail back into his flute. He threw down leaves, which became blankets in which the women dressed themselves. Then Paiyatamu led the women to his house, where they were fed, and then he led them toward the place where the sun comes out. Only they got tired and kept falling down. When Paiyatamu sucked on his flute, the elder sister, the killer, went inside it. Then he blew and a flock of white moths came out. The woman became moths and he told her, "Now, this is the life you will live, so that when spring is near you will be a sign of its coming." Eventually he turned all the other women into moths too. Paiyatamu went on to meet his father, the sun, who praised his way of getting revenge on the women. In this way, the clown society was created long ago. Petroglyphs that combine the elements of moth or butterfly with phallic flute player are shown in figure 1.43.

Another connection between Zuni and Hopi is implied in the form Kokopelli takes at the Hopi village of Hano. Here he appears as a big black man, known as

Nepokwa'i, who carries a buckskin bag on his back. Even the katsina dolls of this figure are painted black. Nepokwa'i may be based on the Negro Esteban who accompanied Marcos de Niza's 1539 expedition; he was stoned to death at Zuni for molesting their women. The Tewa people of Hano had lived with the Zunis prior to settling in the Hopi region.

FIGURE *1.43:* Tewa petroglyphs of a flute player with moths, White Rock Canyon, New Mexico.

KOKOPELLI THE COMMODITY: THE CRAZE CONTINUES

Since the publication in 1994 of my first book about Kokopelli,[73] the intense commercialization of this icon has increased. A veritable marketing frenzy, reflecting a fascination bordering on obsession, has ensued across the country with no sign of abating. The "flute dude" has become nearly ubiquitous in catalogues and other advertising media of our popular culture. His name and image appear on an amazing range of institutions and products. He has wandered far from his Ancestral Pueblo roots—even showing up on T-shirts in the Caribbean, where his libidinous visage accompanies the words "Virgin Islands," and in Hawaii labeled as Koko-Pelé in a clever pun with the native Hawaiian fire-goddess Pelé.

This phenomenon of Kokopelli kitsch was noted in articles a decade ago: "Kokopelli is everywhere, along with whole tribes of fellow rock-art figures in what is nothing less than a tidal change in the socio-cultural currents of Western art."[74] Since then, books have been published on Kokopelli as a commodity—some promising to unleash the secrets behind the phenomenon of the hunchbacked crooner: "To today's merchants, that flute he's tooting sounds a lot like the glorious ringing of a cash register, for Kokopelli can be found on a spectrum of items from snowglobes to pantyhose. It appears the world is cuckoo for Kokopelli!"[75]

Contemporary images of the flute player have indeed become a common sight, especially in art and commerce of the Southwest (fig. 1.44). In the tourist meccas of

FIGURE *1.44:* Images of Kokopelli as a commodity appear in commerce and advertising all over the Southwest.

Santa Fe, Sedona, and Moab, the once ubiquitous "howling coyote" image has been replaced with Kokopelli—interestingly, another version of the Trickster archetype. To list a few, there are Kokopelli-inspired motels, stores, galleries, nightclubs, restaurants, realty offices, rafting companies, golf courses, streets and trails, recorder societies, and chamber quartets. As a decoration, he is found on a bewildering array of objects such as tourist souvenirs, curios and knickknacks, jewelry, ceramics, clothing and textiles, lawn ornaments, lamps, doormats, Christmas ornaments, furniture, mailboxes, bookends, clocks, street signs, even personal tattoos.

There seems to be no end to the absurd modern manifestations for this ancient symbol. In addition to a Golfer-Pelli intended to inspire improvement in your swing, the image has morphed into cyclists, skateboarders, rock guitarists, scuba divers, and skiers (fig. 1.45). That Kokopelli guy sure gets around. But in the majority of contemporary depictions, he is missing something vitally important. His erect penis, the essential feature of his original role as a god of fertility, is typically lacking in the kitschy images. To make the image safe for mass consumption, he has been emasculated and sanitized.

This effect was hilariously illustrated in a newspaper story titled "God of What?" A cute version of the little guy—playing a saxophone instead of a flute and sporting a wavy hairdo—was designed by two Kansas girls for a festival's poster art contest. In an interview with the festival's spokeswoman, it was reported, "They said he was the god of prosperity and joy. We like that. We didn't find out until later he was the god of other things like" Reluctantly admitting the fertility role, she went on to add, "The judges who chose it were unaware that it was Kokopelli. They didn't even know what Kokopelli was." The article concluded by saying the woman sounded a little duped, another victim of Santa Fe style.[76] But there may be hope for the public's eventual enlightenment. If my conservative uncle can refer to Kokopelli as "the dick-man," progress is being made.

Most of these contemporary applications are based on the stick-figure image of flute players from Hohokam ceramics—a misleading irony since the Hohokam character lacks hump and phallus, and is only marginally related to the Kokopelli katsina and the prehistoric flute players seen in rock art.

It seems that contemporary interpretations espoused by this marketing mania tend toward naiveté, and vary from a New Age mystical symbol of indigenous spirituality, to the shopkeepers' "water-sprinkler," to a happy feel-good musician for the average tourist visiting the Southwest. This commercialized form of Kokopelli has become a popular regional icon that, although lacking the symbolic richness of the classic humpbacked flute player, nevertheless transcends temporal and cultural

barriers and is a source of fascination for many. No matter what his form or how complete our understanding of his history, Kokopelli still brings wonder to our lives. Although some decry the cheapening of a once sacred indigenous image, perhaps his role now as a nostalgic mysterious icon is an antidote to our oft-perceived sterile, impersonal, homogenous society.

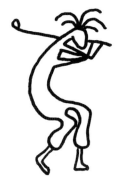

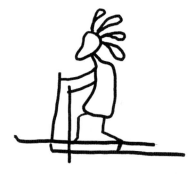

FIGURE *1.45:* Examples of some of the absurd manifestations of Kokopelli in contemporary advertising.

THE MAGIC OF THE FLUTE PLAYER—
ENDURING ICON OF THE SOUTHWEST

1. Slifer and Duffield, 1994. This book discusses in detail the distribution of flute player images in rock art as well as other media throughout the Southwest.
2. McCreery and Malotki, 1994: 156.
3. Roberts, 1932: 101.
4. Erdoes and Ortiz, 1984: 275.
5. Bierhorst, 1979: 78.
6. Ewers, 1986: 160.
7. Erdoes and Ortiz, 1984: 274.
8. Opler, 1941: 151.
9. Ewers, 1986: 162.
10. Bierhorst, 1979: 82.
11. Ewers, 1986: 161.
12. Conn, 1982: 144.
13. Brown, 1961: 10.
14. Brown, 2005.
15. Taube, 2001: 105.
16. Ibid., 116, 119.
17. Ibid., 114–15.
18. Brown, 2005: 210.
19. Brown, 1961: 3.
20. Pepper, 1909.
21. Payne, 1989: 166–67, 171–72.
22. Brown, 2005: 169.
23. Hammond and Rey, 1940: 159.
24. Stephen, 1936: 812, 112.
25. Brown, 1961: 8.
26. Zimmerman, 1996: 102.
27. Whitley, 1994: 12.
28. Goddard, 1918: 20.
29. Ibid., 27.
30. Miller, 2000.
31. Hawley, 1937: 645.
32. Zhang, et al., 1999.
33. Reichell-Dolmatoff, 1971: 169–70.
34. Schaafsma, 1994: 45.
35. Schaafsma, 1980: 136.
36. Hawley, 1937: 645.
37. Malotki, 2000: 72, 106–10.
38. McCreery and Malotki, 1994: 158.
39. Hawley, 1937: 635.
40. Parsons, 1938: 337–38.
41. Malotki, 2000: 21.
42. Ibid., 66.
43. Taube, 2001: 120.
44. Opler, 1946: 161.
45. Taube, 2001: 119.
46. Stevenson, 1904: 192.
47. Tyler, 1964: 83, 126, 143, 147; Cushing, 1979: 360.
48. Grant, 1968: 60.
49. Miller, 1975: 375.
50. Taube, 2001: 114–15.
51. Brown, 2005: 176.
52. Malotki, 2000: 54.
53. Personal communication from Brad Draper, 2002.
54. Slifer and Duffield, 1994. Since this was published, hundreds of additional images have been found, including a number of sites that significantly extend the range.
55. Riggs, 1969: 25–29.
56. Slifer, 1998: 58.
57. Magne and Klassen, 2002.
58. Malotki, 2000: 68-69.
59. Conway, 1993: 125–26.
60. Ibid.
61. Schaafsma, 1994: 63–79.
62. Malotki, 2000: 41.
63. Hawley, 1937: 644–46.
64. Titiev, 1939: 91–98.
65. Ibid., 95.
66. Malotki, 2000: 81–87.
67. From interviews conducted by Utah State Parks at Hopi in 2005 for a museum exhibit about Kokopelli. The exhibit will eventually be housed at Edge of the Cedars State Park in Blanding, Utah.
68. Titiev, 1939: 91–98.
69. Ibid., 91–94.
70. Ibid., 94–95.
71. Young, 1988: 142.
72. Tedlock, 1972: 118–31.
73. Slifer and Duffield, 1994.
74. Neary, 1992.
75. Walker, 1998.
76. *Santa Fe Reporter,* May 28, 1997.

I am sensible of the futility of a book about a place where all realities have melted into shadows. Who can describe silence and space and time, and a world of only immemorial spirits?

—EDGAR L. HEWETT
Pajarito Plateau and Its Ancient People

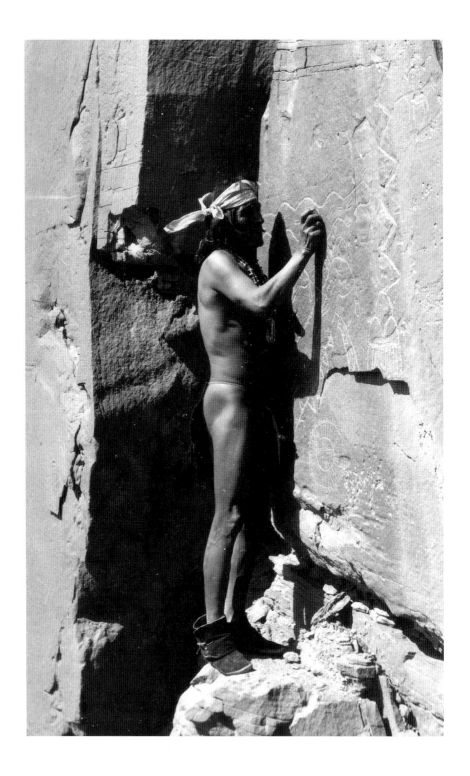

Drawing from the Past
Rock Art and Native Cultures

There are basically two kinds of rock art—petroglyphs and pictographs. Petroglyphs are pecked, carved, or abraded images, whereas pictographs are painted onto rock surfaces with natural pigments, usually under protective ledges or in caves, locations that have helped them survive through the ages. Petroglyphs usually occur on rocks such as sandstone or basalt that have a dark surface or patina, known as desert varnish, which forms slowly as a result of weathering and microbial/chemical alterations. When the desert varnish is removed by pecking or carving with another stone (fig. 2.01), the lighter-colored unweathered rock is exposed, producing a visual contrast. Petroglyphs will eventually darken, or repatinate, as the weathering process continues on the rock surface, although it can take hundreds to thousands of years for the process to completely repatinate petroglyphs, depending on microclimatic factors at specific sites. The degree of patination between different petroglyphs on the same rock provides a relative means of dating, with the fresher-looking ones younger than the darker ones.

FIGURE *2.01:* Unidentified man carving petroglyphs, Hopi, Arizona, ca. 1911. Photograph by H. F. Robinson. Courtesy Palace of the Governors, Museum of New Mexico, negative no. 37014.

53

Pictographs, or rock paintings, are obviously more vulnerable than petroglyphs and, unless protected from the weather, will not usually last as long. Natural pigments such as iron oxides, white or yellow clays, charcoal, and copper minerals were used to produce a palette of red, yellow, white, black, blue, and green. Organic binders were used to mix the powdered mineral pigments into a paint. Binders could be some combination of fluids such as plant juices, egg, animal fat, bone marrow, saliva, blood, urine, and water. Most pictographs are relatively small, although there are some life-size exceptions.

One of the most frequently asked questions about rock art is what it means. Accurate interpretation is difficult, however, because exact meaning cannot be proven, only assumed or extrapolated from ethnographic sources. Because rock art now exists out of its cultural context, attempting to explain how it functioned and what it meant to past societies is tentative at best. This uncertainty is further complicated by the fact that archaeological records are incomplete, especially regarding the earliest societies. Only in the case of historic Indian rock art is it possible to make relatively certain interpretations. As symbols, rock art images must be examined in the contexts of time, place, and culture. On a broad scale, we know that these symbols functioned in information exchange and as a means of expressing group identities, but few studies have demonstrated a more precise meaning of prehistoric rock art.

Reasons for making rock art could include marking territory and features such as trails, springs, and shrines; recording special events such as rituals, successful hunts, and battles; ensuring rain, bountiful harvests, and fertility; creating something of beauty; or simply saying "I was here." No matter what the motivation, rock art is generally aesthetically pleasing and seems to have been creatively inspired, even if that was not always the primary intention. Moreover, it is nearly always located in special places of grandeur or power, something undoubtedly not coincidental. Whatever its function, it seems clear that the elements of rock art are complex and powerful symbols rather than merely decorative ones. The making of rock art was primarily related to concerns about the supernatural and spiritual, with sites selected because they were considered numinous, or inhabited by spirits.

Perhaps rock art is best defined as an artifact of ideas. As ancient records of sacred concepts and former worldviews, rock art images are tangible manifestations of beliefs and visions. These symbols provided communication and a record for future generations about cultural values and ideas. Thus, rock art reflects the minds and souls of ancient vanished people, and allows us to examine aspects of the most basic mode of early human existence—that of the hunter-gatherer. We are all descended

from ancestors with similar cultural practices, and themes in rock art of all continents reflect this universal connection.

There is consensus among scholars that rock art is not "writing," and cannot be "read" as such. It is a language only in the sense that symbols are used to represent things in a nonliteral symbolic manner. There is no doubt that rock art contains messages of many kinds, including ownership, warnings, signatures, demarcations, exhortations, and commemorations, as well as stories and myths. But we cannot read them, and without the ancient artists to inform us, how would we know if we were right or wrong?

Today we can understand certain rock art styles to varying degrees. For example, the more recent Pueblo rock art is more readily interpreted through ethnographic accounts because the beliefs of the artists who created it have been preserved by their recent descendants. By contrast, millennia-old rock art of Archaic peoples is relatively inscrutable because there is no other record of their beliefs passed down to descendants.

The locations of some rock art sites provide clues as to its possible meaning. We know that Pueblo rock art, and probably most other, was often made near places in the landscape imbued with mythic significance, or at shrines where ritual took place. Many are near villages but some are quite remote and hidden. Prominent high points and tributary confluences of streams or canyons are other favored places. Caves and rock shelters were thought to be an entrance to the underworld and so they often contain rock art. Yet in addition to being situated at places of ritual significance, rock art is located in many other places as varied as the landscape itself.

Despite the varied locations of rock art, it seems clear that many rock art sites are in places that are considered sacred or that have power of some kind. Some sites seem to be located specifically around prominent cracks or openings in the rock. Some of these may be rocks that have been struck by lightning. Lightning and thunder are obviously sources of power. Openings in the rock have been described as locales where supernaturals or the shaman's spirit can enter the underworld or emerge to this one. In many indigenous cultures, the surface of rock is seen as a veil separating this world and the supernatural realm, which lies behind. The placement of images near rock features is thus significant, as are prevalent symbols such as lizards and snakes, which may represent spirit messengers who can enter the spirit world via cracks and holes in the rock.

Some rock art sites seem to have special acoustical properties. Rock overhangs, alcoves, caves, and canyon walls can have dramatic resonance and echo-producing effects, which would accentuate the effects of flutes, drums, rattles, chants, or other ritual sounds. Was some rock art created at specific sites for such reasons? Certain

petroglyphs may have been created, or used repeatedly, as a way of addressing the earth or contacting earth spirits. Certain rocks with deeply worn grooves or pits (cupules) were probably ritual sites where contact with supernatural forces was facilitated by the act of rubbing or striking the rock. For example, images related to fertility sometimes have deep pits in the genital areas, and images related to hunting may have evidence of ritual re-pecking on certain animals or parts of animals. In addition, some large rock slabs may possess special acoustical properties that make them ring like a bell or gong when struck with another rock—such sites could have been marked with petroglyphs and used repeatedly to contact the spirits.

Further, hunting magic or ritual is suggested by the placement of some rock art near prominent game trails at narrow passes, canyons, or jump sites where animals could be driven over cliffs. Scenes with game animals pierced by arrows or spears have traditionally been interpreted in this way.

Still another function of rock art may have been astronomical observations. In recent years, substantial research in the field of archaeoastronomy has been focused on rock art sites that may have been created to function as solar observatories or calendrical markers of some kind. For horticultural people concerned with planting and harvesting times, accurate knowledge of solstice and equinox would have been invaluable. One of the first examples of this kind of site to receive popular attention was the discovery of the "sun dagger" petroglyphs that seemed to mark the solstice at Fajada Butte in Chaco Canyon, New Mexico. Since this discovery, other sites have been examined for similar characteristics.

Despite the difficulties of interpreting most rock art, in recent decades, our ability to understand the iconography of some older rock art has significantly advanced—such as rock art depicting shamanistic themes related to hunter-gatherer and early agricultural societies. Shamanism is an ancient, worldwide religious system practiced by most hunter-gatherer and some agricultural societies. The shaman is the tribal specialist in sacred matters, healing, fertility, death, and balancing universal forces. As scholars examine rock art images in this context, it is becoming more apparent that rock art was used by many past cultures to record shamanistic experiences and related spiritual events throughout the world, including the Southwest.

In contrast to the interpretation of representational styles of rock art, such as those where shamanistic elements are apparent, the relatively inscrutable imagery of abstract rock art styles is problematic. Without an understanding of the cultural processes that produced conventionalized symbols, we can only guess at their intended meaning. Even within a given society that produced abstract rock art, perhaps only the specialists or initiates could understand the symbols. Studies of abstract rock art and

symbology conclude only that the images symbolize certain aspects of the natural and supernatural realms, or they served as mnemonic devices to trigger memory and narrative accounts. The exception to this inability to grasp the meaning of abstract rock art is the relatively recent theory about entoptic (within the eye) phenomena related to visions experienced in trance and altered states of consciousness.

One of the more intriguing explanations for some types of abstract or geometric rock art is the neuropsychological model that suggests it mirrors entoptic phenomena. This concept holds that certain geometric visual imagery is projected by the optic nervous system and is caused by an altered state of consciousness. Altered states of consciousness can be induced by psychoactive drugs such as peyote, datura, and mescal; drumming; chanting; dance; sensory deprivation, as in the vision quest; hyperventilation; or meditation. Through such activities, many of which are employed in shamanic practice, people tend to perceive relatively common, fundamental forms such as grids, dots, parallel and zigzag lines, nested curves, concentric circles, and thin meandering lines.

The neuropsychological model predicts that some rock art motifs that exhibit these forms may be products of shamanic or trancing traditions or other altered states of consciousness. They may be the record of someone's vision or mental imagery. Not all shamanic rock art is abstract or entoptic however. Many shaman-influenced styles in the Southwest are representational, and these contain some of the more interesting depictions of flute players and fertility themes (fig. 2.02).

Despite possible interpretations, the meaning of rock art remains elusive. But whatever its function, its aesthetic quality is apparent. In *The Serpents of Paradise*, Edward Abbey expressed a central issue about controversy surrounding the meaning of rock art:

> *Perhaps meaning is not of primary importance here. What is important is the recognition of art, wherever we may discover it, in whatever form. These canyon paintings and canyon inscriptions are valuable for their own sake, as work of elegance, freshness, originality (in the original sense of the word), economy of line, precision of point, integrity of materials. They are beautiful. And all of them are hundreds of years old—some may be much, much older.*
>
> *The artist Paul Klee, whose surreal work resembles some of this desert rock art, wrote in his* Diaries 1898–1918: *"There are two mountains on which the weather is bright and clear, the mountain of the animals and the mountain of the gods. But between lies the shadowy valley of men." How's that for meaning?*

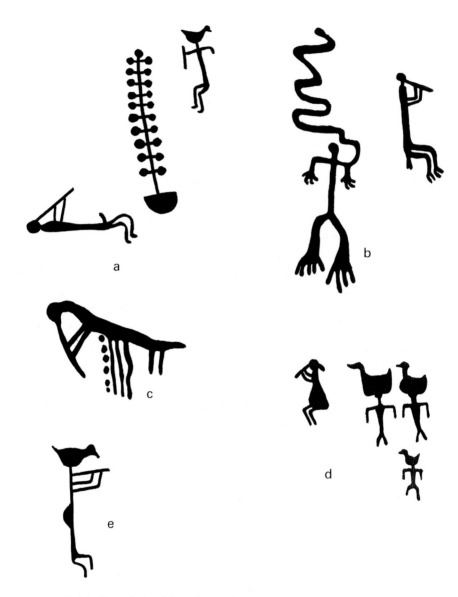

FIGURE *2.02:* Petroglyphs of flute players showing
shamanic influence: a. Comb Ridge, Utah; b. Pinta,
Arizona; c. south of Black Mesa, Arizona; d. Moss
Back Butte, Utah; e. Canyon de Chelly, Arizona.

CULTURAL TRADITIONS OF SOUTHWESTERN ROCK ART

A land of stunning topographic contrasts and great environmental and cultural diversity, the Southwest is a region where many prehistoric cultures have thrived for millennia. The prehistory of the Southwest falls into three broad categories—the Paleo-Indian, the Archaic, and the later periods consisting of at least five major cultural traditions: the Ancestral Pueblo, Fremont, Hohokam, Mogollon, and Patayan. In the following sections, the principal cultural traditions are discussed, including brief descriptions of the rock art styles attributable to these cultures as well as proto-historic cultures present at the time of European contact.

Rock art was created over a long span of time. It was continually produced in constantly evolving styles from the period of early hunter-gatherers to that of later, more complex agricultural societies. To understand its origin, age, and possible meaning, rock art has been classified by styles. Further, rock art styles can be divided into two basic categories, representational and abstract.

Representational rock art depicts life-forms (humans, animals, plants, supernatural beings) but is more often highly stylized than naturalistic. Abstract elements, whether geometric or free-form shapes, are not recognizably related to the real world. Generally speaking, abstract rock art is older and was created by hunter-gatherers, whereas most representational rock art is more recent and was produced by primarily agricultural societies, although in some areas abstract rock art was made continuously up to the time of European contact. Much rock art of the Archaic period and some that is transitional between the Archaic and agricultural periods, such as early Basketmaker, has shamanistic elements.

The basis for organizing rock art into stylistic categories involves patterns observed in systematic investigations of human cultures. The art of any culture group is bound by the confines of a style. In regard to rock art, the main components of style are element inventory and figure types. General aesthetics and technical production are also part of what constitutes a style. Once these are determined, the distribution in space and time of a rock art style can be used within cultural and archaeological contexts to infer limited meaning to the rock art and its development.

Rock art styles usually span broad periods measured in centuries. In areas where a number of styles share similar traits over time, the concept of style tradition is employed. For example, in eastern Utah there is a tradition of shamanic anthropomorphic figures in the rock art of a number of different styles—collectively known as the Utah Anthropomorphic Tradition (fig. 2.03). In areas of great physical and cultural diversity, all rock art does not fit neatly into existing style categories. Nevertheless, rock art styles provide a general conceptual framework useful for comparison and

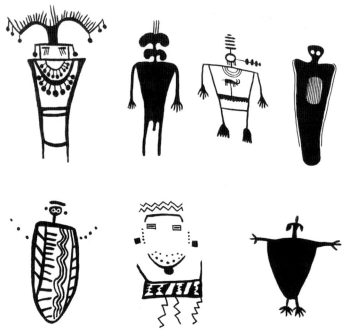

FIGURE *2.03:* Examples of rock art in the Utah Anthropomorphic Tradition.

observation of contextual changes. Currently accepted ideas about rock art styles are broadly correlated to the various cultures known to have inhabited the region.

To most people today, the term *Southwest* probably conjures up visions of the Four Corners states of New Mexico, Arizona, Utah, and Colorado. That area constitutes the core of the Southwest, but because state lines are recent artificial concepts, the Southwest is more broadly defined here on a cultural and geographic basis in order to include the rock art of adjacent and overlapping provinces. This book looks at sites from Texas to Nevada, and from northern Mexico to the Rocky Mountains and Great Basin. This large area of the greater Southwest contains thousands of rock art sites, representing dozens of distinct styles that were produced by many different cultures.

The Paleo-Indians

People have been here for at least 12,000 years. The most accepted explanation is that the first Native Americans crossed a land bridge between Asia and Alaska that was exposed intermittently during the Pleistocene ice ages between 8,000 and 23,000 years ago. This, of course, is the view of the archaeological community; many

Indians believe their people have always been here in their own special, sacred places, or that their ancestors came here from the underground or spirit world. The land bridge theory says that successive waves of immigration eventually peopled all of North and South America. In recent years, other theories have proposed that the first Native Americans arrived here by boat. These first Paleo-Indians are known from their distinctive fluted stone lance heads (Clovis and Folsom points) that have been found with the remains of the big game animals they stalked. As long ago as 12,000 years, they hunted mammoth, giant bison, camels, sloth, antelope, and tapirs. Nearly all of these ice age mega-fauna were extinct by about 8,500 BC, perhaps due in part to successful hunting strategies by the Paleo-Indians. No rock art is known in the Southwest from Paleo-Indians; the earliest is from the Archaic people who followed.

The Archaic Period Peoples
The Archaic Period (typically known as the Western Archaic or Desert Archaic in the Southwest) began with the final drying cycle of the cool, wet, glacial climate that preceded it, and with the commencement of desert and semiarid climates that prevail today. As the climate became more arid, people of necessity became more dependent on the fewer existing perennially flowing streams and springs, and habitation as well as rock art distribution may reflect this.

The Archaic Period spans from about 5500 BC to AD 100. Evidence of the Archaic way of life has been documented from most parts of the Southwest, where slight regional variations have been described. During this time, people in the Southwest were hunter-gatherers and typically were nomadic, at least seasonally, as a function of food supply. There was more emphasis on gathering wild plants and killing small animals such as rabbits, in contrast to the large game hunting of the Paleo-Indians. Populations remained small and unconcentrated. From their artifacts found in dry caves in the Southwest, we know they were skilled in basketry, textiles, and woodworking. Housing was impermanent, and natural shelters such as caves and rock overhangs were often used. Many impressive rock paintings and engravings of this era are found in caves and on cliffs.

The earliest Western Archaic rock art was abstract, followed later by the addition of animal and human elements. Some archaic rock art expresses strong shamanic contexts, featuring large anthropomorphic figures that represent shamans or supernaturals, along with their spirit helpers. The Barrier Canyon Style of southeastern Utah exemplifies this genre with prominent, elaborately decorated anthropomorphs. These figures are commonly described as ghostly, spectral, otherworldly, powerful,

and mysterious. Birds and snakes are two of the most common elements associated with Barrier Canyon Style figures, as well as with flute player images in rock art, suggesting an ancient shamanic connection for the flute player. Barrier Canyon Style flute players are not common, but a few examples are known (fig.2.04).

Demonic or beneficent, there is no doubt that these images represented special beings to the Archaic people who created them. It is likely that Barrier Canyon Style sites served as shrines or ceremonial places due to the remote and special locations selected, and to the large striking figures that convey a sense of spiritual power. The ghostly deathlike aspect of many of these figures may indicate the metaphorical death that the shaman experiences in trance and in initiatory journey to the underworld; in some shamanic cultures, skeletal imagery is used for this purpose.

By 1,000 BC, the lifestyle of Southwestern hunter-gatherers began to change as they learned to cultivate corn (maize), beans, and squash. Gradually becoming more sedentary with dependence on crops and irrigation, the next distinctive cultures of the region

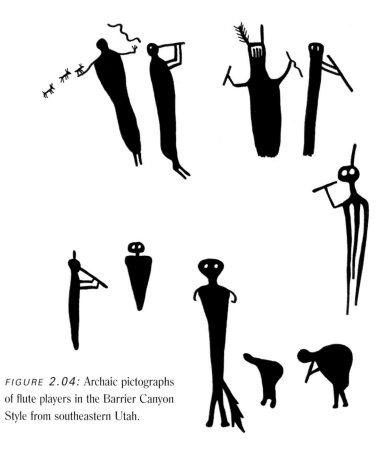

FIGURE 2.04: Archaic pictographs of flute players in the Barrier Canyon Style from southeastern Utah.

were taking shape by 300 BC with the advent of village living and the use of pottery. At first, small communities were scattered across huge territories; then after AD 750, small villages began to grow into towns and even cities (pueblos) with distinctive stone or adobe architecture. In the core area of the Southwest, several approximately contemporaneous cultures evolved, including the Mogollon in southern New Mexico, the Ancestral Pueblo in the Colorado Plateau and upper Rio Grande, the Sinagua and Hohokam in central and southern Arizona, and the Fremont in Utah—all of whom depicted flute players or humpbacked figures in contexts of fertility.

The Mogollon

The Mogollon culture region covers approximately the southern half of New Mexico as far east as the Pecos River and the northern parts of Chihuahua and Sonora, Mexico; it also extends into southeast Arizona about as far north as the Little Colorado River. This mountain and desert culture involved a complex series of developments and a period of major changes with far-reaching consequences for the history of the Southwest. Horticultural activities began very early in the Mogollon region, but village living did not actually commence until around 300 BC. These villages consisted of relatively small groupings of pithouses until about AD 1000; after that, aboveground pueblo-type structures became prevalent.

Mesoamerican civilizations strongly influenced the Mogollon culture development, including the symbols in its rock art. In turn, some of the ideologies of Mogollon rock art apparently were transmitted to and adopted by the Ancestral Pueblo peoples to the north—in particular, the masks associated with the katsina cult. The Western, or Mountain, Mogollon territory encompassed the rugged, wooded highlands of southwest New Mexico and southeast Arizona. The Eastern, or Desert, Mogollon territory extended east to the arid basin and range country of the Chihuahuan Desert. The Desert Mogollon is further divided into the Mimbres and Jornada regions.

The rock art of the Jornada and Mimbres regions is collectively known as the Jornada Style and was influential in the development of Pueblo rock art to the north as well as modern ceremonial art throughout much of the Southwest.[1] The Jornada Style is datable from its appearance on decorated Mimbres ceramics. It reflects a significant cultural shift in the region due to contacts with the high cultures of Mesoamerica. The Jornada Style is known for its rich inventory of visually stunning figures, including masks and faces, mythical beings, animals, blanket designs, horned serpents, fish, insects, and cloud terraces.

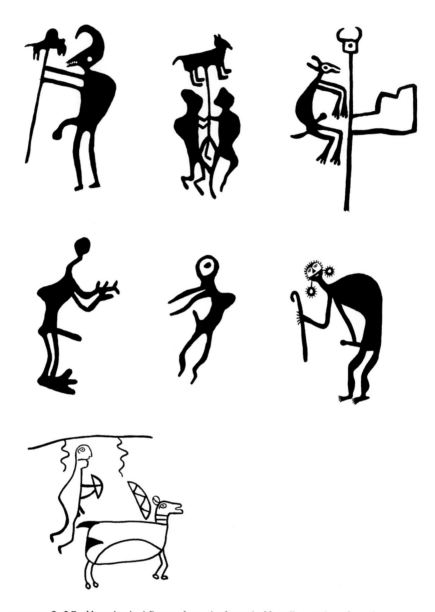

FIGURE 2.05: Humpbacked figures from the Jornada Mogollon region of southern New Mexico.

The Jornada Style persisted in southern New Mexico until approximately AD 1400.[2] The function of Jornada Style sites is undoubtedly complex, but the near-universal appearance of moisture-associated elements such as Tlaloc (a Mesoamerican rain deity), crested serpents, and cloud imagery suggests that the rock art was placed, in part, to ensure adequate rain and good harvests in this harsh desert land. Other water-loving figures found in Jornada Style sites are fish, tadpoles, turtles, and dragonflies. Many rock art enthusiasts consider the Jornada Style depictions of animals and humans to be the most imaginative, stylized, and creative of all Southwestern rock art.

Within the Mogollon culture region there are depictions of humpbacked, sometimes phallic, figures in rock art and ceramics, but almost none are playing flutes (fig. 2.05). An interesting feature of some of these depictions is the crook-staff that is held. While some staffs probably represent ceremonial objects or symbols of rank, the crook-staff is thought to have fertility connotations and may sometimes represent a planting stick. Within the Mimbres area there is a petroglyph of a humpbacked anthropomorph holding a crook-staff at a site near Cooks Peak, New Mexico (fig. 2.06).

At Three Rivers, New Mexico, is a petroglyph that appears to represent a phallic flute player and another depicting two humpbacked phallic figures holding a corn plant (fig. 2.07). At another Jornada Style site in New Mexico, there are numerous depictions of curious humpbacked, sometimes phallic, figures that are holding onto the tails of dragonflies (fig. 2.08). Being creatures associated with water and sometimes with shamanic power, the dragonflies enhance the potent fertility magic of these humpbacked beings.

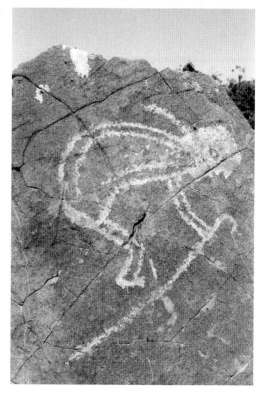

FIGURE 2.06: Petroglyph of a Jornada Mogollon humpback with crook-necked staff, Pony Hills, New Mexico.

FIGURE *2.07:* Jornada Style petroglyphs of humpbacked figures (one a possible flute player), Three Rivers, New Mexico.

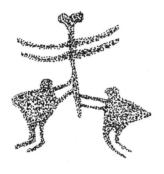

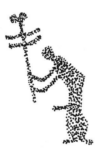

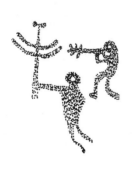

FIGURE *2.08:* Jornada Style petroglyphs of humpbacked figures (one a possible flute player) holding dragonflies, Carrizo Mountain, New Mexico.

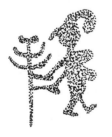

The Pueblo Peoples

The Ancestral Puebloans originated on the Colorado Plateau from Archaic peoples prior to 2,000 years ago. They became the largest and best known of all prehistoric Southwestern cultures and were primarily an agricultural society, growing corn, beans, and squash for their food staples. Spectacular cliff dwellings and multistoried masonry pueblos with underground ceremonial chambers known as kivas are the architectural tradition of the classic Ancestral Pueblo period. The Ancestral Pueblo Tradition spans a period from at least as early as 1000 BC to approximately AD 1540, when the Spanish entered the Southwest. Within the Ancestral Pueblo Tradition, the Basketmaker Period (approximately 1000 BC to approximately AD 800) preceded the Pueblo Period (AD 800 to AD 1540). Modern Pueblo peoples living along the Rio Grande and at Hopi, Zuni, and Acoma are their descendants.

Unlike many of their neighbors who shared common Desert Archaic origin and lifeways, the Ancestral Pueblo culture exhibited a tendency for radical change throughout its history. Their culture became more complex with time, perhaps due in part to the well-documented contacts with the cultures of Mexico across the desert to the south. Many developments from Mexico and elsewhere shaped Ancestral Pueblo life: pottery; irrigation techniques; the bow and arrow; cotton and loom weaving; food crops such as corn, beans, and squash; as well as esoteric knowledge and religious ideas.

There was significant regional variation within Ancestral Pueblo culture, and this is reflected in their distinctive cultural remains, including pottery, architecture, and rock art. The Ancestral Pueblo rock art tradition of the Colorado Plateau endured for more than 2,000 years. Although it evolved through a continuum of stylistic developments, there are great differences between the art of the early Basketmakers and that of the later periods that followed. From its origins in the San Juan Basin, Ancestral Pueblo rock art eventually extended from Nevada to the Rio Grande in New Mexico.

After AD 1300, major changes in the Ancestral Pueblo world produced a new rock art tradition known as the Rio Grande Style that dominates the rock art of the upper Rio Grande but is lacking in the Colorado Plateau. This style is quite different from early Ancestral Pueblo rock art that preceded it. Katsina masks are common, anthropomorphs are large and often stylized, shield bearers and humpbacked flute players are prevalent and highly varied (fig. 2.09). Note the clever depiction of a "reversible" flute player in this figure. Many types of animals are represented, with birds and snakes being more common. Cloud terraces, crosses, stars, corn plants, and handprints are also found. The elements of Rio Grande Style rock art are still maintained in ceremonial art by modern Pueblos.

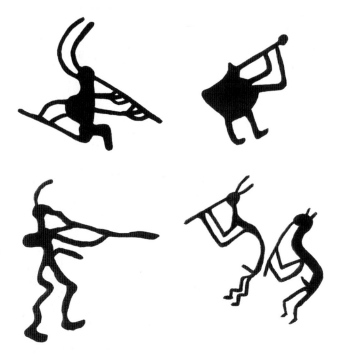

FIGURE 2.09: Rio Grande Style petroglyphs of flute players from northern New Mexico.

The role of rock art in the Pueblo world is probably comparable to that of other cultures in the Southwest, but due to the traditional continuity of the modern Pueblos, it is possible to infer more meaning to many of the elements in Rio Grande Style sites. The religious context of most of the rock art expresses Pueblo worldviews and ritual. Some of it is associated with shrines, clan use areas, war, protective power, and hunting. One of the few symbolic carryovers from earlier Ancestral Pueblo rock art to the Rio Grande Style is the continued presence of the flute player as a fertility symbol, and the majority of known flute player images are attributable to this cultural tradition.

The Sinagua

Most rock art sites in the area centered around the Verde River and Flagstaff, Arizona, are part of the Sinagua tradition, a culture on the fringes of the Western Ancestral Pueblo, with Mogollon and Hohokam relationships. The Sinagua people

appeared in this region in the seventh century AD and maintained their complex tradition until the fourteenth century, when their culture began to merge into that of the Hopi, some clans of which are considered descendants of the Sinagua. Their rock art iconography was influenced by the Ancestral Pueblo to the northeast as well as by the Hohokam, from whom the Sinagua apparently adapted the beautifully executed and elaborate textile and formal abstract designs seen on petroglyph panels in the area (fig. 2.10).

FIGURE *2.10:* Petroglyph of flute player and a textile design, Woodruff, Arizona.

The Hohokam

The Hohokam area occurs in south-central Arizona, centered on the lower Gila and Salt Rivers and their tributaries. It is believed that the Hohokam had Mesoamerican origins, arriving in the area around 300 BC from the south. At the time of their migration to this region, they already lived in villages and had developed pottery making and an extensive irrigation system to support their horticulture. The Hohokam evidently imported the use of ball courts and temple mounds from the south. Their villages consisted of small groupings of houses until the Classic Period (AD 1100 to AD 1450) at which time sizeable adobe complexes and large houses began to predominate. The Papago and Tohono O'Odham (formerly Pima) are probably descendants of the Hohokam.

In the rock art of the Hohokam area, petroglyphs are more common than pictographs. Both abstract and representational designs are present. Humans, game animals, and quadrupeds that may represent dogs are all found in Hohokam rock art. Common among the design motifs of Hohokam ceramics are flute players (fig. 2.11)

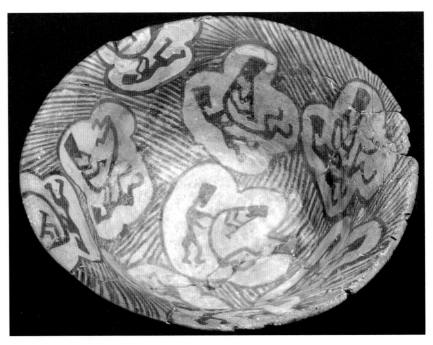

FIGURE 2.11: Hohokam bowl, type: Santa Cruz red-on-buff, with flute player motif, ca. AD 800, courtesy Museum of Indian Arts and Culture, Laboratory of Anthropology, Department of Cultural Affairs (www.miaclab.org). Photograph by Blair Clark (MIAC no. 8754/11).

and figures carrying burden baskets on their backs. The exact relationship between Hohokam flute players and those of the Ancestral Pueblo is unclear, but some postulate that the theme diffused from Mexican antecedents to the Hohokam and thence to the Ancestral Pueblo by about AD 700.[3] This theme appears to have been lost among the Hohokam by AD 1200. A cache of elaborate clay figurines unearthed from a Hohokam site in southern Arizona included a flute player and a female holding a child (fig. 2.12). The woman has red pigment on her abdomen, perhaps to symbolize the power of female fertility as represented by menstrual blood.

The paucity of flute player representations in Hohokam rock art, compared to the many such depictions in ceramics, can apparently be explained merely as a regional cultural variation. In fact, anthropomorphic forms of any type are relatively infrequent in Hohokam rock art when compared to the Pueblo and Fremont areas, and are usually of the stick-figure variety. Six flute player petroglyphs have been reported from the South Mountain near Phoenix (fig. 2.13a), and two others are recorded from a site in the Sierra Estrella (fig. 2.13b).

FIGURE 2.12: Hohokam clay figurines from southern Arizona showing a flute player and a woman holding a baby. Courtesy the Mesa Southwest Museum. Vaughan Cache reproductions by Matt Thomas, 99-101.9 and 99-101.11.

The Fremont

The Fremont culture area includes essentially that part of Utah northwest of the Colorado River and overlaps the Ancestral Pueblo area in some locations; the approximate Fremont date range is AD 400 to AD 1300. The Fremont were a southwest-related culture that, although practicing horticulture, relied more on wild-food gathering than did the neighboring Ancestral Pueblo. Fremont settlements were quite small and kivas did not exist. Most Fremont rock art is found in eastern Utah and northwestern Colorado. This rock art style was strongly influenced by Ancestral Pueblo motifs from the south, such as realistic human figures and frequent depiction of shields. These and other similarities indicate there was cultural interaction between the Fremont and the Ancestral Pueblo.

Fremont rock art includes well-crafted petroglyphs, rock paintings, and sometimes a combination of both. Heroic, supernatural-appearing anthropomorphs are a hallmark, and they often feature details in their clothing, body decorations and jewelry, facial features, and distinctive headdresses. They are typically broad-shouldered

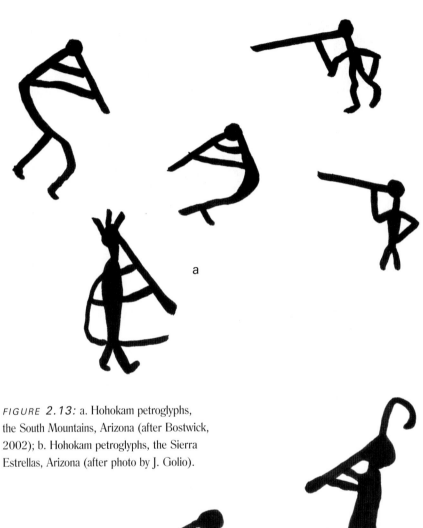

a

FIGURE *2.13:* a. Hohokam petroglyphs,
the South Mountains, Arizona (after Bostwick,
2002); b. Hohokam petroglyphs, the Sierra
Estrellas, Arizona (after photo by J. Golio).

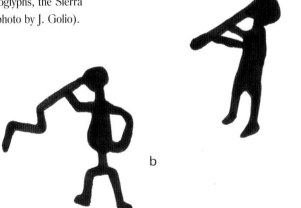

b

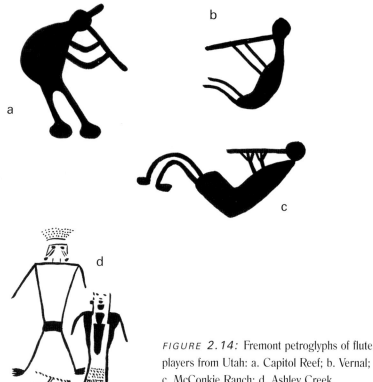

FIGURE *2.14:* Fremont petroglyphs of flute players from Utah: a. Capitol Reef; b. Vernal; c. McConkie Ranch; d. Ashley Creek.

with tapering torsos, although some have other body shapes, and they often occur in rows similar to many Archaic and Ancestral Pueblo styles. Fremont figures often are shown holding objects such as staffs, shields, weapons, bags, and even trophy heads and scalps.[4]

Many examples of Fremont rock art are located very high on cliff walls in nearly inaccessible locations. The artists took considerable risks to place the rock art in these locales—the settings and care taken to make these images seem to attest to the ceremonial importance of some Fremont rock art sites. Fremont rock art appears to contain themes of fertility, warfare, hunting, and mythology. On many panels, the subject matter seems to be arranged or organized, and some even appears to be narrative. Images of flute players are not as widespread or elaborate in Fremont rock art as among Ancestral Pueblo rock art, but a number of sites are known (fig. 2.14).

Along Ashley Creek and Dry Fork, west of Vernal, Utah, is one of the type-sites for the Classic Vernal Style, associated with the Uintah Fremont. This unique style

is characterized by large, broad-shouldered anthropomorphs with elaborate necklaces, kilts, and head ornaments, all of which likely represent ceremonial regalia. This elaboration does not appear to carry over into flute player images, which are similar to those found in the Ancestral Pueblo region.

Fremont flute players are also found in Dinosaur National Monument and the Brown's Park area in northwestern Colorado. In Capitol Reef National Park, a supposedly Fremont flute player is shown "emerging" from a horn on an anthropomorph (fig. 2.15).

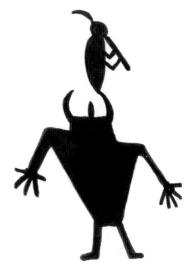

FIGURE *2.15:* Fremont petroglyph of a flute player emerging from the horn of an anthropomorph, Capitol Reef, Utah.

The Apache and Navajo

Indian newcomers to the Southwest arrived about AD 1500. People speaking Athabaskan languages migrated south on the great plains from Canada, and soon moved westward into the Pueblo area of central New Mexico. These Plains-oriented buffalo hunters were ancestral to the Apache and Navajo. By 1540, they had established extensive trading contacts with the Pueblos. Originally referred to as Apaches or Querechos by Spanish chroniclers, by 1626 the Navajo apparently were seen as a separate Athabaskan group living and farming on the upper Chama River.[5]

The Athabaskans borrowed ideology and art from the Pueblos (who in turn had borrowed from the Mogollon) and forged their own unique expression. The lifeway of the Athabaskans changed dramatically with their acquisition of the horse from Spanish stock in the early 1600s. This development allowed revolutionary mobility for hunting and for raiding their neighbors. Depictions of horses in their rock art are thus relatively datable. Today the Navajo are the largest Indian tribe in the U.S. and occupy a huge area in the old Ancestral Pueblo territory of the Colorado Plateau. Their homeland, before occupation of their current reservation, was known as the Dinetah, a vast system of canyons draining through Gobernador and Largo Canyons into the San Juan River in northwestern New Mexico.

Navajo rock art is a result of acculturation and intermarriage between Athabaskan peoples and a number of Pueblo groups (Jemez, Cochiti, Tewa) who fled the Rio

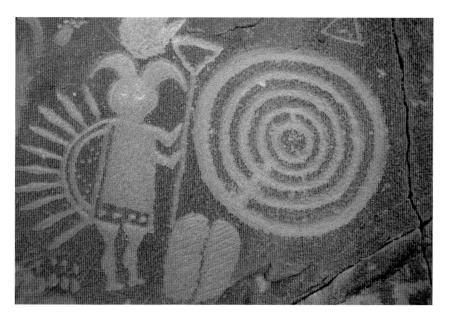

FIGURE 2.16: Navajo petroglyphs showing humpbacked deity Ghanaskidi, Crow Canyon, New Mexico.

Grande area after the Pueblo Revolt of 1680 to escape Spanish reprisal and to join the Navajo in the Dinetah area of northwest New Mexico. The Navajo adopted many aspects of Pueblo religion and ritual during what is known as the Gobernador Phase (approximately 1696 to 1775), and it is from this time that the first Navajo rock art is known.[6] It has similarities to Pueblo art of the time, as would be expected. Depictions of ceremonial figures and Navajo deities, shield bearers, cloud terraces, birds, and corn plants are found in seventeenth-century Navajo rock art. Both petroglyphs and pictographs are found in this style, and both are often beautifully executed. Canyon junctions were favored locations; much Navajo rock art probably functioned as shrines. The sand paintings for which the Navajo are well known evolved out of the earlier rock art ceremonial motifs of the Gobernador Phase.

A likely relative of the flute player that occurs in Navajo rock art is Ghanaskidi (Ghaan'ask'idii, or Ya ackidi)—a humpbacked supernatural who represents a god of harvest, plenty, and mist.[7] He wears horns, carries a staff, and often has a humpback from which feathers radiate (fig. 2.16). The hump is said to be made of the rainbow and contains mist or clouds and seeds of all kinds. He is equated with the mountain sheep, a valued game animal, and has similarities with Pang, the Hopi mountain sheep katsina. Both Pang and Ghanaskidi may be derived from the prehistoric

humbacked flute player—they wear headdresses of mountain sheep horns, have humps, and carry staffs. In the Navajo Night Chant myth, the hero's fingers freeze on his bow while waiting in ambush for mountain sheep, and he cannot shoot. The animals reveal themselves to be humpbacked gods and impart holy teachings to the hero. These gods are in charge of mountain sheep and make them available to the people.[8] Ghanaskidi is one of the most frequently depicted deities in the Navajo rock art of the Largo Canyon area near Four Corners, and is also depicted in Navajo sand paintings.

By contrast, rock art of the Apaches is less well known than that of the Navajos. Rock art believed to be attributable to Apaches is not concentrated in a particular region such as the Dinetah, but instead is found at relatively few sites scattered over a large area, primarily from southern Arizona through southern New Mexico and in west Texas and northern Chihuahua. Through a combination of raiding and trading with their Pueblo neighbors, the Apache acquired some of the Pueblos' ideas about religion and its expression in ceremonial art. The horse and rider are common elements, as are bison, shields, snakes, lizards, masks, small animals, and abstract designs. Figures depicted with sunburst head motifs, horned headdresses, and staffs may be related to the Apache Sun Shaman. Flute players are essentially unknown in Apache rock art, and even humpbacked figures are rare.

The Utes

The Numic-speaking Ute Indians were apparently also recent newcomers to the Southwest region, although their ancestors were probably Desert Archaic residents of the Great Basin and the northern periphery of the Southwest for thousands of years. Their primary territory was the western slope of Colorado, and eastern Utah. After acquiring the horse in the 1800s, they began raiding their Pueblo neighbors, and eventually joined with their Comanche cousins to raid Spanish settlements too. Anglo settlement of Colorado and the gold rushes of the nineteenth century spelled doom for the raiding and roaming Utes.

Ute rock art has been studied mainly in western Colorado and eastern Utah—the area that was their principal territory at the time of historic contact. In terms of general archeological knowledge, there seem to be more questions than answers about the Utes. Their mobile lifestyle may partly explain this paucity in the archeological record. At the time of historic contact, Utes were making rock art of a distinctive style as well as imitating some earlier rock art. Often they imitated the older figures "just for fun."[9] They may have incorporated symbolism and styles of various cultures—again, possibly a function of their mobility.

Ute rock art can sometimes be identified by the historic context of elements such as horses, tipis, trains, and guns. Petroglyphs and pictographs are both present, and sites occur in diverse settings. The alpine cave sites are particularly interesting as only Ute rock art is found in these higher elevations.[10] Their art typically superimposes other styles.

Early historic Ute rock art subject matter includes anthropomorphs (both on foot and mounted), shield figures, horses, bears and bear shamans, vulva symbols, birds, weapons, and abstract linear designs. Themes of this style include battles and raids, individual

FIGURE *2.17:* Ute or Navajo pictograph of humpbacked figure, Uncompahgre River, Colorado (after Cole, 1990: 212).

prestige/power, and hunting. Biographical or narrative content is implied in some panels. Flute player images were apparently not part of Ute rock art iconography. A humpbacked figure holding a flute-like object is depicted in a pictograph from the Uncompahgre River drainage in western Colorado (fig. 2.17). This is probably a Navajo depiction of the humpbacked god, but may also have been made by a Ute Indian, as they sometimes were known to copy the rock art of other tribes.

Drawing from the Past—
Rock Art and Native Cultures

1. Schaafsma, 1980: 186–87.
2. Ibid., 72.
3. Haury, 1976: 239.
4. Cole, 1990: 191.
5. Schaafsma, 1980: 302.
6. Ibid., 305.
7. Reichard, 1950: 443.
8. Ibid.
9. Heizer and Baumhoff, 1962: 222.
10. Cole, 1990: 224.

A man traveled through this country with a bag of corn seed over one shoulder. His shadow against the desert looked like a deformity. He would stop at every village and teach the people how to plant corn. And then when the sun slipped behind the mesa and the village was asleep, he would walk through the corn fields playing his flute. The seeds would flower, pushing themselves up through the red, sandy soil and follow the high-pitched notes upward. The sun would rise and the man would be gone, with corn stalks the height of a young girl shimmering in the morning light. Many of the young women would complain of a fullness in their bellies. The elders would smile, knowing they were pregnant. They would look to the southwest and call him "Kokopelli."

—Terry Tempest Williams
Kokopelli's Return

FIGURE **3.01:** Shadows of the ancient flute player can still be seen against the desert—in this case, the lava flows of El Malpais, Zuni-Acoma Trail, New Mexico.

Trickster, Trader, Troubadour

The Many Faces
of the Flute Player

It is clear that the flute player's roles and metaphors converge on the overarching theme of sustaining fertility. There is no more obvious or potent symbol of fertility among the world's mythic and supernatural figures. This fact is illustrated throughout the region in many interrelated ways. A unique example of the extent to which the fertility persona of the flute player was perceived and expressed by ancient people came to light during the excavation of a remarkable kiva at Yellow Jacket Canyon in southwestern Colorado. This kiva lacked the nearly universal feature known as the *sipapu*—a hole in the floor that symbolizes the place of emergence of the people, the site of creation. In place of the sipapu and encircling half the kiva was a large image of a phallic flute player that had been carved into the earthen floor, filled with yellowish sand, and plastered over.[1] The flute player concealed under the floor of this kiva must have been consciously chosen to replace the sipapu and, hence, represents a symbolic substitute for the source of creation. At another pueblo ruin in nearby Sand Canyon, a second kiva with an unusual subfloor feature was excavated. Here, too, a stylized phallic flute player was pecked and incised into a smoothed portion of the bedrock surface, after which the entire kiva floor was covered with compacted fill.[2] These two subfloor figures, being hidden from view, evidently had an esoteric, magico-religious purpose intended to enhance the

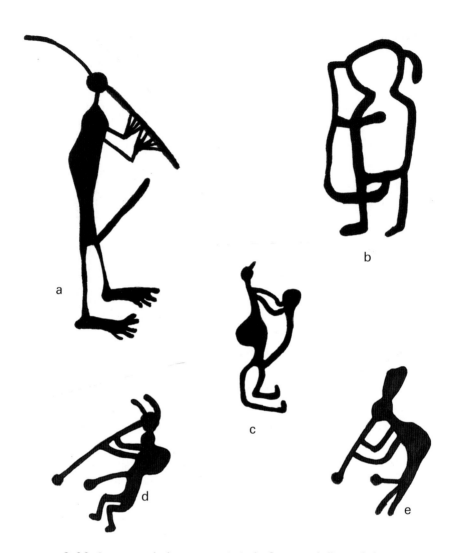

FIGURE 3.02: Some petroglyphs seem to mimic the flute as a phallic symbol: a. Jemez Mountains, New Mexico; b. Rio Arriba County, New Mexico; c. La Cieneguilla, New Mexico; d. Galisteo Basin, New Mexico; e. Tomé Hill, New Mexico.

horticultural and human fertility of the pueblo. Perhaps this was especially important at a time when prolonged drought caused fertility rates to diminish.

Of primary concern to ancient people was their own successful reproduction, and many depictions of the flute player represent this clearly. Themes of sexual potency, eroticism, copulation, pregnancy, and birth abound in the rock art record.[3] In some depictions, the flute itself seems to be a phallic symbol, and mimics the player's erection (fig. 3.02). In other scenes, the flute player's penis is the focus of attention from women or, in the case of figure 3.03, a small anthropomorph that clings to it in apparent veneration.

In examining rock art portrayals of sexual activities, we need to remind ourselves that concepts of obscenity and pornography are European inventions and did not exist in the prehistoric cultures of the Southwest.

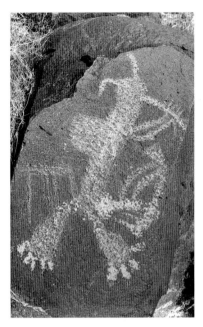

FIGURE *3.03:* Petroglyph of flute player with small anthropomorph attached to phallus, West Mesa, New Mexico.

Graphic sexual scenes, many of which involve flute players, are not as rare as early scholars would have us believe.[4] Some were probably created as a joyous celebration of life, love, and pleasure. Others served symbolic religious and ritual purposes to ensure the continuity of all life, since the complementary principles of male and female are the obvious partners of creation.

Coital scenes occur throughout the Southwest. Certain images indicate symbolic copulation, where phallic males are positioned next to a vulva symbol or a natural hole in the rock that may symbolize the womb of mother earth (fig. 3.04). Scenes of sexual activity were probably created for a number of reasons. Some may simply represent an individual's desire to attract the opposite sex or to record success in doing so. The theme of courtship or seduction is suggested by the scenes depicted in figure 3.05. Perhaps depictions such as this are explained by the following types of accounts:

The men joked together and told many stories about sexual intercourse. They drew figures on the rocks representing the sexual organs. I found a carving of this kind near the Buffalo shrine. There was an outline of a vulva with a coyote symbol and

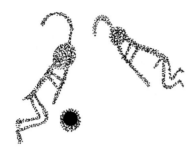

FIGURE *3.04:* Petroglyph of flute players next to a natural hole that has been ritually pecked, Abo Pass, New Mexico.

FIGURE *3.05:* Petroglyphs of flute players with a female and a copulating couple, suggesting courtship or seduction: a. Santa Fe River, New Mexico; b. Pajarito Plateau, New Mexico.

a

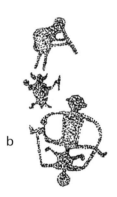

b

eight marks above it; nearby was a drawing of the male organs, and above them the symbol of our Sun shield. I was told it signified that a man of our Sun Clan had had intercourse with eight women of the Coyote Clan. Somebody was boasting. My companions drew similar pictures on other rocks, some with arrows leading to sheltered places suitable for the act.[5]

*Near the village, the trail led past a corner formed by two large boulders. On the face of one rock had been carved the pictographs of a reed (*bakap*), gun, vulva, and coyote head. Ned said that these pictographs indicated that at this spot someone had detected a Bakap clansman having intercourse with a Coyote clanswoman.[6]*

Other images may have originated as part of fertility rites with broader spiritual connotations. Some could have been made by shamans to indicate concepts like "entering the rock" or "penetrating the supernatural"—metaphors for going into the shamanic trance (see the section on shamanism for more on this). Still others of these images may be illustrations of mythic or supernatural events. Some of the figures in such scenes do not appear quite human, and may be representing supernaturals, ancestors, or spiritual beings, or perhaps they are persons wearing masks as part of a

ceremony or rite (fig. 3.06). The two most commonly associated motifs accompanying scenes of sexual intercourse are snakes and flute players (fig. 3.07).

Certain images of sexual intercourse seem to be emphasizing "power" or a spiritual connection between the couple, rather than mere genital union. In these instances, long curving "power lines" may substitute for a phallic link between somewhat distant partners and objects (fig. 3.08). By intentionally representing intercommunication in this way, the abstraction or distortion of the image is probably connoting something in addition to physical copulation. Without ethnographic substantiation, we can only imagine what is intended here. There is also the possibility that some artists had difficulty depicting complex three-dimensional subjects, and solved this awkward problem by connecting the couple with a greatly exaggerated phallus (fig. 3.09). One possible ethnographic parallel to such an exaggerated image is suggested by a Kokopelli tale from Hopi, in which the libidinous flute player inserts his very long penis through a hidden tube of hollow reeds in order to inseminate secretly an unsuspecting maiden as she relieves herself. A petroglyph that may illustrate this story is shown in figure 1.41, and the text of the story is recounted in the section on Stories from the Pueblos in Chapter 1. More examples of flute players engaged in sexual intercourse are presented in fig. 3.10. In examining the nature of flute player images as well as their immense spread over time and space, we cannot doubt the importance this figure held in promoting fertility for the prehistoric peoples of the Southwest.

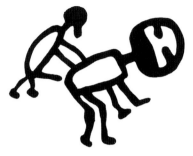

FIGURE *3.06:* Petroglyph of anthropomorphs, one of which is wearing a mask or is a supernatural being, Petrified Forest, Arizona (after McCreery and Malotki, 1994: 110).

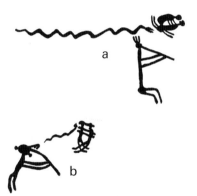

FIGURE *3.07:* Images of snakes and flute players are the most common symbols accompanying scenes of sexual intercourse in Southwestern rock art: a. Monument Valley, Arizona; b. south of Black Mesa, Arizona.

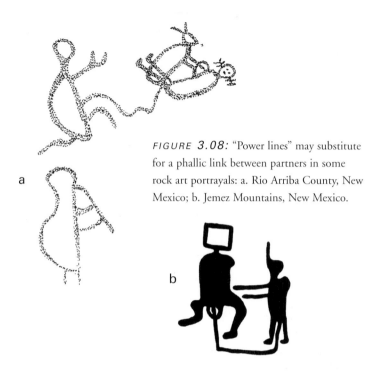

FIGURE *3.08:* "Power lines" may substitute for a phallic link between partners in some rock art portrayals: a. Rio Arriba County, New Mexico; b. Jemez Mountains, New Mexico.

a

b

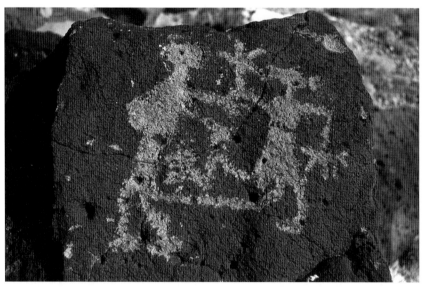

FIGURE *3.09:* Petroglyph of a humpbacked figure having sex with a female, Rio Arriba County, New Mexico.

FIGURE *3.10:* Petroglyphs of humpbacked flute players having sex: a. Santa Fe River, New Mexico; b. Galisteo Basin, New Mexico; c. through e. La Cieneguilla, New Mexico.

Pregnancy and Birth

As many tales demonstrate, a result of copulation was pregnancy and birth. That this was a desired outcome is attested to in the rock art, where images of pregnancy and birthing are widespread, and in fact are more common than depictions of coitus. Rarely, these themes are combined in the same scene or with flute players, proving that the connection between sex, birth, and the flute player was well known (fig. 3.11). In many portrayals of pregnant females, a small anthropomorphic figure is placed inside the body of the female; this convention is seen in various rock art styles of different cultures (fig. 3.12). The act of giving birth is shown in various ways also. Sometimes the female shows a prominent hollow, or empty, womb, with

FIGURE 3.11: Petroglyph scenes where flute players are associated with depictions of copulation, pregnancy, and birthing: a. Cedar Mesa, Utah; b. Holbrook, Arizona; c. Woodruff, Arizona; d. Grand Falls, Little Colorado River, Arizona; e. Chaco Canyon, New Mexico; f. Abiquiu Dam, New Mexico.

FIGURE 3.12: Fremont petroglyph of flute player next to female with small figure inside her, Indian Creek, Utah.

less emphasis on the baby itself (fig. 3.13). More typically, a small anthropomorphic figure can be seen emerging from between the legs of a female in the squatting posture for giving birth. As with the depictions of sexual intercourse, snakes and flute players are often seen next to scenes showing pregnancy and birth.

Menstrual Blood

Ever since the Paleolithic era, blood has been a significant part of ritual and worship. "From the earliest human cultures, the mysterious magic of creation was thought to reside in the blood women gave forth in apparent harmony with the moon, and which was sometimes retained in the womb to 'coagulate' into a baby. Men regarded this blood with holy dread, as the life-essence, inexplicably shed without pain, wholly foreign to male experience."[7]

FIGURE *3.13:* Petroglyphs of flute players next to females with empty wombs: a. Quemado, New Mexico; b. Sand Island, Utah.

Among many Native American cultures, blood was perceived as an important powerful essence. Ritual bloodletting activities among some Native American groups had important fertility implications and were used to summon and feed the gods. Similarly, women's menstrual bleeding received special attention in religious and ceremonial practices. Although commonly the subject of taboos, menstruation among Native Americans was treated as a matter of power more than of restriction or shame. Typically, a girl's first period was celebrated with special puberty rites.

In rock art, we see some images that seem to depict certain aspects of menstrual blood, which may be examples of native views on this subject. The use of red ochre (naturally occurring iron oxide minerals used for pigment) in making pictographs and for painting objects, including the human body, has been an ancient and universal practice. At an Ancestral Pueblo petroglyph site along the San Juan River in northwest New Mexico, naturally occurring iron oxide concretions that cause red

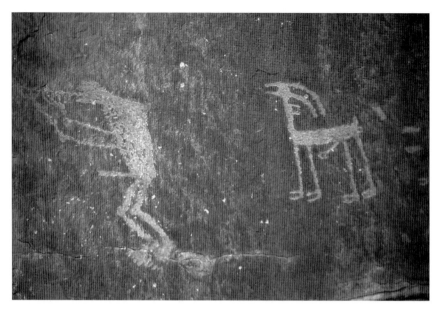

FIGURE 3.14: Petroglyph of flute player seeming to charm a bighorn sheep, Monument Valley, Arizona.

blood-like stains to form on the cliff walls have been incorporated into fertility-related designs that indicate these features were seen as symbolic vulvas with menstrual blood.[8] Here at least eight of these circular cavities with red pigment stains have been intentionally pecked—sometimes the rim of the concretion and sometimes the red stain on the sandstone itself. This may represent a ritual effort to stop menstrual flows, which is necessary for conception to occur. There are several female figures depicted by incorporating a concretion in the genital area, and a phallic male is shown penetrating a concretion as a symbolic vulva. Other fertility related symbols include copulating figures, birthing scenes, flute players, and sprouting seeds motifs.

Other examples of rock art that relate the significance of menstrual blood and flute players are found in Basketmaker images from the San Juan River region in southeastern Utah. At a petroglyph site in a narrow canyon on Comb Ridge there are stylized depictions of females wearing belts with possible aprons or menstrual pads, in association with fertility images such as a flute player, a copulating couple, a phallic humpbacked figure holding a crook-necked staff, and a stylized yucca plant with seedpods or flowers. Similar diaper-like clothing has been observed on Basketmaker female figurines of unfired clay. These are proposed to have functioned as fertility fetishes.[9] Basketmaker women apparently wore such aprons with fiber menstrual pads.

Fecundity of Plants and Animals

Kokopelli appears as a combination Pied Piper and St. Francis of the canyons; he stands facing a mountain sheep that looks at him intently—mountain sheep are notoriously curious and I can well imagine one enticed to the sound of Kokopelli's flute. Perhaps Kokopelli enchants him, rendering him easier to kill. On another panel, far down the canyon, a butterfly-like shape takes flight near two atlatls while Kokopelli plays: a charm so that the atlatls would fly . . . "like a butterfly," their aim true, the hunting good?

— Ann Zwinger, *Wind in the Rock*

Fecundity—defined as fruitful in offspring or vegetation—is generally interchangeable with fertility. It is used here to illustrate those concepts that apply to the natural world beyond human societies. This is, of course, an artificial distinction because indigenous peoples' concerns with fertility are inextricably linked with the fecundity of the earth, plants, and animals. Many cultures perceived a connection between human sexuality and plant and animal fertility, and through sympathetic magic and rituals related to sex, they invoked supernatural power in guaranteeing the fruitfulness of the earth.

Abundance of animals has been associated with human sexuality by hunting cultures around the world. In their myths, humanity often is descended from animals, which are also the source of power and knowledge needed by humans to survive. These gifts from the animal ancestors were often granted by sexual means—giving the idea of the hunt an identity as a form of sexual or mystical union. These notions may be expressed in the petroglyphs at Inscription Point, Arizona (fig. 3.15), showing copulating animals and humans in the presence of snakes and a flute player. Hunters among some Athabaskan groups claim that their knowledge of the animals' ways is the result of men marrying them long ago and acquiring this knowledge from their animal wives.[10] Some Plains tribes believed humanity resulted from a sexual transfer of power between a woman and a buffalo. The Mandan's Buffalo Dance ritualized this ancient event to ensure abundant herds of the animal—a woman would have intercourse with a man of great power who represented the buffalo, and would extract the power from the medicine bundle he carried.[11]

Images depicting these concepts occur in prehistoric art around the world, including the Southwest. Older rock art attributable to the Archaic period in the Southwest is most likely to have been influenced by shamanism and to exhibit such fecundity themes related to hunting and animals. But even in the more recent rock

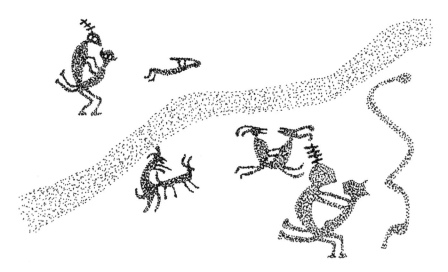

FIGURE *3.15:* Themes of sex, fertility, and animal increase are implicit in this scene with a flute player, Inscription Point, Arizona.

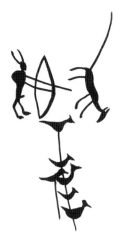

FIGURE *3.16:* Humpbacked flute player and hunters, La Cieneguilla, New Mexico.

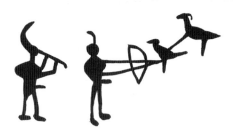

art of settled, agricultural peoples there are vestiges of the ancient shamanic hunting rituals along with themes pertaining to plants, rain, and fertility of the soil.

The fertility rituals of planting cultures, though sometimes possessing elements from the hunter-gatherer past, often center on concerns about rain and seasonal cycles. With the shift from hunting to planting and harvesting, humans focused on the mysteries of the plant world, where metamorphosis and change prevail, and on the celestial elements of sun and rain upon which a fruitful harvest depends. Beliefs about the sky fertilizing the earth with rain and sun are nearly universal in the Southwest and elsewhere around the world.

Turning now to depictions of fecundity associated with flute players, we find these same concerns with animals and hunting, and with rain and the germination and growth of plants. The fecundity of game animals was of particular concern. The link between hunting and fecundity/sex is sometimes expressed by the presence of hunters with erect phalli, including hunting scenes with phallic, humpbacked flute players (fig. 3.16). Prayers for abundant game are reflected in depictions of pregnant animals, such as the scene showing a pregnant deer with spotted fawn inside her, next to a flute player (fig. 3.17), and in the depiction of mating animals next to a phallic flute player and a receptive female (fig. 3.18). A scene in the lower Santa Fe River canyon contains a group of about twenty humpbacked figures and flute players in a depiction of a ceremony, dance, or hunting scene, in which a dozen figures carry bows rather than flutes (fig. 3.19).

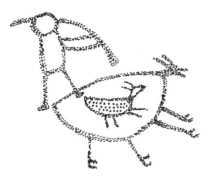

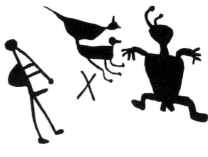

FIGURE 3.17: This petroglyph scene from the Jemez Mountains, New Mexico, illustrates the association of the flute player with pregnant animals.

FIGURE 3.18: Early Ancestral Pueblo petroglyphs depicting a phallic humpbacked flute player with copulating animals and a receptive female, Santa Fe River, New Mexico.

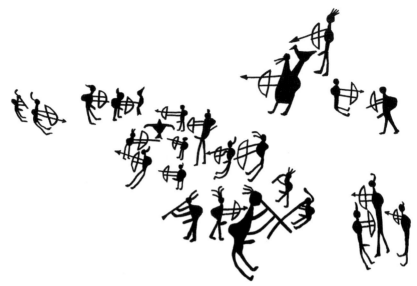

FIGURE *3.19:* Petroglyph scene with a large group of flute players and humpbacked archers, La Cieneguilla, New Mexico.

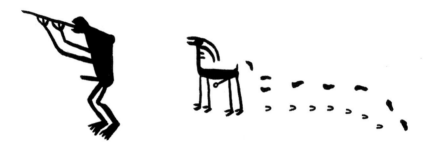

FIGURE *3.20:* Kayenta Style petroglyphs of a flute player with bighorn sheep and tracks of each, Monument Valley, Arizona.

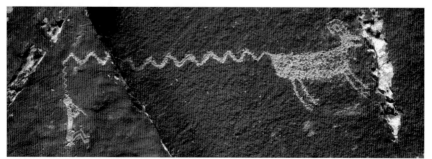

FIGURE *3.21:* Petroglyph of flute player connected by a long wavy line to a bighorn sheep, Johns Canyon, Utah.

The hunting magic of a humpbacked flute player is also implicit in the petroglyph panel from Monument Valley depicted in figure 3.20. Here the flute player is shown with a phallic bighorn sheep, whose tracks are shown along with a row of human footprints to suggest tracking or hunting. Equally compelling is the flute player connected by a long wavy "power" line to the tail of a bighorn sheep in Johns Canyon, Utah (fig. 3.21). In keeping with this theme, flute players are shown next to game animals and birds at many sites throughout the Southwest.

In addition to animals, the fecundity of plants was important to hunter-gatherers, and the role of the flute player is well expressed in this regard. In Basketmaker images, flowering wild plants that were important food and fiber sources are portrayed in the context of fecundity—such as the flowering yucca-like plant next to a phallic flute player and bird-headed shaman in fig. 2.02a.

Flute players apply their fertility magic to vegetation in similar scenes, such as the Basketmaker petroglyphs along the San Juan River, Utah, in figure 3.22. The plants here resemble yuccas with flowers or seedpods; one of them sports limbs, suggesting a yucca spirit is being contacted by the flute player and his humpbacked assistants.

In the transition from hunter-gatherers to planters, Southwestern peoples continued to depict animals and hunting scenes in their rock art, but also incorporated ideas about plants and rain in their expressions of fecundity. The symbolic, fertilizing power of rain is particularly important to the Pueblos, and in its various forms is a dominant theme in ritual and art—as are seeds, germination, and plant growth.

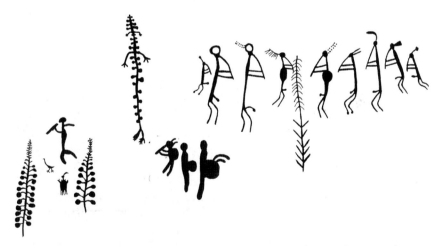

FIGURE 3.22: Basketmaker petroglyphs illustrating the flute player's role in vegetal fecundity, San Juan River near Bluff, Utah.

Winter ceremonies focus on the return of the sun and its life-affirming warmth, as well as germination and sprouting of seeds. In some pueblos, beans are ritually sprouted inside the subterranean, womb-like kivas to prepare for the coming growing season. "During winter solstice we bring in all our seeds and pray that those seeds will be reborn. It teaches you about growth—the seed that you are, the seed that you are becoming."[12] The music of the flute was believed to aid germination and promote growth. In a petroglyph panel from Canyon de Chelly, Arizona, flute players are shown playing to some sprouting seeds and a snake, while another figure holds a sprouting seed in each hand (fig.3.23). A row of flute players are shown with possible sprouting seed designs in figure 3.24.

Summer ceremonies celebrate the fecundity of the earth and often center on corn—the dietary staple but also a profound symbol of fruitfulness. Corn lies at the center of Pueblo religious beliefs, myths, and art—it is synonymous with their identity. Pueblo ceremonies are based on knowledge of the seasons, especially sun and moon cycles, and this knowledge makes it possible to cultivate corn in a harsh, arid land with risky growing seasons.

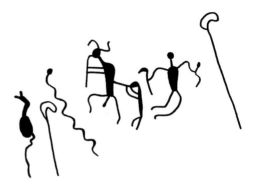

FIGURE *3.23:* Flute players with sprouting seed designs, Canyon de Chelly, Arizona.

FIGURE *3.24:* A row of flute players next to possible sprouting seed designs, San Juan River, Waterflow, New Mexico.

Corn plants are abundantly represented in Pueblo and Navajo rock art, often in ritualized depictions intended to promote fecundity. At a pueblo ruin in the Galisteo Basin in New Mexico, a petroglyph of a corn plant adorns the rock surface above a natural basin that collects water and which probably functioned as a shrine to promote the fecundity of corn. Nearby, a flute player and a corn plant adorn the cliff face (fig. 3.25). Navajo rock art has some of the boldest depictions of corn and associated elements of fecundity. The corn in figure 3.26 grows from a cloud terrace (symbol for rain) and is flanked by wavy lines suggestive of flowing water along with a hump-backed ye'i (deity) known as Ghanaskidi—a fertility symbol whose hump contains mist and seeds of all the plants. A humpbacked flute player sits on a cloud terrace next to a shield with corn-like design in figure 3.27.

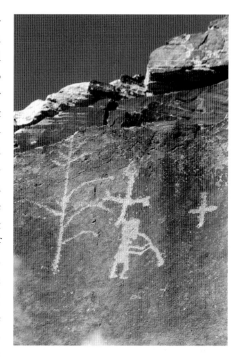

FIGURE *3.25:* Tewa petroglyphs of a flute player and a corn plant, Galisteo Basin, New Mexico.

Abundance of both plants and animals is invoked by the Ancestral Pueblo petroglyphs in figure 3.28, where plants have numerous birds perched in them—next to the plants a humpbacked flute player copulates with a female to promote growth and fecundity.

A fitting image to conclude this discussion of fecundity in rock art is the Basketmaker petroglyph panel from southeastern Utah shown in figure 3.29. It is obvious the ancient artist was representing concerns with the abundance of both plants and animals (in this case, with bighorn sheep). A phallic flute player provides his fertility magic, as hunters throw atlatl darts into the sheep. In the center of the composition is a small, pregnant figure. Some of the plants bend over as if heavy with seeds or fruit. The line of sheep grades from large to small, suggesting a continuation of generations, while over the plants a horizontal figure hovers—perhaps representing a supernatural being or a shaman in spiritual flight as part of his ritual to ensure fecundity and abundance.

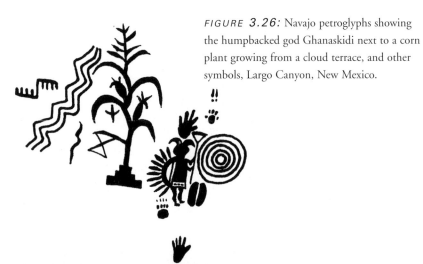

FIGURE *3.26:* Navajo petroglyphs showing the humpbacked god Ghanaskidi next to a corn plant growing from a cloud terrace, and other symbols, Largo Canyon, New Mexico.

FIGURE *3.27:* A humpbacked flute player sits on a cloud terrace next to a shield with a possible corn symbol, Tonque Arroyo, New Mexico.

FIGURE *3.28:* Ancestral Pueblo petroglyphs of a flute player having sex next to a tree full of birds, La Cieneguilla, New Mexico.

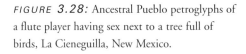

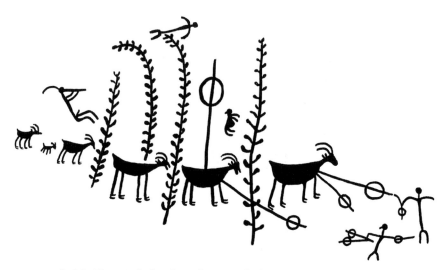

FIGURE 3.29: This panel of Basketmaker petroglyphs illustrates the flute player's role in fertility of plants and game animals, Johns Canyon, Utah.

Bringing Clouds and Rain

Moisture and the means of attracting it were dominant themes in the lives of Indians throughout the desert Southwest. Wherever the water supply was scarce, people ritually summoned rain by some process, and moisture and fertility were closely related concepts in such rituals. Water is the foundation of all life in the Southwest, and the mysterious powers that create and bestow moisture are appealed to in rituals for bringing rain. Appeals for rain and the well-being of the people are obviously another manifestation of the flute player's role that is connected with fertility of the land and all its inhabitants. The Flute Clan priests were originally accepted into Hopi following their migrations because they possessed songs necessary to bring rain. Their chief said, "We carry on our backs the wood of the Flute altar, and we can cause the rain to fall." As soon as they were allowed to enter and set up their altar, rain began to fall.[13]

Depictions of clouds and the associated rain and lightning are a common means of symbolizing moisture in the Southwest, and such elements are sometimes linked to flute player images. In rock art motifs, as well as ceramics, basketry, murals, and other media, the cloud terrace, or rain altar, is a nearly ubiquitous symbol, especially in the Four Corners region. The cloud terrace has been drawn in different ways, from

FIGURE *3.30:* A hump-backed figure blows a short flute or possible cloud-blower pipe toward a cloud terrace symbol in an apparent rain-bringing ritual, La Cienega, New Mexico.

FIGURE *3.31:* Petroglyph of a flute player with possible rain falling from his body, south of Black Mesa, Arizona.

precise, geometric, step-like designs to more realistic, rounded, cloud-like portrayals—it represents the towering thunderhead clouds that bring life-giving rain in the summer. There is no doubt about the importance of this symbol, as it occurs over a large area and in a variety of ingenious uses involving symbolism for lightning, rain, growth of corn, and birds for carrying prayers for rain up to the sky.

The connection between fertility and the cloud terrace can be seen in figure 3.30. Here a phallic, humpbacked figure blows into a ceremonial "cloud-blower" to produce two large, symmetrical cloud terraces. The fertility aspect of the phallic humpback is obvious. Cloud blowers are pipe-like objects that were used in rain-making rituals by blowing smoke into the air to simulate rain clouds. Elsewhere, flute players are seated on small cloud terrace elements (fig. 3.27). Sometimes flute players are portrayed with streams of dots that resemble rain falling from their bodies or flutes as part of their rainmaking powers (figs. 1.08 and 3.31).

TALES OF TRANSFORMATION:
SHAMAN, MAGICIAN, AND TRICKSTER ARCHETYPE

Sometimes the flute player is depicted in the shape of various creatures, suggesting animal or spirit-helper shapes are assumed by the flute player as shaman (figs. 1.03

and 3.32). For instance, among the lore of various Pueblo groups, the flute's magical power could transform creatures from one shape to another, such as a man to a butterfly or an ear of corn into a beautiful maiden.[14] Among Hopi stories are accounts of serpents and cicadas transforming as humans.[15]

However, such images among the rock art of Ancestral Puebloans could just as well depict mythological or supernatural transformations. While shamanism is evident in much Archaic rock art, this connection is not so well established for Ancestral Puebloan rock art. While some Pueblo religious organ-

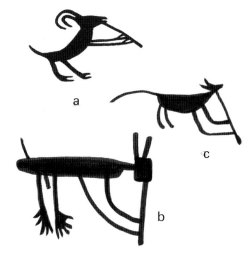

FIGURE 3.32: Petroglyphs depicting flute players in various animal shapes, suggesting shamanic activity or influence: a. Sand Island, Utah; b. Red Gap, New Mexico; c. Rio Arriba County, New Mexico.

izations probably evolved from shamanistic roots (as did essentially all the world's religions), the major difference is that shamans are individually unique and not community organized. Probably most rock art made by Ancestral Puebloans was recognizable to members of the community and was not unique to the makers.[16] However, there are certain conventions in the rock art symbolism of Archaic and early Ancestral Puebloan people that may relate to shamanistic themes, and these could have been recognized as such by everyone from those cultures. Examples of these include bird-headed anthropomorphs (including flute players) and figures with bird and snake "spirit helpers" hovering near them. To varying degrees, such elements probably persisted into later Ancestral Pueblo periods in both the rock art imagery and religious ideas. For example, katsinas sometimes have bird-like heads but they are not shamans.

The shaman was a priest/healer who was believed to possess supernatural or psychic powers received through trances and dreams. He was responsible for healing the sick, revealing the arcane, and using his power to control events that affected the fertility of crops, of game animals, and of the tribe itself. In some cultures, shamanic trances and visions were achieved by the use of hallucinogens such as peyote, datura, or mescal. The strange, dreamlike images in figure 3.33 could be interpreted as hallucinatory. The figure at the top seems to play a flute that resembles the datura plant

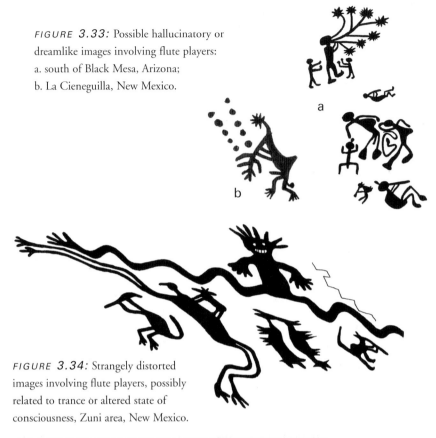

FIGURE *3.33:* Possible hallucinatory or dreamlike images involving flute players: a. south of Black Mesa, Arizona; b. La Cieneguilla, New Mexico.

a

b

FIGURE *3.34:* Strangely distorted images involving flute players, possibly related to trance or altered state of consciousness, Zuni area, New Mexico.

FIGURE *3.35:* Images of birds and snakes are the most common symbols accompanying flute players in rock art, suggesting an ancient shamanic connection, Creston, Galisteo Basin, New Mexico.

with its spiny seedpods (or perhaps flowers; at Walpi, the Flute Society is closely associated with sunflowers). The humpbacked figures below him are distorted, as if in a vision. Even more strange and distorted are the creatures with elongated limbs, and two accompanying flute players in figure 3.34. It is difficult not to associate such images with altered states of consciousness—whether drug induced or not.

Bird symbolism was important in shamanism, thence the concept of magical "soul-flight." Snakes too are commonly depicted with shamanistic imagery; as spirit helpers, snakes can access the underworld by entering cracks in the rocks, and their ability to shed their skins represents powerful regenerative magic. Birds and snakes are two of the most common elements associated with flute player images in rock art, suggesting an ancient shamanic connection for the flute player (fig. 3.35), as previously stated. Some of the earliest images of flute players accompany bird-headed anthropomorphs thought to represent shamans, or in some cases the flute player himself is bird-headed (figs. 1.02, 1.25, 2.02).

Because maintaining fertility is a major interest of shamans, a link between shamanism and the flute player is not surprising. As discussed earlier, in some cultures the sound of the flute is associated with certain aural hallucinations that precede the visions of the shaman's trance, and the playing of the flute signaled a transition to sacred time. Some rock art depictions of the flute player suggest visions or dreaming—states associated with the shamanic trance (fig. 3.36).

The interconnectedness of all things is a basic tenet of the shamanic worldview. Flute players are sometimes depicted with "spirit" or "energy" lines that connect them with other people and creatures (figs. 3.21 and 3.37). With the aid of spirit helpers, the shaman travels to other realms to contact supernatural powers in the interests of healing, fertility and abundance, divining, hunting, and weather control. They played important roles in influencing the health and economic and social well-being of their group.

The nature of certain shamanic symbolism in rock art was discussed in previous

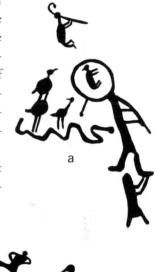

FIGURE 3.36: Some rock art depictions of flute players suggest visions or dreaming, states associated with shamanic trance: a. south of Black Mesa, Arizona; b. Montezuma Canyon, Utah.

FIGURE *3.37:* Flute players connected by "spirit" or "energy" lines to other people or creatures, a basic tenet of the shamanic world-view: a. La Bajada, New Mexico; b. Mill Creek, Utah; c. La Cieneguilla, New Mexico.

sections that dealt with entoptic phenomena and the neuropsychological model for explaining certain types of abstract rock art, and in the role of the flute as it pertains to aural hallucinations. For representational styles of rock art, there are numerous other models and metaphors for interpreting shamanic themes in rock art.[17] Some of the major ones are death (because of the obvious physical similarities between dying and collapsing in a trance), mystical flight (shamans in many regions of the world can "fly" to the supernatural realm, and their art is replete with flight imagery and birds), drowning or going under water (many of the sensations in an altered state of consciousness simulate this), and sexual intercourse.

People in shamanistic societies believed that the supernatural world was intimately connected to the fecundity of the natural world, and that the shaman could manipulate this power to influence the mundane world. Because of these links between sex/fecundity and fecundity/power, it was believed that sexual potency was an expression of supernatural power. The extreme sexual appetites and virility of shamans is emphasized in the ethnographic literature, which abounds with tales of shamans forcing themselves on young women. Strongly erotic elements characterize many shamanic rites, which may include wearing of phallic symbols (fig. 3.38) and singing erotic songs to strengthen men sexually and increase fertility.[18] It is likely that many phallic figures in rock art, including humpbacks and flute players, have an origin in shamanic concepts.

Certain hallucinogens sometimes used by shamans to induce an altered state of consciousness, such as native tobacco and datura, can result in sexual arousal. In some cultures, shamans were said to "enter" the rock during their trance, so these sites became symbolic vaginas that were penetrated to go into the supernatural. There is an obvious sexual symbolism of caves, crevices, and other vulva-like rock features that are sometimes incorporated into rock art—such as the flute players who focus their magic on a natural hole in figure 3.04. The rim of the hole has been pecked and worn, indicating a ritual use of the opening.

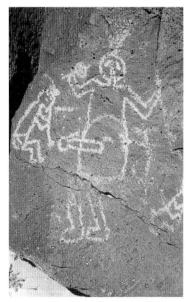

FIGURE 3.38: Petroglyph of a flute player accompanying a ceremonial figure with a possible strapped-on phallic symbol as part of his costume, West Mesa, New Mexico.

FIGURE *3.39:* Petroglyph scenes of flute players seeming to entrance or charm animals: a. Indian Creek, Utah; b. Cliff Dweller Canyon, New Mexico.

The Southwestern flute player has been proposed as a manifestation of the universal trickster archetype. Tricksters are transformers and appear in animal disguise (Native American versions include Raven, Coyote, Hare, and Spider). For example, among the Numic-speaking Southern Paiutes, the mythic trickster Coyote (who is renowned everywhere for his excessive sexual habits) was said to have three penes and to have invented copulation as well as other sexual acts and taboos.[19] As trickster, the flute player shares traits with many characters from other Native American regions: Wakdjunkaga and Hare—the buffoon and culture hero of the Winnebago tribe, Wisaka of the Fox Indians, Sitconski of the Assiniboine, Ishtinike of the Ponca, Nixant of the Gros Ventre, Iktomi (Spider) of the Oglala-Sioux, Nanabozho or Glooscap of the Algonkians, and Raven of the northwest coast tribes.[20] As we have seen throughout, the humpbacked flute player has been depicted in rock art of the Southwest in the form of various creatures.

A comparison of Kokopelli with Wakdjunkaga, the Winnebago Trickster, illustrates many parallels.[21] Both are notorious for their sexuality, as symbolized in each by a large phallus. Wakdjunkaga seduces the chief's daughter, and Kokopelli cleverly impregnates the most sought-after girl in the village. Wakdjunkaga carries his penis coiled up in a box on his back, whereas Kokopelli (and Ghanaskidi) carries seeds in his hump. In some accounts, both characters are said to carry songs in their backpacks. Wakdjunkaga can change into a woman; the Kokopelli katsina has the female Kokopelmana counterpart.

Scholars, including Carl Jung, have compared the North American Indian Trickster archetype to manifestations elsewhere in the world. Similarly, the humpbacked flute player of the Southwest is perhaps a mythological cousin of other fertility figures such as Pan and Orpheus, also musicians. Such archetypes survive from the early stages of

human consciousness. Pan was a Greek god of fertility who wandered in wild places and amused himself with chasing nymphs and leading their dances with music played on his shepherd's pipe (panpipe). All Pan myths deal with amorous affairs. He came to personify Nature and all the gods of paganism. Orpheus played a lyre so masterfully that nothing could withstand the charm of his music—mortals and wild beasts alike were entranced by it. It was said even trees crowded around him and rocks were softened by his music. In the Southwest, there are rock art depictions of the flute player in scenes that suggest his music was entrancing to both women and wild animals (fig. 3.39). Yet another example of this archetype is from India. The most celebrated deity of the Hindu pantheon, Krishna, played a magic flute and was noted for his interest in the female sex. He had some 16,000 wives. In one story, he captivated young Gopinis (milkmaids) with his enchanting flute music, and had sex with 28,000 of them in one night.

One scholar states that Kokopelli "may be compared with the universal Trickster archetype, who, in spite of his unrestrained sexuality, in his roles as hunting magician and rain priest changes from an unprincipled amoral force into a creator who brings order and security into the chaos of the world."[22]

HUMPBACKED FIGURES

While many flute players have a humped back, there are also depictions of humpbacks that, though not playing a flute, are often linked with fertility (fig. 3.40) and may therefore be symbolically related to the flute player. The humpbacked figure is widely associated with supernatural qualities in native myth and religion. The Mesoamerican god/kings Quetzalcoatl, Moctezuma, and Xochiquetzal included humpbacks in their courts and entourage, where they provided religious consultation as well as entertainment. They were also in great demand as favored sacrificial subjects.[23] Humpbacks appear in the architecture, sculpture, and ceramics of ancient Mesoamerica as persons of apparent important social status. Recent translations of a Mixteca codice refer to a humpbacked servant to Quetzalcoatl who played a flute and "made water come out."[24]

FIGURE *3.40:* Ancestral Pueblo petroglyph of a phallic humpbacked figure embracing a maiden, Rio Arriba County, New Mexico.

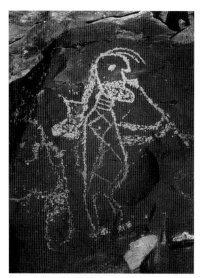

FIGURE *3.41:* Ancestral Pueblo petroglyph of a flute player wearing a pack on his back, near Tetilla Peak, New Mexico.

FIGURE *3.43:* Some depictions of the flute player are exaggeratedly phallic, Cerro Seguro, New Mexico.

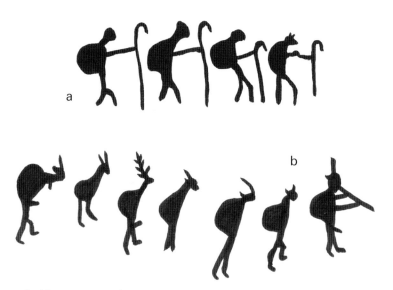

FIGURE *3.42:* Processions of humpbacked figures (backpackers?) and flute player: a. Comb Ridge, Utah; b. Behind the Rocks, Moab, Utah.

The hump has been interpreted in various ways. For example, the hump on some figures' backs may sometimes represent a burden basket, which was employed throughout northern Mexico, and at Hopi was used along with a supporting forehead strap. The burden basket was typically used by women for mundane purposes, but it is also associated with many katsinas and mythic beings. At the Hopi village of Hano, the flute player's hump was thought to be filled with buckskin for shirts and moccasins to barter for brides. The flute player depicted in figure 3.41 is clearly a man carrying a pack on his back. Whether representing packs of trade goods or baskets filled with collected food, humps in this context could indicate abundance and therefore fertility.

Throughout the Southwest, particularly across the Colorado Plateau, are depictions of rows of humpbacked figures, which often include a flute player or two (fig. 3.42). They most likely represent processions of burden bearers, such as traders traveling in groups for safety, migrating clans, or perhaps ceremonial participants. They may even represent young men bearing wealth to trade for wives in distant villages. In matrilochal societies, where the husband lives with his wife's family, wealth-bearing men would have been welcomed to potential host villages.

Some researchers contend that the flute player's hump is indicative of an individual suffering a spinal deformity such as that caused by Pott's disease.[25] A type of tuberculosis, Pott's disease produces kyphosis, an exaggerated convexity of the spine. The existence of tuberculosis in prehistoric America has been demonstrated at a number of sites. Rock art scholars with medical backgrounds have examined paleopathological evidence along with the flute player's traits to suggest this theory. In some rock art portrayals, he also seems to possess a clubfoot and misshapen or paralyzed legs, and is shown lying on his back playing the flute. His erect phallus is further explained as priapism, another symptom of Pott's disease whereby spinal cord disturbance results in permanent engorgement of the penis. Priapism would create the appearance of sexual prowess and supports the connection with a legendary fertility role. Certain images that are exaggeratedly phallic seem to support this idea (fig. 3.43). When embodied with the supernatural qualities of the humpback and the obvious fertility aspect, it is plausible that such individuals would be seen as special or powerful.

SYMBOLS AND IMAGES ASSOCIATED WITH FLUTE PLAYERS
Serpents
Images of serpents are one of the most common rock art symbols, and are especially linked to concepts of fertility and sexuality. Therefore, it is not surprising that snakes are the most common element accompanying depictions of flute players (fig. 3.44).

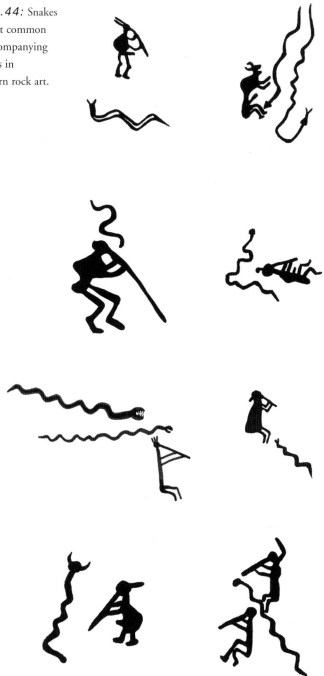

FIGURE *3.44:* Snakes are the most common symbol accompanying flute players in Southwestern rock art.

In addition to the Horned Water Serpent deity, the Pueblos as well as most other Southwestern groups took special account of living snakes, to which were attributed supernatural powers. Snakes are ancient symbols in these cultures and others worldwide. By the dawn of history, the snake was widely worshiped as a supernatural power, and it is a profound symbol in mythology. The serpent has impacted human consciousness in extraordinary ways—no other animal has played such an important or varied role in man's thinking. In its many unique and sometimes contradictory attributes, the snake has been venerated and feared by humans for millennia. The snake embodies the life force and is associated with water, fertility, regeneration, and phallicism. It has been a major symbol of fertility and procreation as well as health, longevity, immortality, wisdom, and power.[26]

FIGURE *3.45:* The dynamic energy of the snake as a symbol of regeneration is probably why so many are found with flute players. Sometimes the flute itself resembles a snake, as in this petroglyph, La Cieneguilla, New Mexico.

Ethnography tells us that snakes were regarded in the Southwest as powerful sacred creatures for the same reasons as in other parts of the world. The primary attributes of the snake that make it such a potent fertility symbol include its association with water, rain/lightning, and the underworld; the ability to shed its skin and appear to be immortal; phallic symbolism; and the power to kill (in venomous snakes), which means they also have powers for healing. The dynamic energy of the snake as a symbol of regeneration is probably the main reason so many snake images accompany the flute player and other fertility-related rock art. Sometimes the flute is depicted as snake-like (fig. 3.45), which may metaphorically link flute-playing with rituals such as the Snake Dance, where live snakes are carried in the mouths of dancers. Recall that in certain Pueblo lore, the flute player (as represented by Maahu, the cicada) plays the flute to melt the snow when appealed to by the sun-loving snakes, which probably accounts for some of the many depictions associating flute players and snakes.

In the desert Southwest, the symbolic association of serpents and water is of primary importance. Because water and fertility are so intertwined in Native views, and

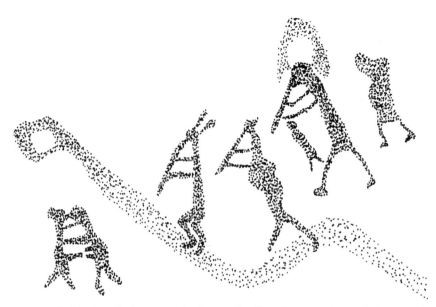

FIGURE *3.46:* Petroglyph scene with a large snake, flute players, and a copulating couple, Train Rock, Ute Mountain Tribal Park, Colorado.

because the snake moves like water and is often seen near water, the symbolic connection is strong. In addition to rainmaking rituals, snakes have also been ceremonially used to maintain the vitality of springs and rivers.

Snake images are also commonly associated with scenes of copulation and birth in rock art of the Colorado Plateau and the upper Rio Grande (fig. 3.46). Symbolic associations between the snake, female/vulva, and male/phallus are found throughout the Southwest, and are illustrated graphically in rock art from many locations.[27] The Inscription Point site in northern Arizona is especially significant for its concentration of snake images associated with scenes of sexual activity and flute players (fig. 3.15).

Birds

Of all the forms used in indigenous art, the bird is probably the most widespread, particularly in the Pueblo area of the Southwest. It is found not only in rock art but also in every other media, including pottery, basketry, kiva murals, clothing, jewelry, pipes, and flutes (figs. 1.04 and 1.05). As previously discussed, bird symbolism is nearly ubiquitous in shamanic art, where it usually represents spirit helpers or the shaman's mystical soul-flight in which his soul takes the form of a bird when it leaves

his body during a trance. This probably explains the many bird-headed anthropo-morphs in the Archaic and Basketmaker rock art of the Colorado Plateau, especially in Canyon de Chelly and the San Juan River area (fig. 2.02).

It has been shown that birds, along with snakes, are the most common symbol associated with flute player images in rock art (fig. 3.47). There are a number of complex interrelated reasons for this, including the association of birds and flute players with rain and fertility, the shamanic association of birds and flute-playing, and—perhaps most obviously—the sounds of a flute mimicking birdcalls. Some flutes and whistles were even made from the wing or leg bones of large birds. As the conveyor of sweet melodies, the symbolism of the bird/flute conflation is compelling. Canyon wrens are incorporated in the Hopi flute altar; its song resembles the notes of the flute in the rainmaking flute ceremony. Moreover, flickers are associated with flutes at Hopi; the water flute of the flute ceremony is encased in their feathers.[28] Most bone flutes in the Southwest are made from bird bones, especially eagles, hawks, and turkeys.[29]

Of all these associations, the most evident expression in rock art seems to be the concern with rainmaking that is a universal preoccupation in the Southwest. Birds and feathers appear in all aspects of Pueblo rituals, both prehistorically and in modern times. They are used on dance costumes, prayer sticks, masks, headdresses, altars, rattles, and other ritualistic paraphernalia. Feathers and bird images are used for prayers and petitioning for rain—perhaps in part because birds can fly and carry one's prayers into the sky, whence rain and clouds originate and where supernatural powers who control these things reside. In addition to rainmaking, feathers are used in curing ceremonies to drive away evil.

The extent to which this reliance on birds and feathers was practiced in the Pueblos is illustrated in the painted kiva murals excavated at Pottery Mound, New Mexico.[30] At least seventeen bird

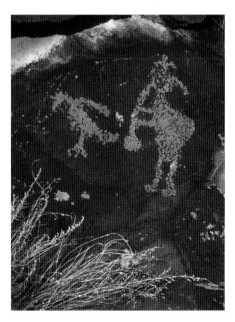

FIGURE *3.47:* Images of birds frequently accompany flute players in rock art, Rio Arriba County, New Mexico.

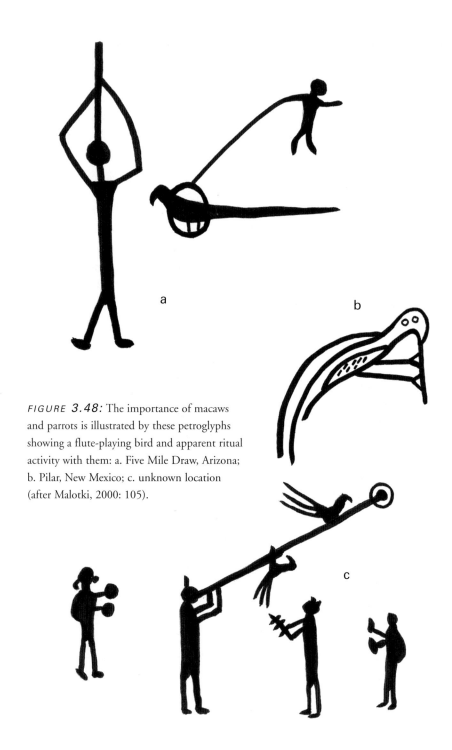

FIGURE *3.48:* The importance of macaws
and parrots is illustrated by these petroglyphs
showing a flute-playing bird and apparent ritual
activity with them: a. Five Mile Draw, Arizona;
b. Pilar, New Mexico; c. unknown location
(after Malotki, 2000: 105).

species were identified there from depictions of feathers, including macaws and parrots, eagles, ducks, turkeys, swallows, herons and cranes, owls, and roadrunners. These colorful murals may be an indicator of the intended function of avian imagery in rock art. The limiting nature of rock as a media does not usually permit the depiction of as much detail as these murals contain.

The importance of macaws and parrots and their feathers is obvious in the Pottery Mound murals as well as in rock art. The petroglyphs in figure 3.48 show a flute-playing macaw or parrot; a flute player, with flute raised over his head, posed next to one of these birds sitting in a hoop; and ceremonial activity with two parrots or macaws clinging to a long flute. The trading throughout the Southwest of these sacred birds from Mexico has been well documented. Rooms excavated at Chaco Canyon contained special burials of these birds, with offerings. They were sometimes known as the Sun Bird because of their brilliant colors and their origin from the south.

Since birds are liminal creatures that are able to move between different worlds such as earth/sky, or in the case of ducks, earth/sky/water, they held special powers

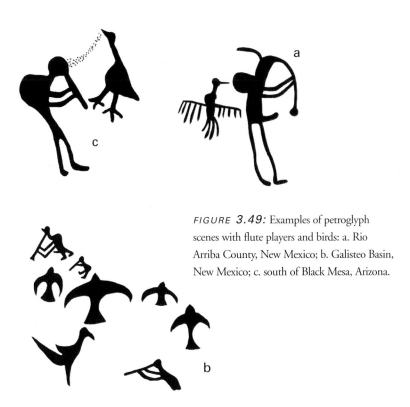

FIGURE *3.49:* Examples of petroglyph scenes with flute players and birds: a. Rio Arriba County, New Mexico; b. Galisteo Basin, New Mexico; c. south of Black Mesa, Arizona.

in the mythic and supernatural sense. This is reflected in the many stories and legends about birds in Native American lore, and is therefore an important element in their symbolic imagery as well. A few other examples of flute players with birds are shown in figure 3.49.

Crook-staffs

Another interesting symbol that often accompanies the flute player or his hump-backed relatives is the crook-staff, resembling a cane (fig. 1.28). Crook-staffs have been found in archaeological sites throughout the Southwest, including California, Nevada, Arizona, New Mexico, Utah, and the Plains. They still have important symbolic meaning in Pueblo societies. While some probably represent ceremonial objects or symbols of rank, the crook-staff is also a symbol of fertility and may in some cases represent a planting stick. Among rock art images of the Colorado Plateau are portrayals of crook-staffs in association with flute players and copulating couples; one petroglyph shows a phallic figure holding both a flute and a crook-staff (fig. 3.50). Early excavations of Pueblo Bonito in Chaco Canyon unveiled rooms in which multiple flutes were found stored with numerous staffs. There is an obvious fertility aspect to the Mogollon figure from a Mimbres bowl that is holding both crook-staff and erect phallus with apparent glee (fig. 2.05). In addition to the Pueblo and Mogollon examples, there are also Hohokam ceramics and rock art sites showing hump-backed figures carrying crook-staffs and burden baskets.

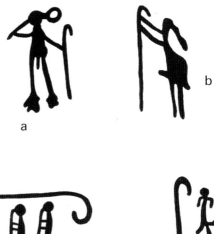

An intriguing petroglyph site in southeastern Utah has long lines of figures that may represent a migration or emergence story; among the figures are some holding crook-staffs,

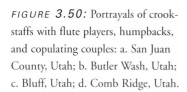

FIGURE *3.50:* Portrayals of crook-staffs with flute players, humpbacks, and copulating couples: a. San Juan County, Utah; b. Butler Wash, Utah; c. Bluff, Utah; d. Comb Ridge, Utah.

as if leading or watching over the people (fig. 3.51). Some of the figures in this scene resemble walking crook-staffs—perhaps to indicate a symbolic merging of the shaman and his sacred crook-staff.

As symbols of authority and power among the Pueblos, crook-staffs are required possessions of those holding political or ceremonial office.[31] Moreover, men preparing for a long journey were given such staffs as a prayer for stamina and safe return. The long-distance traders of the Aztecs (known as Pochtecas) also carried canes or crook-staffs, which were venerated with offerings and kept in special shrines between journeys. In the Ancestral Pueblo center of Chaco Canyon, excavations have uncovered rooms containing hundreds of such staffs.

The crook-staff in some contexts symbolizes long life, representing an old man with head bent over by age.[32] At Hopi Pueblo, the Kokopelli katsina is portrayed sometimes as an old man who shuffles into the village plaza during a dance and entertains the crowd by chasing and trying to catch girls with the crook of his cane.[33] In the Flute Ceremony, a crook-staff is used to draw down the clouds when their rain is wanted.[34] This concept appears to be represented by the Tano petroglyphs in the Galisteo Basin, New Mexico, and by the Tompiro petroglyphs from Tenabo ruin in New Mexico that show a phallic figure gesturing toward cloud terrace symbols that contain a crook-staff (fig. 3.52). The crook-staff is also associated with Pueblo emergence myths; it was through the use of this object that the people climbed up into the fourth world.[35] It is also possible that the depiction in the above figure represents a type of germinator deity similar to Muingwu from Hopi, who has been described

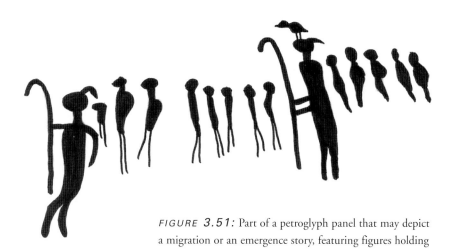

FIGURE 3.51: Part of a petroglyph panel that may depict a migration or an emergence story, featuring figures holding crook-necked staffs, Comb Ridge, Utah.

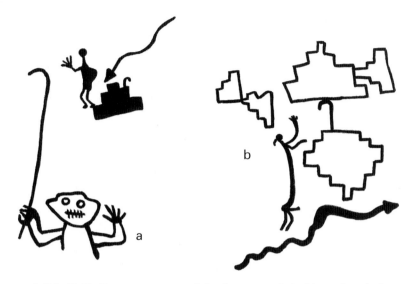

FIGURE *3.52:* Phallic figures gesture toward cloud terrace symbol with crook-necked staff: a. Galisteo Basin, New Mexico; b. Tenabo, New Mexico.

as holding a crook-staff, which represents the stages of life. He also uses a rattle with curved thorns to "hook the clouds."[36]

Spirals

One of the most ancient and universal signs, the spiral has symbolized energy, renewal, wind or breath, water, and cycles of time since the Paleolithic period. The life force inherent in the spiral is manifested in nature in many ways; it is associated with serpentine forms (coiled snakes), crescents (curving animal horns and shells), vegetative shapes such as sprouting seeds and twisting vines, and even the serpentine umbilical cord connecting mother and new life. Thus, spirals are nearly ubiquitous in ancient art everywhere.[37]

In the Southwest, the spiral is a very common rock art motif that is sometimes associated with the flute player (fig. 3.53), and it has been given a variety of meanings by native peoples of the region. It is known as the Life Way for the Pima and Tohono O'Odham of southern Arizona, and presumably was equally significant to the prehistoric Hohokam and Salado peoples, who preceded and left many spiral petroglyphs etched on the rocks in that area.

For Pueblo people, the spiral represents such various concepts as wind, water, serpents, and migrations or journeys of the people. At Zuni Pueblo, they say the spiral

represents the journey of the people in search of the Center, referring to their origin or emergence myth (fig. 3.54).[38] The Hopi also interpret spirals as signs of their ancestors' journeys, with the direction of the spiral indicating whether they were going or returning.

Earlier discussion pointed out how wind and breath are metaphorically related and are represented by the same spiral symbolism and ideas about flute-playing. Notions of the breath spirit are widespread among the Pueblos. More than a century ago, this prayer was recorded from a Zuni hunter inhaling the breath of a dying deer: "This day I have drunk your sacred wind of life."[39] The "Breath of Life" is probably symbolized by the spiral on the chest of the virile man in figure 3.55.

FIGURE *3.53:* Flute players with a large spiral design, White Rock Canyon, New Mexico.

Among the Hopi, some spiral petroglyphs also represent whirlwinds.[40] Similarly, spiral movement is part of certain rituals. During the "wind song" performed at a Hopi flute ceremony, pollen is scattered from hollow reeds in a circular, decreasing spiral movement, and the Sand Chief "spirals" into the pueblo to hasten the rain clouds.[41]

The significance of the sign seems to lie in the spiral movement, and most of the fertility aspects relate to this. Cornfields were sometimes planted in a spiral—some Pueblos starting at the outside and working spirally in to the center, while Navajos would start in the center and move outward in circles. In some Pueblo ceremonies, participants circle the village four times (a sacred number) in a spiral pattern and end in the central plaza at the symbolic Sipapu—Place of Emergence, or Mother Earth Navel. This is a sacred point that draws the web of life like a centripetal force. One can easily imagine such planting ceremonies taking place to the music of the flute,

FIGURE 3.54: Petroglyph of a flute player with spiral may represent an origin or emergence myth, Hardscrabble Wash, Arizona.

being used to bring the warmth of the sun, rain, and germination of the seed.

Depictions of the spiral thus represent the life force that animates all things. Tewa people express this belief as *powaha*—the breath of life that flows through and energizes all of life's expressions. Powaha translates as "water-wind-breath," and many rituals are about achieving harmony with this force.[42] Sometimes anthropomorphs are shown with the spiral leaving the body, perhaps to suggest the escape of the breath of life in transitional states such as death, shamanic trance, or soul-loss associated with sorcery. The life force of the spiral is also frequently expressed in rock art as coiled snakes and sometimes as sprouting vegetation. Thus, the ancient symbol of the spiral accompanies the flute player representing a number of symbolic meanings—water, breath of life, emergence or origin, spiritual power, crop fertility—all related to fertility and life. An interesting armless flute player is shown next to a spiral that has been split by a crack in the rock in figure 3.56.

Insects

In addition to the depictions of flute players resembling insects, sometimes images of insects and humans with insect qualities are encountered along with flute players and humpbacks in rock art. Among the most recognizable of these are dragonflies and butterflies (fig. 3.57). What these images may have represented to the prehistoric creators of the rock art is a matter of speculation, but Pueblo myth and lore provide clues to the nature of their fertility symbolism.

Dragonflies have long been important symbols of water and fertility in the Southwest. Occurring in rock art primarily in New Mexico, Arizona, and Utah, they are portrayed in Pueblo and Mogollon sites; in greater antiquity, they occur in certain archaic rock art as shamanistic creatures or spirit helpers.[43] Dragonfly lore from historic Pueblo ethnography, primarily at Hopi and Zuni Pueblos, is useful for understanding this symbol in Pueblo and Mogollon rock art, but the ancient roots

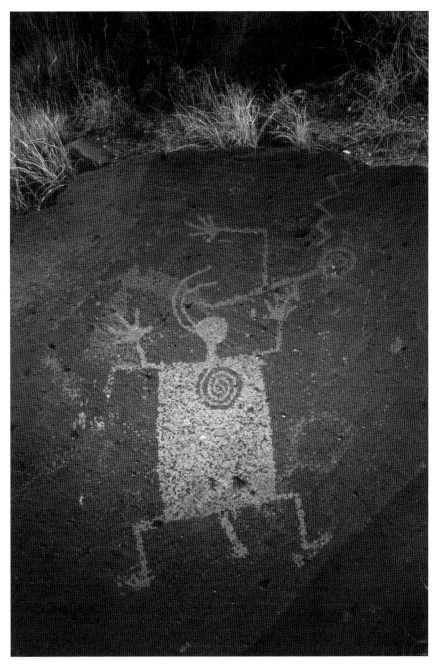

FIGURE 3.55: The spiral symbol on this virile anthropomorph may represent the "breath of life" or "breath-spirit," La Bajada, New Mexico.

FIGURE 3.56: An armless flute player with spiral motif split by a crack in the boulder, San Juan River near Bluff, Utah.

FIGURE 3.57: Ancestral Pueblo petroglyphs of a phallic flute player with two moths or butterflies, White Rock Canyon, New Mexico.

of these concepts are expressed in the archaic images that are several thousand years older. These ancient dragonfly images are interpreted as shamanic spirit helpers and metaphors for the shaman's soul-flight to the spirit world. Its use as a power animal by archaic shamans is related to its close association with water and perhaps by its iridescent coloring and large eyes that may have symbolized the hallucinatory visions of the shaman's trance. The dragonfly may have been petitioned in rituals for making rain and worshiped for its role in providing this sustenance.

Some of the shamanic precepts of archaic hunter-gatherers continued to live on into later agricultural societies, especially in the weather-controlling role of Pueblo rain priests. Pueblos

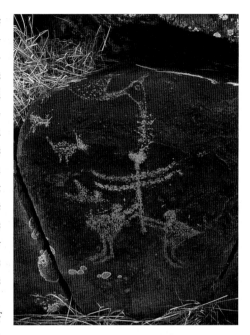

FIGURE *3.58:* Jornada Mogollon petroglyphs of two humpbacked figures holding dragonflies, Macho Creek, New Mexico.

have deified a number of insects for their role in bringing life-sustaining moisture, but the dragonfly was especially important and sacrosanct. Apparently the sound of the dragonfly ("Tsee, Tsee, Tsee") resembles the word for water in some Indian languages, which may explain the belief that it is a supernatural with the power of speech and the ability to bring summer rains.[44] As the servant of the cloud deity Oomaw, the dragonfly could reopen blocked springs and lead people to the place of a new spring.[45]

In a dragonfly story recorded at Zuni Pueblo, the magical insect helps two abandoned children survive and is ultimately responsible for the renewed fecundity of the earth. "That is why we worship the dragonfly, and why no one is allowed to kill it."[46] At Zuni Pueblo, killing a dragonfly was taboo, except for ritual use; they mixed hearts of dragonflies and butterflies with certain plants to make "sun medicine," which they rubbed on their bodies for psychic purification. This medicine was only used by men as it was thought to be an aphrodisiac for women.[47]

At a Jornada Style rock art site in southern New Mexico, there are numerous images of dragonflies being held by humpbacked, sometimes phallic, anthropomorphs (fig. 3.58). Humpbacked phallic figures in Jornada Style rock art, though

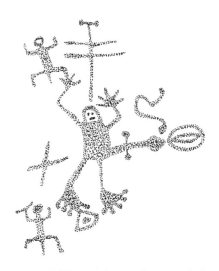

not usually playing a flute, are thought to be conceptually related to the flute player so widespread in the Pueblo region. One of the anthropomorphs appears to be playing a flute-like object. At this same site, another example of the connection between dragonflies and fertility is the phallic man in figure 3.59; a large dragonfly is poised over his head and a snake over his exaggerated penis, which points purposefully at a natural vulva-like protuberance on the rock that has been enhanced by selective pecking. Perhaps the boulder on which this scene was placed served as a fertility shrine; in any case, the dragonfly seems to have a prominent role in this scene.

FIGURE 3.59: Jornada Mogollon petroglyphs showing phallic figure with dragonfly and vulva symbol, Macho Creek, New Mexico.

Although not a common symbol in Southwestern rock art, the butterfly motif also occurs in pottery, jewelry, and other ceremonial applications such as clan symbols. Some Jicarilla Apache flutes have butterfly designs on them. It is associated with rain, fertility, growth, flowers and pollinating plants, and the well-being of all living things. In some cultures, a butterfly attached to a plume offering carried prayers to the supernaturals and encouraged an amorous state of mind. In one ritual, sacred clowns carried a drum containing fluttering butterflies; this made people follow them and "go crazy," meaning sexually.[48] Some tribes had the same word for butterfly and moth, so these creatures may have served similar symbolic functions. In chapter one, a myth from Zuni was recounted about the flute-playing hero Paiyatamu, in which butterflies and moths played a prominent role related to sexuality.

At Zuni Pueblo, the butterfly may be used magically by the sacred clowns to lure people to the dances. A Zuni informant reported the following:

Lahacoma is the brightest of all butterflies. It is yellow with spots of red and white and black. It affects everyone, but especially young girls. It makes them follow the one who has it, whether they want to or not. It is as if they were crazy. They must go after anyone who has lahacoma. The Koyemci always use it.[49]

Supernaturals

A mythic female figure that is sometimes portrayed with the flute player and is related to fertility is the Mother of Game, or Mother of Animals. This deity in the historic Pueblo pantheon "owns" the animals and is responsible for their increase. If hunters follow the prescribed rituals, she grants them the right to hunt her children. Although her image differs from tribe to tribe, this concept of a female spirit who owns the animals is ancient and could have shamanic roots originating in Paleolithic times. Her various names include Mother of Animals, Earth Mother, Patroness of the Hunt, Fertility Goddess, Childbirth Water Woman, and Mother of Katsinas. Her lore is most varied at Hopi Pueblo, where ethnologists have gathered myths for years. One of her names there is Tiikuywuuti, which means "child-sticking-out woman,"

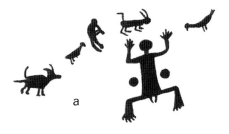

referring to a legend about a pregnant woman who died in childbirth and was transformed into the goddess after giving birth to infant game animals.[50] It has also been reported that her fertility powers extend to humans—she "bestows infants" and "sends infants inside women."[51]

Rock art depictions of the Mother of Animals have been best documented in the Little Colorado River drainage near Petrified Forest National Park in Arizona.[52] In this area, she typically is depicted in the same rigid posture with legs spread and arms upraised, often flanked by twin disks (of unknown significance) and surrounded by animals, symbols of hunting, and flute players (fig. 3.60a). Another possible Mother of Game depiction in the Rio Grande region near Santa Fe, New Mexico, is shown in figure 3.60b, where she is in the same posture and has a female hairstyle but also has animal traits, including a tail and three-toed hands and feet. She is flanked by two birds and two

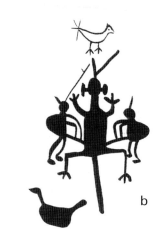

FIGURE *3.60:* Petroglyphs depicting the supernatural being Mother of Animals, with flute player and humpbacks: a. Petrified Forest, Arizona; b. Galisteo Basin, New Mexico.

symmetrical humpbacked figures who are copulating with her. Perhaps these squat little humpbacks have replaced the two disks that are usually shown at her side in examples from elsewhere. In her role as guardian of game animals, the Mother of Animals clearly shares responsibility with the flute player for the fertility and increase of animals important to ancient people.

Flute-playing is also closely linked to other important supernaturals—the Corn Maidens. Stories about them portray the flight of these fertility/vegetation goddesses after being ignored in rituals or insulted by unwelcome sexual advances (the desirable Corn Maidens were often the subject of someone's lust), hereby causing famine in the land. Various messengers and culture heroes go after the Corn Maidens and lure them back. In one version, the seeker is the flute-playing Paiyatamu, who taught the people to cultivate corn, and who bears the shield of the Sun and represents the fertilizing and sexual power of the Sun. A story from Zuni Pueblo about Paiyatamu was presented in chapter one.

Petroglyphs from the upper Rio Grande (fig. 3.61) may be depicting aspects of the Corn Maiden myths. In one image, a phallic humpbacked figure chases a female beneath a corn plant; in the other scene, a phallic humpbacked flute player (Paiyatamu?) plays to a female from whose arms vegetation seems to sprout. These two scenes are located forty miles apart but both may be related to a similar story or myth. Both females have the hair-whorls indicating unmarried Pueblo girls, and both flute players wear a conical hat.

FIGURE *3.61:* Aspects of the Corn Maiden myths may be depicted in these Ancestral Puebloan petroglyphs from the upper Rio Grande near Espanola, New Mexico.

It has been suggested that these images may be related to similar images from kiva murals at Kuaua ruin near Albuquerque. It also may be connected to an elaborate Pueblo myth that explains how Ne'paiyatam'a (Paiyatamu) brought the Corn Maidens to earth; the female

FIGURE 3.62: Pictographs of two flute players seated beneath rainbow symbols and a bird image that may represent the Great White Duck, Canyon de Chelly, Arizona.

figure may represent the Yellow Corn Maiden, Shiwanokia.[53] Flute-playing is an important aspect of these myths, as the flute's music was thought to aid germination of seeds and growth of corn as well as generating sexual excitement.[54]

In Canyon de Chelly, rock paintings in Pictograph Cave have been interpreted as illustrating components of the Corn Maidens myth.[55] The scene shows twin flute players beneath the Great White Duck—a wise, protective, motherly figure who knows all the trails and helps find the Corn Maidens (fig. 3.62). In summary, the Corn Maidens represent the staple of life and basic food crops, and their flight is a myth of the cycle of the seasons. Where the Maidens breathe, "warmth, health, and fertility shall follow."[56] The Corn Maidens thus bestow the same blessings on the people as does the flute player in his multiple forms.

TWINNED FLUTE PLAYERS

The occurrences of twinned or paired flute players can perhaps be explained by the fact that twins are important not only in the Southwest, but are fertility symbols in mythology and ancient art throughout the world. In addition to the auspicious nature of multiple births, twins are often accorded special powers by native peoples.[57] Twins

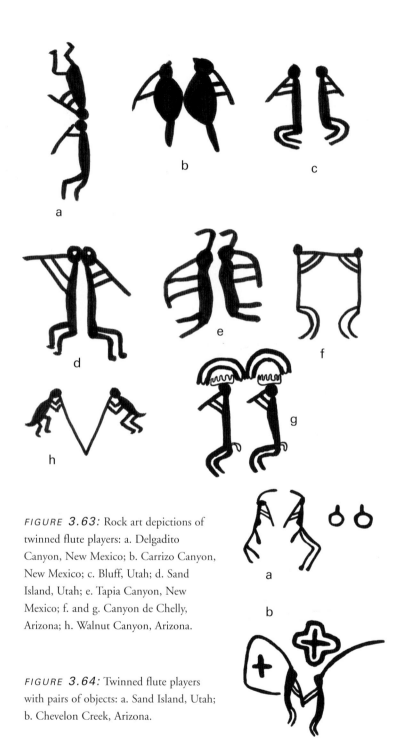

FIGURE *3.63:* Rock art depictions of twinned flute players: a. Delgadito Canyon, New Mexico; b. Carrizo Canyon, New Mexico; c. Bluff, Utah; d. Sand Island, Utah; e. Tapia Canyon, New Mexico; f. and g. Canyon de Chelly, Arizona; h. Walnut Canyon, Arizona.

FIGURE *3.64:* Twinned flute players with pairs of objects: a. Sand Island, Utah; b. Chevelon Creek, Arizona.

inherently represent duality and symbolize opposing principles—a basic tenet of most religions. Throughout all mythologies, the same pair occurs—twins of light and darkness, born from the Great Mother or primordial womb.

In the Americas, myths of the Hero Twins or Warrior Twins are especially prolific; here the two appear in many guises, such as in myths as the Sun and Moon.[58] Although they are war gods, at the same time they are intrinsically associated with fertilization; such duality is common in many Native American cultures and the image of twins represents this concept. The Hero Twin's epic has been described as the basic myth in North America; among Southwestern Indian cultures, the Warrior Twins myth is nearly universal. One group of such myths indicates they are powerful Sons of the Sun; another group tells of their exploits leading the first people and protecting them at the time of emergence from the underworld; a third group describes the twins as crafty hunters who use magic to lure their prey. Among the Southwestern Pueblos, there are a great variety of stories about the War Twins, or Twins of the Sun as they are sometimes called. Details differ but the twins are prominent in stories about emergence and creation, and their conception by a supernatural woman is usually miraculous and is obviously associated with the idea of the fertilization of the earth by the sun and water.

Thus, because of the special nature of twins and of the prominence of twin culture heroes and supernaturals in Southwestern mythologies, it is reasonable to assume that this ideological emphasis found expression in rock art, including the depiction of flute players (fig. 3.63). Rock art images suggesting twins and associated mythology occur as pairs of similar anthropomorphs as well as pairs of metaphorical or symbolic elements. This ancient theme is apparently expressed in rock art at least as old as that of the Basketmakers. Occurring in the San Juan River area are twinned flute players with mysterious objects known as lobed circles that are associated with fertility (fig. 3.64).[59] In the same figure, from the Little Colorado River region is a pair of flute players holding onto a single flute, next to a pair of crosses.

An interesting aspect to myths about twins involves the notion that twins were originally united in the womb but were forced apart at birth. Constituting a single person, they belong together, and it is necessary, though difficult, to reunite them. They represent the two sides of human nature, such as masculine/feminine, introvert/extrovert, and dynamic/acquiescent. This polarity has found expression in beliefs and stories that relate to the nature of the soul and to sexuality. The special powers of hermaphroditic individuals, berdaches, and transvestite shamans have been noted.[60]

Some of the beliefs about twins can be extended to the various ways in which duality and dichotomy have been expressed among Indian tribes.[61] Ideas about the

dualistic personality pervade Indian myth and ceremony and derive from ancient archetypal sources. These are expressed in such ways as the trickster-transformers, hermaphroditic personalities, intra-tribal divisions, and clown societies who do everything backwards or contrary to normal. A common means of visually depicting duality is a face divided and painted in two colors.

FLUTE PLAYERS IN RITUALS AND CEREMONIES

Some portrayals of flute players appear to be representing participants in rituals or ceremonies. Rituals shape people's perceptions of the sacred and the profane, and help maintain balance. In the sense that these images show group activities or imply some sort of formal customary procedures, a few examples have been selected to illustrate this possibility. It may be that many of the images in this book are in fact associated with ritual and ceremony, but it would be conjecture to suggest this. A joke in archaeology says that unidentifiable objects are "ceremonial." And so it may be the case here that some images of flute players that do not fit other explanations are also "ceremonial." The role of music and performance in ritual and maintaining traditional authority is a subject of research among few Southwestern scholars, but undoubtedly flute-playing was an important aspect of this.[62]

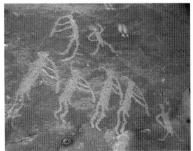

FIGURE *3.65:* Petroglyphs of flute players and dancers, Gallo Wash, New Mexico.

The most obvious examples in this category are those that appear to represent a group of dancers with flute players. In such scenes, the participants are in poses that suggest dancing (fig. 3.65), or else they are in lines or

FIGURE *3.66:* Petroglyphs of flute player and people holding hands in an apparent ceremony, Largo Canyon, New Mexico.

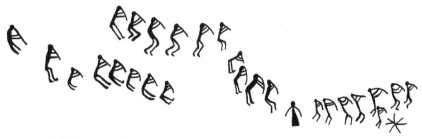

FIGURE *3.67:* Pictograph panel with twenty-six flute players, Montezuma Canyon, Utah.

holding hands (fig. 3.66). The central figure in this scene has a "hollow" belly, which may indicate a female who is barren or has just given birth. One of the largest known gatherings of flute players is the pictograph scene showing twenty-six of them clustered around a possible lone female (fig. 3.67).

Other symbolic clues suggesting the flute player is involved in ceremonial activity is the presence of likely ritual objects or paraphernalia being held by participants, such as the apparent prayer sticks in figure 3.68. A procession of some kind is implied by the row of participants in figure 3.69, who hold staffs or banners. In other scenes, the flute player himself is being held aloft or carried, indicating some out-of-the ordinary event or activity (fig. 3.70). Lastly, some images show flute players in scenes where costumes or katsina masks are being handled (figs. 3.71 and 3.72). The conical objects in figure 3.72 represent Shalako katsinas, which are still practiced at Zuni Pueblo. Another petroglyph site near Zuni Pueblo depicts apparent ritual centered on a flute being held by two of the participants (fig. 3.73).

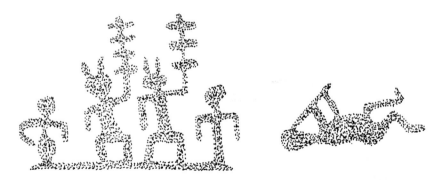

FIGURE *3.68:* Petroglyphs of flute player and people holding prayer sticks, Inscription Point, Arizona.

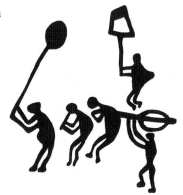

FIGURE **3.69:** Tompiro petroglyphs of a flute player in a procession with people holding ritual objects, Cerro Indio, New Mexico.

FIGURE **3.70:** Scenes with flute players being held or carried by others: a. Canyon de Chelly, Arizona; b. Inscription Point, Arizona; c. La Cieneguilla, New Mexico.

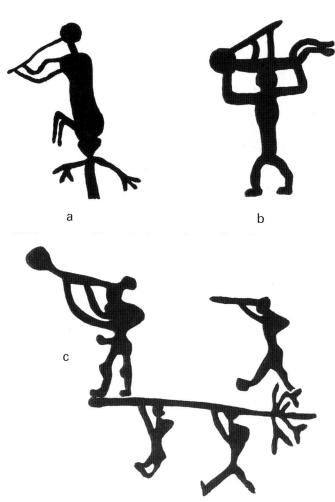

a

b

c

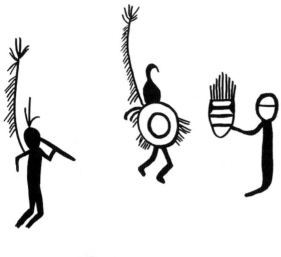

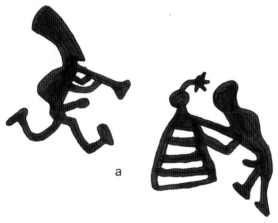

FIGURE *3.71:* Rio Grande Style pictographs (in red, two inches high) of a ceremony involving a flute player, a shield bearer, and a person holding a katsina mask, Cerro Indio, New Mexico.

a

FIGURE *3.72:* Petroglyphs of flute players with ritual objects or costumes: a. La Cieneguilla, New Mexico; b. Bandelier National Monument, New Mexico.

b

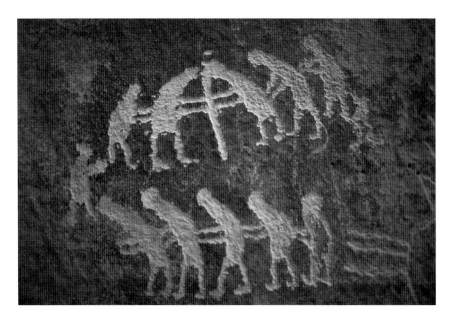

FIGURE 3.73: Petroglyphs of a ritual activity centered on a flute being held by two people, Village of the Great Kivas, Zuni, New Mexico.

FLUTE PLAYER IMAGES IN ROCK ART AROUND THE WORLD

The focus of this book has been on the Southwestern region of North America, but because rock art of indigenous peoples occurs worldwide and images of flute players are equally widespread, an overview from other regions is provided here to emphasize the universal archetypal nature of such images. A brief discussion of flute-playing archetypes such as Orpheus, Pan, and Krishna was given in chapter one. It is beyond the scope of this book to treat the rock art and cultural setting of any of these regions comprehensively; this section is intended to be only a sampling of the relevant material available in the literature.[63] It shows that many of the symbols and expressions for fertility and sexuality are similar among diverse cultures separated in time and space. Although flute-playing is not always associated with such themes, images of vulvas, phalli, snakes, mating and birthing, flowering and fruiting plants, the fertilizing powers of rain and sun, the sexuality of shamans and the hunt, the Earth Mother Goddess—these, and more, are recurring constants in rock art around the world. The relevance of taking a global view in the study of rock art is being recognized by scholars:

> *Tribal societies around the world have the common characteristic of produc-*
> *ing art, especially rock art. Their visual output is recorded in millions of figures,*

in thousands of zones distributed in 120 countries on all inhabited continents. Over 70 percent of all known rock art was produced by hunting and gathering societies while less than 30 percent is the work of pastoralists and agriculturalists. The growing interest in this art is caused by the light it projects on the collective memory and on universal conceptual processes.

Through these ancient expressions of the human mind, a wide range of submerged memories come back to consciousness, reviving stored chapters of our intellectual heritage. But as important is rock art's historical relevance. Rock art is a sort of pictographic writing which constitutes humanity's largest and most significant archive of its history for 40,000 years until the advent of conventional modern ideographic and then alphabetic writing.[64]

Africa

The African continent, especially southern Africa, may have the greatest concentration of rock art in the world. The oldest African art so far known is from Namibia, where animals painted on stone slabs were found in a cave and dated to approximately 25,000 BC, but there is evidence that suggests such activity goes back to at least 38,000 years BC.[65] It is reasonable to expect that the continent on which mankind evolved would have the longest occupation by hunter-gatherers, and therefore contain an enormous amount of rock art; major sites are still being discovered in some areas. Much of our current understanding of shamanic trance imagery in rock art stems from studies of the sophisticated rock paintings and ethnography of the San Bushmen in South Africa. Rock art images of apparent flute players from the countries of Namibia, Algeria, Tanzania, and Zimbabwe are shown in figure 3.74.

South America

Major rock art sites are known to occur in the South American countries of Argentina, Bolivia, Brazil, Chile, Columbia, Ecuador, Guatemala, Peru, and Venezuela. In the Americas, apparently the oldest rock art dated so far comes from sites in Brazil and Argentina, where radiocarbon dating has produced a range of 10,000 to 15,000 years BC.[66] Although recording and analysis of South American rock art iconography is still in an early stage, quite a few images of flute players have been documented already,[67] and the ubiquitous themes of fertility and sexuality will undoubtedly be well represented there too. A cursory view of some of the continent's ethnography demonstrates that these themes were prominent in many native cultures there.

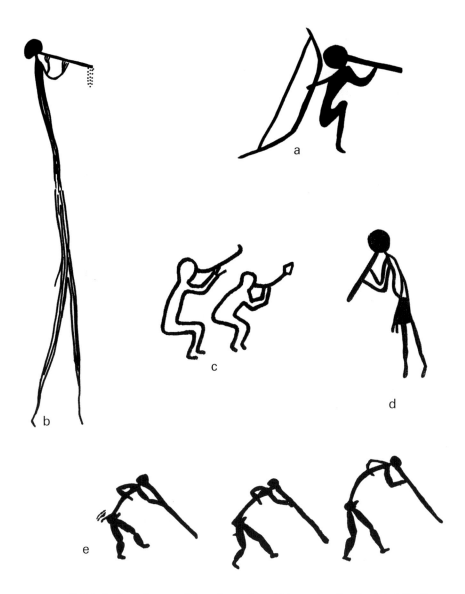

FIGURE *3.74:* Rock art images of flute players from Africa: a. Ameib, Namibia (after Van Hoek, 2005); b. Pahi, Tanzania (after Leakey, 1983); c. Algeria (after Martineau, 1973); d. Mashonaland, Zimbabwe (after Coulson and Campell, 2000: 99); e. Guruve, Zimbabwe (after Garlake, 1995).

An example of sexual ritual used as imitative magic to promote fecundity of plant growth is illustrated by the following:

For four days before they committed the seed to the earth the Pipiles of Central America kept apart from their wives in order that on the night before planting they might indulge their passion to the fullest extent; certain persons are even said to have been appointed to perform the sexual act at the very moment when the first seeds were deposited in the ground.[68]

Elsewhere, elaborate carvings focus on themes of fertility and genitals among the enigmatic Los Danzantes figures of Monte Alban in Mexico:

In one danzante *a curved line representing liquid comes from the head of a god drawn on a man's chest. It joins another stream which flows from his sex organs. The streams flow outward together to create what looks like the forked tongue of a serpent. It is as if god and man have merged to create a symbol of the life force. The concept of the stream of life is illustrated in dancer after dancer. From the genitals come flowers, symbols of wind and water, and intricate scrolls of unknown meaning.*[69]

The diverse and spirited sexuality of many Indian cultures in Latin America has been recorded in early Spanish records from the time of conquest. Particularly in Peru and Mexico, where there was a rich artistic tradition of erotic art, sexual customs were depicted in detail.

Perhaps the most important ethnographic record of Native concepts concerning fertility and sexuality from South America is a study of the Desana Indians on the border of Colombia and Brazil.[70] In the sexual and religious symbolism of the Desana, their worldview is replete with sexual meaning, and nature, as well as their culture, is endowed with vaginal and phallic symbolism. A Desana origin myth relating to incest taboo and involving flute-playing was presented in chapter one.

Most examples of South American flute players are from Peru (figs. 3.75 to 3.78), but others are from Chile (figs. 3.79 and 3.80). Although these appear to be playing flutes, researchers have cautioned there may be other explanations.[71] For example, in Peru there exists the *paicha* ("drinking flute"), a ritual object through which a liquid is poured into the mouth. Or some depictions could be objects used to inhale drugs, blow guns, or tubes used by metalworkers to blow air into kilns. An interesting Andean wind instrument is the *focedor de clarin*—a long cane or bamboo tube with

FIGURE *3.75:* Petroglyph of a flute player, Huancor, Peru. Photo by Maarten Van Hoek.

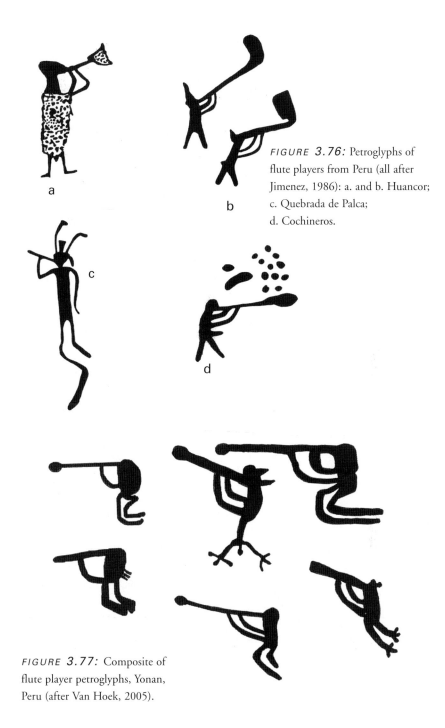

FIGURE 3.76: Petroglyphs of flute players from Peru (all after Jimenez, 1986): a. and b. Huancor; c. Quebrada de Palca; d. Cochineros.

a

b

c

d

FIGURE 3.77: Composite of flute player petroglyphs, Yonan, Peru (after Van Hoek, 2005).

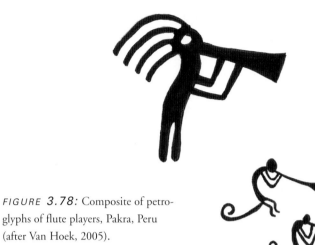

FIGURE *3.78:* Composite of petro-glyphs of flute players, Pakra, Peru (after Van Hoek, 2005).

FIGURE *3.79:* Composite of flute player petroglyphs, Rosario, Chile (after Van Hoek, 2005).

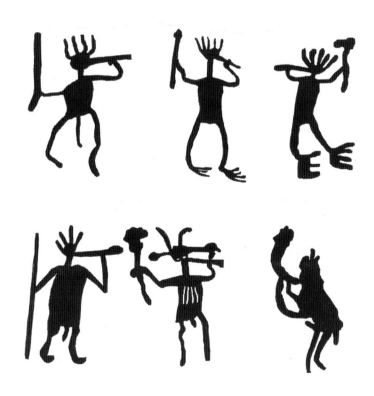

a gourd at the end.[72] This is a fascinating parallel with certain flutes at Hopi Pueblo and other Southwest locales. Andean shamans also used the sound of flutes to enter the supernatural or spirit world. Such flutes were sacred, and the instruments as well as individual melodies were guarded and sometimes associated with taboos. Only males were allowed to play because the flute was a means of seduction. As in the Southwest, some flute players in the Andean region have animal attributes, such as monkeys and foxes.

A cache of thirty-two flutes made from pelican and condor bones was found in the ancient ruins of Caral, north of Lima, Peru.[73] Caral is among the oldest cities of America, at 2600 to 2000 BC. These flutes are relatively uniform in length and have a single hole in the center. They are decorated with incised designs of monkey and anthropomorphic faces, birds, and linear elements. Although it is unknown how these were played as musical instruments, it is suggested they could have been used to simulate the chorus of frogs in ceremonies to invoke rain. Alternatively, some of their sounds are similar to that of monkeys.

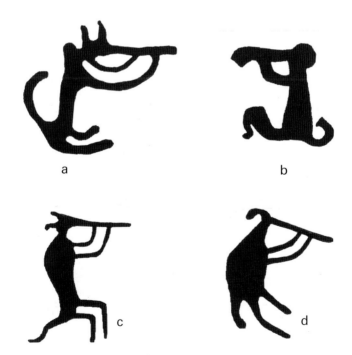

FIGURE *3.80:* Petroglyphs of flute players from Chile (all after Van Hoek, 2005): a. and b. Tarapaca; c. Huancarane; d. Ariquilda.

Australia

Australian Aboriginal rock art is some of the most beautiful and diverse in the world. More than 100,000 sites are known, including the oldest firmly dated rock art in the world—40,000 years old.[74] Moreover, there is a continuum here with a living tradition of some Aboriginals still making and maintaining rock art. Because Australia is an island continent with such an ancient human history, the cultural traditions and rock art are unique in some ways. Nevertheless, themes with which we are concerned here still resemble those from other regions. For example, snakes figure prominently in Aboriginal religion and rock art. They are very significant in the Dreamtime (the era of creation) and are related to water resources just as in Southwestern lore. During the Dreamtime, they formed rivers, springs, and rock cisterns as they traveled across the landscape before coming to rest in deep pools. There are some apparent parallels between the Aboriginal Rainbow Serpent and the Horned Water Serpent of the Southwestern Pueblos: both are intimately related to water, rain, and fertility.

Australian rock art also has some of the most interesting and evocative depictions of human sexuality. In some regions of the continent, human sexuality dominates the themes and imagery, particularly in northern Australia.[75] All forms of male-female relationships are vividly depicted. Some of these images are expressions of love magic, in which hoped-for encounters are portrayed.

A pictograph scene from Northern Territories shows an apparent flute player (although it could be a didgeridoo player) and some figures who seem to be dancing or perhaps entranced by the music's magic spell (fig. 3.81). It is a strange coincidence indeed that this is from a place called Oenpelli, curiously similar to Kokopelli.

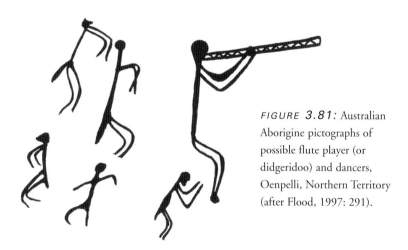

FIGURE *3.81:* Australian Aborigine pictographs of possible flute player (or didgeridoo) and dancers, Oenpelli, Northern Territory (after Flood, 1997: 291).

TRICKSTER, TRADER, TROUBADOUR—
THE MANY FACES OF THE FLUTE PLAYER

1. Lange, at al., 1986.
2. Bradley, 1989: 158–59.
3. Slifer, 2000.
4. Ibid.
5. Talayesva, 1942: 76.
6. Titiev, 1972: 151.
7. Walker, 1983: 635.
8. Warner, 1983.
9. Cole, 1989: 66.
10. Bishop, 1996: 12.
11. Ibid., 13.
12. Trimble, 1993: 47.
13. Tyler, 1979: 126-27.
14. Tyler, 1964: 83, 126, 143, 147;
 Cushing, 1979: 360.
15. Malotki, 2000: 72, 106–10.
16. Personal communication with Dick Ford,
 comments on manuscript, 2006.
17. Whitley, 1994: 12–24.
18. Vastokas, 1973: 86.
19. Whitley, 1994: 22.
20. Wellman, 1974: "Some Observations . . .," 6.
21. Ibid.
22. Ibid.
23. Linne, 1943: 170.
24. Personal communication with
 Curt Schaafsma, 2004.
25. Wellman, 1970: 1678–82.
26. Slifer, 2000: 110–17.
27. Ibid.
28. Tyler, 1979: 212, 216.
29. Brown, 2005: 174.
30. Hibben, 1975: 93–102.
31. Cole, 1989: 81.
32. Fewkes, 1989: 30.
33. Hirschman and Thybony, 1994: 41;
 Malotki, 2000: 33–34.
34. Fewkes, 1914: 28–29.
35. Parsons, 1939.
36. Tyler, 1964: 127.
37. Gimbutas, 1989: 278–88.
38. Young, 1998: 136.
39. Cushing, 1920: 417.
40. Fewkes, 1892: 20.
41. Taube, 2001: 115.
42. Swentzell, 1993: 141.
43. Malotki, 1997: 57–72.
44. Mallery, 1893: 704–5.
45. Wade and McChesney, 1980: 26.
46. Benedict, 1969: 1–9.
47. Packard, 1974: 22.
48. Ibid., 23.
49. Bunzel, 1932: 871–72.
50. McCreery and Malotki, 1994: 140.
51. Parsons, 1939: 178, 318.
52. McCreery and Malotki, 1994: 139–42.
53. Boyd and Ferguson, 1988: 67.
54. Tyler, 1979: 83,126, 143, 147;
 Cushing, 1979: 360.
55. Harris, 1993: 123–32.
56. Cushing, 1896: 442.
57. Keyser, 1992: 77–78.
58. Campbell, 1998: 314.
59. Manning, 1990: 159–210.
60. Slifer, 2000: 94–96.
61. Wellman, 1981.
62. Brown, 2005.
63. Slifer, 2000: for a discussion of
 fertility themes in world rock art.
64. Anati, 1994: 12:32.
65. Ibid., 12: 24.
66. Ibid., 12: 25.
67. Van Hoek, 2005.
68. Frazer, 1993: 221.
69. Smith, 1968: 42.
70. Reichel-Dolmatoff, 1971.
71. Van Hoek, 2005.
72. Ibid., 3.
73. Cabrera, 2002.
74. Flood, 1997: 11–12.
75. Chaloupka, 1993: 221.

Massive walls, old before time, offer shade. . . . Barely hidden, a river of time runs deep here, unbridged by man. It carries you to the paintings. . . . The people never left the canyon. As the paintings gained depth and life, the people faded, became translucent, were swallowed as sound is swallowed here, returned to the rock.

This I saw at the place of paintings. Kokopelli still wanders these canyons. The sly old rock musician may be disguised as a tourist, but certain characteristics are diagnostic. The small daypack. The tendency to lick his lips as he studies the women. Do not trade with this man. Maintain a respectful silence, a discrete distance. He will not stay long. As I lingered there I felt the pull of the rock. The air seemed thicker somehow. Before I could see the solid walls through the flesh of my body, I came away.

—CLAY JOHNSON
"Clay's Tablet (Barrier Canyon)"

FIGURE 4.00: This weathered petroglyph depicts an ancient humpbacked flute player who seems to be dancing, located north of Zuni Salt Lake, Catron County, New Mexico.

Exploring Kokopelli's Trail

Guide to Sites with Public Access

PROTECTING ROCK ART AND GUIDANCE FOR VISITING SITES

Rock art is a fragile treasure—once destroyed it cannot be replaced. Desecration such as target shooting at images, stealing and damaging panels, painting and carving graffiti, and digging in archaeological areas are hopefully on the decline due to increasing public awareness and more aggressive law enforcement. But even if we have good intentions, we need to be aware of the potential harm from the cumulative impact of the increasing numbers of visitors. As rock art becomes more popular, we risk loving these sites to death. Thus, unintentional damage caused by visitors is also a serious preservation challenge. It is important, therefore, to instill a code of ethics in visitors to these sites through education about low-impact behavior.

- Do not touch rock art.
- Do not use chalk or other material to highlight rock art for photography.
- Do not make rubbings of petroglyphs.
- Do not use fire, candles, and incense, which damage sensitive sites.
- Stay on trails to reduce soil erosion that damages archaeological features.
- Do not let children touch and rub against the rock art and pick up artifacts.

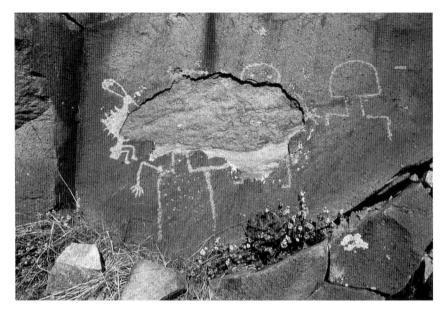

FIGURE 4.01: Vandalized petroglyph panel with remnants of a flute player, Galisteo Basin, New Mexico.

If you visit a rock art site, do so with the utmost care and respect. Tread lightly and do not touch the rock art—ever. The conservation adage "take nothing but pictures, leave nothing but footprints" is especially true for visiting rock art sites. Many of these sites are sacred to Native Americans. Behave as you would in other sacred places.

Much rock art is on public land and is protected by federal and state antiquity laws. The remains of structures (even the most obscure rock piles), artifacts of all kinds, fire hearths, as well as petroglyphs and pictographs are protected resources. Laws stipulate that only those with permits may dig in archaeological sites. Federal felony, misdemeanor, and civil convictions can result in fines, vehicle confiscation, and imprisonment. Moreover, many states enforce burial laws to protect human remains and associated materials found on private property.

Unfortunately, bullet holes and graffiti are fairly common conditions encountered at rock art sites today. Furthermore, we see evidence of stolen rock art where fresh scars from chisels or saws and broken slabs of rock mark the previous locations of petroglyphs. Ironically, such shameful and criminal activities often result in destruction of the sought-after treasure since the rock usually fractures into small pieces, as shown in figure 4.01, where a panel that once contained a fascinating flute player has been destroyed by the vandal's chisel.

To report illegal activities involving cultural resources, see the phone numbers for the sites described, or contact the National Park Service's toll-free, twenty-four-hour hotline at 1-800-227-7286.

DISCOVERING ANCIENT IMAGES AROUND THE FOUR CORNERS: A GUIDE TO SITES WITH PUBLIC ACCESS

The locations in figure 4.02 contain rock art where examples of flute player images can be seen and are managed for public visitation. You can visit some of these sites on your own at any time, while others require you to call in advance and reserve a spot on a tour (for example, sites managed by tribes). The maps and directions provided will enable visitors to locate the sites. Traveling in the desert Southwest in search of sites can be dangerous; even visiting the less remote sites near highways or in parks can be risky, especially if you are not used to such rugged terrain. Be prepared for emergencies, be cautious, and use good judgment.

Although walking to most of the sites in this guide is not particularly strenuous or dangerous, to reach some you must enter backcountry areas. You need to be properly prepared in these areas and follow safety guidelines. First, it is always best to avoid traveling alone. However, if you must, then advise others of your itinerary. Second, it is crucial to carry plenty of water. Also, take maps, a compass, appropriate clothing, food, and first-aid supplies. Wear a hat and sunscreen. Avoid excessive heat during midday. Because many pictographs and petroglyphs are located in remote canyons, be aware of the weather. Flash floods are common occurrences.

New Mexico
Bandelier National Monument
Bandelier National Monument is located near Los Alamos. At Bandelier, you can see Rio Grande Style petroglyphs associated with the pueblo ruins in Frijoles Canyon beyond the visitor center, as well as at the detached unit of the monument known as Tsankawi (Sahn-kah-we)—a pueblo ruin located on a spectacular mesa top a few miles north of the town of White Rock. National Park Service trail guides provided at these locations explain more about the petroglyphs found here. At these sites located along mesa tops of the Pajarito Plateau, petroglyphs are pecked or incised into the soft tuff (volcanic ash) that is exposed there. In some cases petroglyphs are made in smoke-blackened ceremonial chambers and living quarters (known as cavates) that are dug into the tuff (fig. 4.03). Less accessible are the spectacular pictographs in Painted

FIGURE 4.02: Map showing southwestern rock art sites with flute player images that the public can visit: 1. Bandelier National Monument; 2. Chaco Culture National Historic Park; 3. La Cieneguilla Petroglyphs; 4. Petroglyph National Monument; 5. Tomé Hill; 6. Edge of the Cedars State Park; 7. Grand Gulch Primitive Area; 8. Sand Island Recreation Area; 9. Shay Canyon and Newspaper Rock; 10. Vernal area: Dinosaur National Monument and McConkie Ranch; 11. Canyon de Chelly National Monument; 12. Chevelon Canyon; 13. Homolovi Ruins State Park; 14. Lyman Lake State Park; 15. Monument Valley Tribal Park; 16. Petrified Forest National Park; 17. Palatki Heritage Site; 18. Ute Mountain Tribal Park.

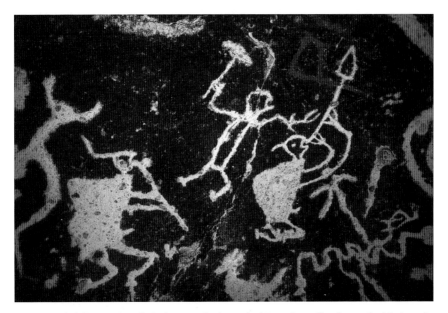

FIGURE 4.03: Rio Grande Style petroglyphs pecked into the walls of a smoke-blackened cavate carved into volcanic ash, Los Alamos, New Mexico.

Cave that lie deep within the backcountry of Bandelier, requiring an overnight backpacking trip and a permit from the National Park Service. Flute player depictions are present at the petroglyphs at Tsankawi and in Frijoles Canyon.

Chaco Culture National Historical Park

Chaco Canyon was a major center of Ancestral Pueblo culture between AD 850 and 1250. It was a hub of ceremony, trade, and administration for the prehistoric Four Corners area. Chaco is remarkable for its monumental public and ceremonial buildings as well as its distinctive architecture. To construct the buildings—along with the associated roads, ramps, dams, and mounds—required a great deal of well-organized and skillful planning, designing, resource gathering, and construction. The Chacoan people combined planned architectural designs, astronomical alignments, geometry, landscaping, and engineering to create an ancient urban center of spectacular public architecture.

Up to 5,000 people may have lived in the canyon between AD 1000 and 1125. There are at least 2,000 ruins in the area (eleven major ones) and a great many petroglyph sites (fig. 4.04), some of which are accessible by the trail system in the Park.

The Penasco Blanco trail covers 6.4 miles roundtrip and is accessed from the

Pueblo del Arroyo parking area. It leads to the westernmost Chacoan building in the canyon. Construction at Penasco Blanco began around the middle of the ninth century. From the trail, a concentration of petroglyphs and historic inscriptions can be seen along the canyon wall. The route also includes a spur trail to the Supernova Pictograph site. Perhaps the best-known rock art site in Chaco Canyon, this site consists of a star, a crescent moon, and a handprint. On July 5, 1054, the crescent moon in the Southwest was within three degrees of the supernova. The supernova was visible in broad daylight for twenty-three days. Chaco Canyon was a thriving community at that time, with great awareness of the heavens, so this celestial event would not have been overlooked. Researchers believe the maker of the pictographs painted what he saw and signed it with his handprint.

Additional rock art can be found along the trail behind Pueblo Bonito that leads to the ruins of Chetro Ketl, above Una Vida Pueblo, behind the campfire circle in the campground, and just past the ruins of Wijiji Pueblo. For a detailed description of Chaco Canyon's rock art, see Schaafsma's *Rock Art in New Mexico* or *Indian Rock Art of the Southwest.*

Chaco Culture National Historical Park is remote and isolated. It offers few amenities, so come prepared. Hwy 57 from Blanco Trading Post (on U.S. 550) is permanently closed at the park's north boundary. Do not take Hwy 57. From U.S. 550, go to mile 112.5 (3 miles southeast of Nageezi) and turn onto CR 7900 and CR 7950. Follow signs to the park. Hwy 57 south is open from the southern park boundary to Hwy 9, but there are 20 miles of rough dirt road and it is not recommended for RVs. Both the visitors' center and campground are open year-round, and rangers conduct daily guided tours. The best seasons for visiting are spring and fall. For more information, contact the park at 505-786-7014.

La Cieneguilla Petroglyphs

In prehistoric times, the Santa Fe River served as a major trail from the Rio Grande up into the mountains above present-day Santa Fe. A number of pueblos thrived here, including one where Santa Fe's plaza now sits. Many petroglyphs are concentrated along the lower fifteen miles of the Santa Fe River, from near its confluence with the Rio Grande up to the southwestern edge of Santa Fe.

At the village of La Cieneguilla, thousands of petroglyphs decorate the edge of escarpments formed by lava flows. Abundant meadows and springs as well as the Santa Fe River once supported several pueblos in this area. The U.S. Bureau of Land Management (BLM) has designated an area of 3,556 acres near here as the La Cienega Area of Critical Environmental Concern (ACEC). Among its nationally significant

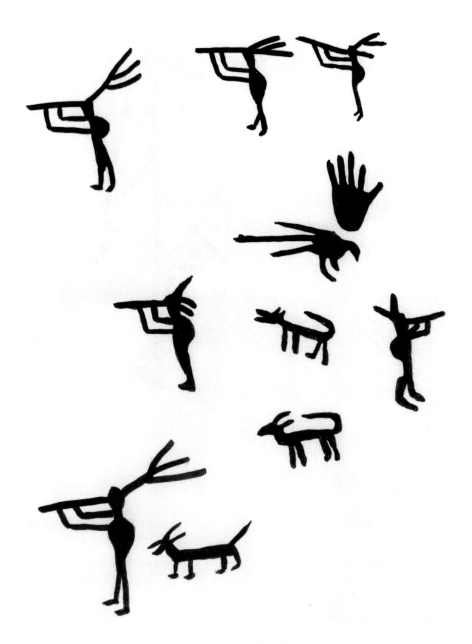

FIGURE 4.04: Petroglyph panel, Flute Player Rock, Chaco Canyon, New Mexico.

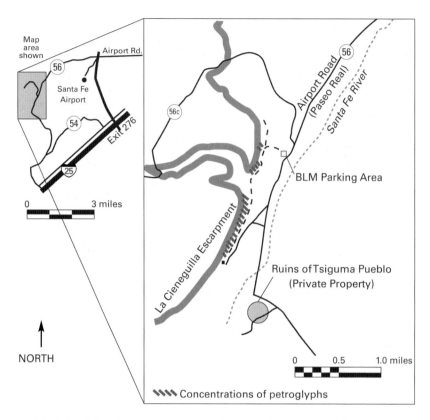

FIGURE 4.05: Map of La Cieneguilla petroglyph area, Santa Fe, New Mexico (after Slifer, 2005; map by Richard Huelster).

cultural resources are Archaic and Ancestral Pueblo sites, as well as thousands of petroglyphs. The BLM has developed an area for public access at La Cieneguilla. For information about this site, contact the BLM Taos Resource Area at 505-758-8851.

From the intersection of Airport Road and NM 599, continue west on Airport Road for 3.3 miles to the BLM's parking area and trailhead. You can see petroglyphs on the escarpment a short distance to the west; the best concentrations are about a quarter mile south of here (see map, fig. 4.05).

Over 4,000 petroglyphs are recorded along a one-mile stretch of escarpment alone. The pueblos here were probably important in the turquoise trade because the mineral was mined prehistorically in the Cerrillos Hills about three miles to the southeast. During the Spanish Colonial Period, the Camino Real was built through the Santa Fe River Canyon, linking the Pueblo of Santo Domingo on the Rio Grande to the Santa Fe area.

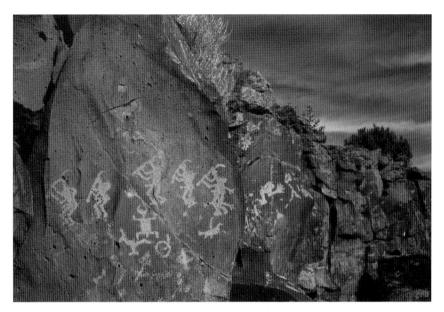

FIGURE 4.06: Rio Grande Style petroglyphs depicting a row of flute players,
La Cieneguilla, New Mexico.

The majority of images here are Rio Grande Style petroglyphs. In addition to numerous bird depictions, there is a proliferation of flute player images (fig. 4.06). Displaying great diversity and creativity, more than a hundred images of this important figure are recorded here. Fertility and the flute player's role in sexuality were obviously of great importance to the people who created the rock art at these sites.

Petroglyph National Monument
Petroglyph National Monument, encompassing 7,000 acres on the volcanic escarpment of West Mesa at Albuquerque, has the greatest concentration of petroglyphs on the Rio Grande—an estimated 20,000 petroglyphs. The monument includes the five extinct volcanoes along Albuquerque's western horizon and the entire seventeen-mile-long dark cliff below. It was created in 1990 to protect the petroglyphs and other resources from destruction by encroaching development and vandalism as Albuquerque's population expanded westward.

This has always been a sacred place to native peoples in the upper Rio Grande. The governors of five area pueblos have stated: "Our ancestors chose the petroglyph area to be a sacred site because it was born with Mother Earth's great labor and power. If you walk around the petroglyphs, you can see the unique features that our

ancestors saw—five volcanoes in a straight line, their once-opened vents communicating with the world beneath and the lava that they sit on. The petroglyph area is where messages to the spirit world are communicated. It is the center of great spiritual powers! . . . The Petroglyph National Monument should be a place of reverence and prayer and used in this manner."

Petroglyph concentrations occur at three main areas within the Monument—Rinconada Canyon, Piedras Marcadas, and Boca Negra. At Boca Negra Canyon, you can view a few hundred petroglyphs on three self-guiding trails. Approximately a third of the park's petroglyphs can be seen at Piedras Marcadas Canyon by hiking several miles. In addition, you can hike two and a half miles through Rinconada Canyon to see many more petroglyphs. An estimated 90 to 95 percent of the petroglyphs on West Mesa belong to the Rio Grande Style (AD 1350 to 1680). Many large pueblos were built along this section of the Rio Grande during this period. Piedras Marcada ("marked rock") Pueblo covered seven acres and contained a thousand rooms stacked in several stories around two plazas. The people farmed along the Rio Grande floodplain and foraged along the base of the escarpment. The common association of petroglyphs with agricultural areas and grinding slicks (rock surfaces worn smooth by grinding seeds and herbs) indicates some of these rock art sites played a ritual role in food gathering and processing and in the use of medicinal plants. Many of the petroglyphs express a concern with rain and fertility. Images of flute players occur throughout the monument (fig. 4.07).

Some of the older (Archaic) petroglyphs found on the northern part of the escarpment and on the volcanoes could be nearly 3,000 years old. They are abstract patterns such as circles, meandering lines, and rake-like symbols. A few early Ancestral Pueblo sites have also been found in the monument; typical images from this period consist of outlined crosses, sandal tracks, handprints, stick-figure men, and small, solidly pecked animals.

As you progress along the trails, you will see many figures repeated, such as masks, flute players, foot- and handprints, spirals, cloud terraces, lizards, birds, snakes, and horned serpents. The West Mesa contains numerous depictions of figures incorporating the four-pointed star symbol. This is a complex symbol related to warfare in Pueblo

FIGURE *4.07:*
Petroglyph depicting a kilted flute player, West Mesa, New Mexico.

iconography, often appearing as a humanized figure with faces, feathered headdresses, limbs, and weapons. This symbol represents Venus, or Morning Star, which was seen as a spirit warrior who protects and heralds the Sun. This is the mask symbol of the Morning Star katsina at some pueblos. Bird symbols are also common in West Mesa rock art. Eagles and hawks, powerful masters of the sky, are present throughout.

For further information, contact the monument at 505-899-0205. The visitor center is located on Unser Boulevard, 3 miles north of I-40 at the intersection of Unser Boulevard and Western Trail Road, and is open from 8 a.m. to 5 p.m.

Tomé Hill

The small Hispanic farming village of Tomé, founded on the east bank of the Rio Grande below Los Lunas, had a tenuous existence in its early years due to frequent raids by Comanches and Apaches. Nearby Tomé Hill had been the site of ceremonial activities in the prehistoric past as evidenced by the petroglyphs placed there by ancient Pueblo people. Tomé Hill is owned by the nonprofit Valley Improvement Association that, in a joint project with Valencia County, has developed an interpretive park and trails. These are located on the south side of Tomé Hill and are accessed via Tomé Hill Road off Hwy 47 (figure 4.08). The site is on the National Register of Historic Places. In addition to the petroglyphs on the hill, the area is significant for having a portion of the Camino Real corridor nearby.

More than 1,800 petroglyphs have been recorded on the hill, and finding them requires climbing on rocky outcrops and boulders. One of the best concentrations is found low on

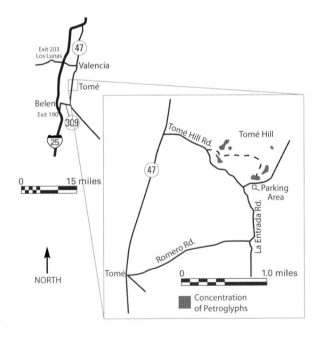

FIGURE *4.08:* Map of Tomé Hill petroglyph area near Los Lunas, New Mexico (after Slifer, 2005; map by Richard Huelster).

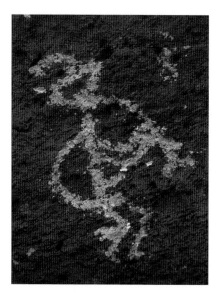

*FIGURE **4.09:*** Petroglyph of humpbacked flute player, Tomé Hill, New Mexico.

the hill's southeastern side, about a quarter mile east of the South Trail. By exploring with binoculars, you will find others. Look for short spur paths off the main trail that lead to other petroglyphs. The petroglyphs here consist mostly of images such as humpbacked flute players (fig. 4.09), katsina masks, birds, cloud terraces, snakes, and other typical Rio Grande Style elements. On some of the horizontal rock surfaces, a series of petroglyphs of human footprints may indicate a journey or migration of the tribe. Interpretive display information about this site can also be viewed at the Petroglyph National Monument in Albuquerque.

Utah

Edge of the Cedars State Park

Although there is no actual rock art at Edge of the Cedars State Park in Blanding, Utah, it is well worth a visit for several reasons. Placed on the National Register of Historic Places in 1971, the park contains an Ancestral Pueblo ruin that was occupied between AD 750 and 1220, as well as an excellent museum that includes a fine exhibition of artifacts and a special permanent rock art exhibit. This exhibit, Spirit Windows, is a series of rock art images reproduced on the stucco walls of the museum. Nine panels are reproduced from actual rock art sites, many of which have been inundated by the waters of Lake Powell. The panels were created by artist Joe Pachak from various archaeological archives and other records. A booklet explaining the exhibit *Spirit Windows: Native American Rock Art of Southeastern Utah*, by Winston B. Hurst and Joe Pachak, is available at the museum. In addition to the nine panels of Spirit Windows, there is a large mural of composite rock art images in an enclosed stairwell, representing many different rock art styles and cultural traditions of the Southwest. The images are organized according to common themes or motifs, which are described in the booklet. In addition to Spirit Windows, the museum also contains sculptures depicting rock art in three-dimensional form and a

reconstructed solar calendar that demonstrates how certain rock art sites functioned to mark seasonally important dates. Edge of the Cedars State Park Museum is located on the northwest side of Blanding at 660 West 400 North Street. From U.S. Hwy 191 (Main Street), go to the four-way stop in the middle of town. Proceed west on Center Street to 600 West, turn right (north) and go two blocks to the museum. For further information, call 435-678-2238 or 435-678-3392.

Grand Gulch Primitive Area

Grand Gulch and its tributaries form an extensive and spectacular canyon system that originates on Cedar Mesa and twists its way south to the San Juan River between Mexican Hat and Lake Powell. The sinuous main canyon, from the Kane Gulch Ranger Station to the San Juan River, is more than fifty miles long. Grand Gulch, like all the canyons draining Cedar Mesa, is an archaeological treasure house; it contains dozens of well-preserved Ancestral Pueblo ruins and hundreds of pictographs and petroglyphs. As a primitive area administered by the BLM, the only access is by hiking or horseback. Days of arduous foot travel are necessary to see much of it.

The Ancestral Pueblo flourished in Grand Gulch over a period of at least 1,000 years. It is best known for the Basketmaker culture, whose dwellings, artifacts, and rock art are abundant here. It was in Grand Gulch that the Basketmaker culture was "discovered" by Richard Wetherill in the late 1800s, when he excavated a cave containing mummified bodies and exquisite basketry. Although there are many Basketmaker rock art sites (both pictographs and petroglyphs), later Ancestral Pueblo rock art also occurs in the canyon. Because of the continuity of Ancestral Pueblo habitation here, this is a good area to study the development of different Ancestral Pueblo rock art styles and their superimposition. Although Archaic rock art is also present in Grand Gulch, it is rarer. The most typical and dramatic rock art encountered in Grand Gulch is probably the large polychrome pictographs of broad-shouldered anthropomorphs that characterize the Basketmaker styles. Color is a unique aspect of these paintings. A site might include, for example, a row of red men with white legs next to bicolored birds; or yellow figures outlined in purple-red, along with green and red figures. Handprints are common and are executed in red, white, and green—often in association with the large anthropomorphs. Even some of the ruins are decorated with bands of color. Basketmaker paintings typically occur in rock shelters and around ruins, and sometimes, later Pueblo elements are superimposed on them.

Many sites occur near the confluences of tributaries and the main canyon or are associated with ruins. Most of the rock art in Grand Gulch occurs in the upper three-fourths of the canyon, between Kane Gulch and Collins Canyon. Because of the

increasing popularity of the area for recreation, a permit system was recently implemented. For information, contact the BLM at 435-587-1532. The Kane Gulch Visitor Center is located 3 miles south of Utah 95 on Utah 261. At this facility, you can obtain information, maps, and hiking permits to visit Grand Gulch Primitive Area.

Sand Island Recreation Area

The San Juan River flows through the southeastern corner of Utah, providing an invaluable source of permanent water and a narrow green oasis in this otherwise barren expanse of rock and sand. Accordingly, the canyon and tributaries of the San Juan have sustained human populations from Archaic times to the present. Most of the rock art along the San Juan River and its tributaries is Ancestral Pueblo in origin, with later contributions by Navajo and Ute peoples.

There are many outstanding rock art sites along the San Juan River and its tributaries between the town of Montezuma Creek and Lake Powell. The sites are mostly on BLM land, and many can be accessed from the river between the towns of Montezuma Creek and Mexican Hat, but this requires a permit from the BLM unless you hire a commercial guide company to take you down the river. These companies know the locations of all the sites and are permitted to visit them.

The Sand Island Recreation Area is located approximately 3 miles west of Bluff, Utah, at the intersection of U.S. 163 and U.S. 191. The area is managed by the BLM

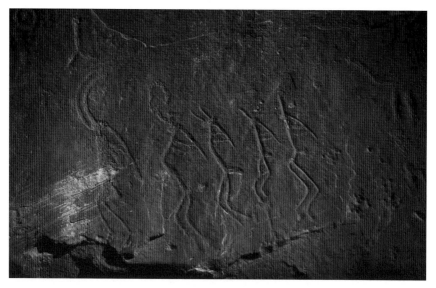

FIGURE 4.10: Petroglyphs of flute players, Sand Island near Bluff, Utah.

as a river access point and a campground. A major petroglyph site is located on the sandstone cliffs at the northwestern corner of the recreation area; a gravel road leads up to the fenced enclosures protecting the site. A complex of panels extends along the cliff. The hundreds of petroglyphs are significant for representing various periods and at least seven different styles: Great Basin Abstract, Glen Canyon Linear, San Juan Anthropomorphic, Early Ancestral Pueblo, Late Ancestral Pueblo, historic Ute, and historic Navajo. Because of the number of styles present at Sand Island, rock art here can be used to demonstrate the relative dating of styles by superimposition of various elements. Some of the oldest petroglyphs at Sand Island date back at least 2,000 years.

A great variety of animals and anthropomorphs are represented in these complex panels of often overlapping images. The impressive shamanic figures of the San Juan Anthropomorphic Style are present. Other figures of interest here are the many flute players (fig. 4.10). Among these are some whose phallic attributes have been greatly exaggerated, a flute-playing bighorn sheep (fig. 1.03), and a flute player with a receptive female (fig. 3.10).

In addition to the rock art at Sand Island Recreation Area, there is extensive rock art along the cliffs adjacent to the San Juan River in this vicinity. Adventurous individuals who don't mind bushwhacking through the thick riparian vegetation that grows up to the cliff face can find other sites both upriver and downriver.

Shay Canyon and Newspaper Rock

Shay Canyon is a tributary of Indian Creek, one of the main drainages from the Abajo Mountains through the Needles District of Canyonlands National Park to the Colorado River. As an important prehistoric travel corridor and habitat with perennial water, this area is rich with archaeological sites, including abundant rock art. This is a large petroglyph site located 1.9 miles west of Newspaper Rock (a large panel of mostly Ute petroglyphs), at the confluence of Indian Creek Canyon and Shay Canyon (fig. 4.11). Look for a small parking area on the south side of the road next to a large flat-topped boulder. Some stone steps and a primitive trail lead across Indian Creek and the canyon bottom to the site about 200 yards from the road. The petroglyphs begin at the point in the cliffs and extend for several hundred yards along the east-facing cliff.

Here there are several styles and ages of rock art. A few examples of the Glen Canyon Linear Style are present, mainly bighorn sheep and other quadrupeds, but these are almost completely repatinated and are therefore difficult to discern. The majority of the figures at Shay Canyon are Ancestral Pueblo, Abajo–La Sal Style.

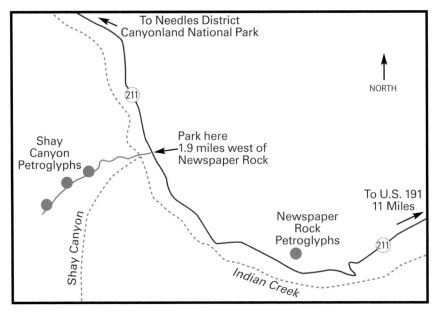

FIGURE 4.11: Map of Shay Canyon and Newspaper Rock petroglyph sites, Indian Creek, Utah (after Slifer, 2000).

There are many anthropomorphs, including several panels with flute players (fig. 4.12). The one illustrated in Figure 3.39a contains a flute player and what appears to be a dancing deer. Numerous animals are depicted here. In addition to the typical assortment of deer, elk, and bighorn sheep, there is a curious image on a detached boulder that has been referred to as the Shay Canyon mastodon, but since the head is indistinct and no trunk or tusks can be identified, it is unlikely to be a mastodon. There are also a number of interesting figures located high on the cliff face that could be overlooked.

Dinosaur National Monument

Located on the northeastern edge of the Uinta Basin, Dinosaur National Monument straddles 325 square miles on the Utah-Colorado border, and is centered on the canyon confluence of the Green and Yampa Rivers. Famous for the well-preserved dinosaur fossils found in its sedimentary rock formations, this monument also contains outstanding rock art sites and other archaeological resources throughout a remote area of deep canyons and rugged plateaus.

Some of the finest examples of the Fremont Classic Vernal Style are found in Dinosaur National Monument and in nearby Dry Fork Valley north of Vernal. Many

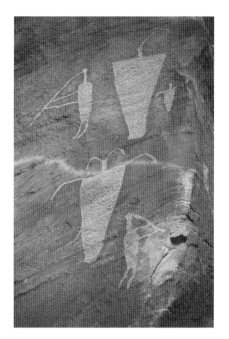

FIGURE *4.12:* Petroglyphs of flute players with anthropomorphs, Shay Canyon, Utah.

FIGURE *4.13:* Fremont petroglyph of a flute player, McKee Spring, Dinosaur National Monument, Utah.

other rock art sites occur on cliffs along the Green River and its tributaries, which flow through the heart of the basin and are accessible only by boat.

Several sites featuring Fremont rock art are accessible to the public in Dinosaur National Monument, two of which contain flute players. The one easiest to reach is along Cub Creek, a few miles east of the Dinosaur Quarry. McKee Spring, near Island Park, features some outstanding large Fremont anthropomorphs in a number of impressive panels, among which is the humpbacked flute player in figure 4.13.

To reach Cub Creek, take the self-guided auto tour of 22 miles roundtrip that begins near the Dinosaur Quarry and leads to rock art at three locations. The monument recommends you pick up the brochure entitled *Tour of the Tilted Rocks* to increase your enjoyment of this scenic drive. The last 2 miles of road are unpaved but suitable for passenger cars; the main rock art sites are located about 1 mile from the end of the paved section. There are numbered posts along the roadside corresponding to interpretive stops. The first rock art is found at Stop 1, in a rock shelter (the "Swelter Shelter") where excavations revealed Desert Archaic Period habitation dating back as long ago as 4000 to 7000 BC. The faint pictographs and petroglyphs on

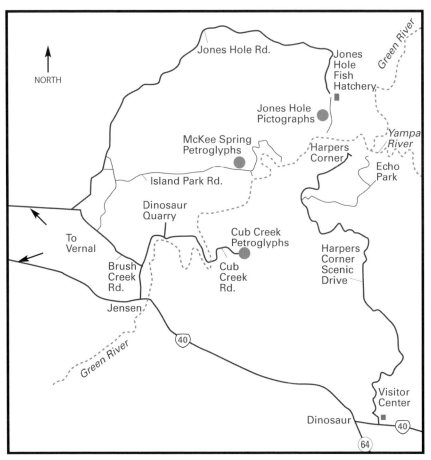

FIGURE 4.14: Map of Dinosaur National Monument showing location of rock art sites, McKee Spring and Cub Creek (after Slifer, 2000).

the walls of the shelter are doubtless more recent Fremont images, however, and were probably made about 1,000 years ago. The broad-shouldered, horned anthropomorphs are characteristic of the Fremont, but the peculiar anthropomorph with a large oval head is somewhat anomalous.

The other two main sites on Cub Creek are located at Stops 13 and 14, approximately 10.6 miles and 10.8 miles from the Dinosaur Quarry. These sites feature bold Fremont petroglyphs pecked into the varnished red sandstone cliffs on the north side of the road. Some are adjacent to the road, but most extend for several hundred yards along cliffs to the north of the road. The perennial water and lush, shaded riparian areas along Cub Creek allowed small Fremont settle-

ments to thrive in this vicinity. Symbols of Fremont ritual activities and religious beliefs are among the images recorded on the cliffs here. There are numerous Fremont anthropomorphs as well as animals such as bighorn sheep and lizards, some of which are more than six feet long. A single flute player also occurs here; although they are found elsewhere in Fremont rock art in the Uinta Basin, they are uncommon.

Some of the finest petroglyphs in Dinosaur National Monument are at McKee Spring near Island Park (fig. 4.14). Large, elaborate Fremont anthropomorphs are especially well executed on the sandstone cliffs, along with geometric designs and other elements. The road to Island Park, a 51-mile roundtrip drive from the Dinosaur Quarry, is mostly unpaved and rough. It is suitable for most passenger cars but impassable when wet. The petroglyphs occur in a number of panels on the cliffs along both sides of the road after entering the monument on the Island Park road. The large anthropomorphs at McKee Spring are shown holding shields and other objects, and are depicted with elaborate necklaces, headdresses, earrings, and other ceremonial regalia. This style is an example of the Utah Anthropomorphic Tradition, a continuum of different styles that emphasizes representations of imposing, super-natural-looking anthropomorphic figures.

McConkie Ranch

The most advanced expression of Fremont rock art is found northwest of Vernal along Dry Fork and Ashley Creek. These streams, which drain the southern slopes of the Uinta Mountains, provided excellent habitat for prehistoric peoples in beautiful valleys. Although many of the rock art sites in this region are on private land, fortunately one of the finest is open to the public at the McConkie Ranch, 10 miles northwest of Vernal. The ranch owners have long appreciated and protected the world-class rock art here. In 1975, Utah recognized the efforts of Sadie McConkie in guarding this outstanding site from vandals and designated her property a historic site. There is a nominal admission fee, and the owners ask that visitors sign in, respect the rock art, and stay on the trails. The McConkie Ranch has graciously shared this rock art treasure with the public for decades. Please respect their property and express your gratitude for this privilege.

Here the Classic Vernal Style is grandly displayed in a long series of dramatic petroglyph panels along the white sandstone cliffs, among the most technically advanced petroglyphs to be seen anywhere. This distinctive style developed using a number of techniques to produce designs and textural effects, including pecking, incising, rubbing, abrading, and drilling. Pictographs are uncommon in this area,

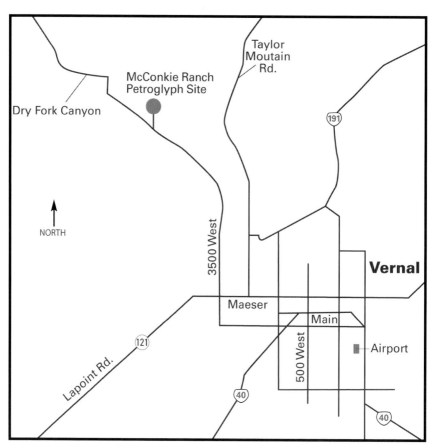

FIGURE 4.15: Map of Vernal, Utah, showing access to McConkie Ranch petroglyph site (after Slifer, 2000).

but a number of the petroglyphs show residual traces of pigment, indicating that these designs had formerly been enhanced by painting.

The most compelling aspect of these petroglyphs is the many large anthropomorphs, which occur in groups or lines along the cliffs. The most striking and well-known example is the panel known as the "Three Kings," which has been featured in a number of publications, including *National Geographic.* These heroic figures are a hundred feet above the ground—accessible to the ancient artists by a perilous, narrow ledge on the cliff face. Fortunately, they can be safely viewed from below at ground level, although binoculars help in appreciating the detail. Traces of red pigment can still be seen on the largest figure and the shield he is holding. Such grand human figures occur in approximately 80 percent of the rock art sites in the Dry

Fork and Ashley Creek area. One of their hallmarks is precise, ornamented detail and decorative effects. They show facial features, jewelry, and highly variable headgear. Other details include items of apparel such as fringed aprons, breechcloths, belts and sashes, armbands, and torso decorations. Figures are often shown holding decorated shields as well as objects that have been interpreted as masks, scalps, or human heads. Some anthropomorphic figures have tear streaks on their faces, a device known as the "weeping eye" motif.

Carefully executed spirals and concentric circles are other common elements in these panels. The flute player figure, although relatively rare in Fremont rock art, occurs in about 4 percent of these Uinta Fremont sites. In these depictions, the flute player is usually humpbacked but is not phallic, as is often the case in Ancestral Pueblo portrayals. Fremont artistic expression in material culture is usually considered to be less elaborate than Ancestral Pueblo expression—with the notable exception of rock art, which achieved great merit, as demonstrated here on Dry Fork.

To reach the site (fig. 4.15), from the center of Vernal, drive north and west on Utah 121 (LaPoint Road) for approximately 3 miles to Maeser. In Maeser, look for 3500 West (Dry Fork Canyon Road) and turn right (north). Travel approximately 6.5 miles in a northwesterly direction on Dry Fork Road, and then turn right into the McConkie Ranch at their signed driveway. Information about Uinta Basin rock art can also be obtained at the Utah Dinosaur Natural History Museum in Vernal.

Arizona
Canyon de Chelly National Monument
Canyon de Chelly, one of the longest continuously inhabited landscapes of North America, also sustains a living Navajo community. Unique among national parks and monuments, it is comprised entirely of Navajo tribal land that remains home to the canyon community. The monument covers 131 square miles and encompasses the floors and rims of the three major canyons: de Chelly, del Muerto, and Monument. The name de Chelly is a Spanish corruption of the Navajo word Tsegi, which means roughly "rock canyon." The vertical walls of the canyon range from 30 feet high at Chinle Wash to 1,000 feet at its highest point. Along with the awe-inspiring beauty comes the possibility for hazards such as flashfloods and quicksand that can be encountered while exploring Canyon de Chelly. Access to the canyon floor is restricted and visitors are allowed to travel in the canyons only when accompanied by a park ranger or an authorized Navajo guide.

The canyons have been inhabited for more than 2,000 years by Archaic,

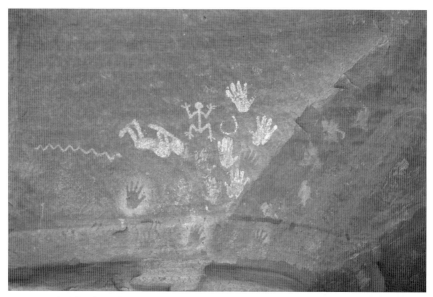

FIGURE *4.16:* Flute player pictograph, Canyon de Chelly, Arizona.

Ancestral Pueblo, and Navajo peoples. Numerous pictographs, petroglyphs, and ruins tell of the people who made their homes here. Although its history is marred by incidents of massacre, forced relocation, and abuse, Canyon de Chelly's overall effect is a lasting sense of peace and profound beauty. Highlights of the canyon are Spider Rock, an 800-foot spire said to be the home of "Spider Woman," and White House Ruin, an ancient dwelling that allows visitors to understand how the ancients lived and thrived here. The Indians, past and present, have considered the canyons a spiritual place.

Canyon de Chelly National Monument has some of the finest rock art in Arizona, with a record spanning several thousand years from early Basketmaker through the Pueblo Period to historic Navajo. Hundreds of sites have been recorded within the canyons contained in the Monument. There are numerous petroglyph sites, but the area is especially well known for its many fine pictographs. The most comprehensive source of information is Campbell Grant's book *Canyon de Chelly: Its People and Rock Art.* The highest development in rock art was from late Basketmaker times into the subsequent Pueblo Period (approximately AD 450 to 1100), when the bulk of the canyon paintings were produced in a polychrome palette. There are many imposing anthropomorphic figures in ceremonial attire and contexts. Other elements that find common expression here are animals and birds, handprints, and, of

course, flute players (fig. 4.16). Some of the earliest known depictions of the flute player come from this region. The later Navajo rock art records some historic events such as battles and raids.

Among the many pictographs of flute players in Canyon de Chelly are the pair shown sitting beneath rainbows in plate 1. Twinned flute players also sit beneath the Great White Duck—the wise, protective motherly figure who knew all the trails and never got lost (fig. 3.62).

You will need a Navajo guide and a four-wheel-drive vehicle to visit rock art sites in the canyon. To protect the sites from damage, many have been fenced or declared off limits by the Park Service. This means they must be viewed from a distance with binoculars, making photography a frustrating experience unless you have a very long telephoto lens. If photography is a goal, it is important to ask your guide about sites that can be approached closely. Tsegi Guide Association (928-674-5500) and De Chelly Tours (928-674-3772) offer private jeep tours and hikes for a minimum of three hours with longer tours and overnight camping trips available. Thunderbird Lodge canyon tours depart from the lodge in large six-wheel vehicles that accommodate up to twenty-four people. Half- and full-day tours are available. Call 1-800-679-2473 or 928-674-5841 for more information. The National Monument headquarters can be reached at 928-674-5500.

Chevelon Canyon

Rock Art Ranch, situated in a remote area between Holbrook and Winslow, Arizona, offers tours of a spectacular rock art site in Chevelon Canyon. Petroglyphs are found

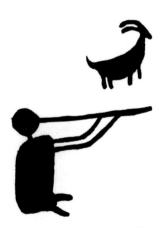

for about a quarter of a mile on both sides of the canyon. To view the rock art, visitors can drive to the rim of the canyon and take a short hike to the bottom, or the observation deck on the rim can be used. The rock art remains in pristine condition in a watered canyon of great beauty. The petroglyphs here range from Archaic through Basketmaker to early Pueblo periods (fig. 4.17). The oldest may be on the order of 4,000 years old.

Rock Art Ranch is a working cattle ranch owned by the Baird family, who offer tours, chuck wagon dinners, and family entertainment. The ranch also contains a museum of pioneer

FIGURE *4.17:* Petroglyph of flute player, Chevelon Canyon, Arizona.

and Native American artifacts. The last remaining bunkhouse of the Hashknife Outfit, a spread that covered 2 million acres, is restored at the ranch. Visitors can also stay at the ranch and enjoy a steak fry and cowboy music. Tours are available year-round except Sundays. Write or call in advance for detailed directions on how to get there. Contact Brantley Baird, Box 224, Joseph City, AZ 86032, or call 928-288-3260. There is a small fee for visitation.

Homolovi Ruins State Park

Homolovi Ruins State Park is west of Petrified Forest National Park on the north bank of the Little Colorado River. More than 300 archaeological sites have been identified within the park boundaries, including four major pueblos and a number of rock art sites. These sites were occupied during the thirteenth and fourteenth centuries. The Hopi say Homolovi was a stopping place for their ancestors as they migrated north toward their present home, and they consider it part of their homeland. They continue to make pilgrimages to these sites, renewing the ties of the people with the land. In an effort to protect some of these sites, the Hopi people supported the idea of Homolovi Ruins State Park, established in 1986 and opened in 1993.

Homolovi Ruins State Park now serves as a center of research for the late migration period of the Hopi from the 1200s to the late 1300s. While archaeologists study the sites and confer with the Hopi to unravel the history of Homolovi, Arizona State Parks provides the opportunity for visitors to visit the sites and use park facilities, including a visitor center and museum, various trails, and a campground.

The Tsu'vö Trail (Path of the Rattlesnake in Hopi) is a half-mile loop trail between the twin buttes within the park. It is a nature trail and also an archaeological trail where milling stone areas and petroglyphs can be seen. The Homolovi II Trail is a half-mile paved trail that is wheelchair accessible and allows access to the largest of the park's archaeological sites, which contains an estimated 1,200 to 2,000 rooms.

Homolovi is located approximately three miles northeast of Winslow, Arizona. Take I-40 to Exit 257, and then go 1.3 miles north on Hwy 87. Call the park at 928-289-4106 for additional information (e-mail: homolovi@pr.state.az.us).

Lyman Lake State Park

Created as an irrigation reservoir by damming the Little Colorado River, this 1,200-acre park encompasses the shoreline of a 1,500-acre reservoir. A number of pueblo ruins and rock art sites are accessible to the public here. Rattlesnake Point Pueblo and the Lyman Lake rock art sites have continuing significance to Hopi people.

They understand these sites as homes of their ancestors during their migrations and the petroglyphs as signs left by those migrating through the area (fig. 4.18).

The Peninsula Petroglyph Trail is a quarter-mile self-guided trail accessible from the campground and open during daylight hours every day. The Ultimate Petroglyph Trail is a half-mile steeper trail on the east side of the lake and can only be accessed by boat. Tours are available through the ranger station on a seasonal basis. This trail ends at Ultimate Rock, a large petroglyph-covered boulder. The Rattlesnake Point Pueblo Trail takes hikers to the ruin of a medium-sized village that was home to about fifteen families between about AD 1325 and 1390. When occupied, the architecture would have resembled that of historic pueblo villages. The pueblo sat on a long ridge overlooking the Little Colorado River. Rooms from this fourteenth-century ruin can be viewed from a short trail. Tours are available through the ranger station on a seasonal basis.

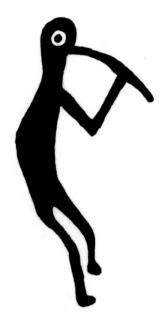

FIGURE *4.18:* Petroglyph of flute player, Lyman Lake, Arizona.

Lyman Lake is popular during the spring, summer, and fall. Summer days, with temperatures in the 80s to low 90s, are perfect for fishing, swimming, boating, water-skiing, or hiking. The park is located 11 miles south of St. Johns on U.S. 191. For more information, contact the park at 928-337-4441.

Monument Valley Tribal Park

Famous the world over, the majestic buttes and spires of Monument Valley contain some equally magnificent rock art sites. Located on the northern edge of the Navajo Nation and managed as a 1.5-million-acre park by the Navajos, this stunning Southwestern landscape was once home to the Kayenta Branch of the Ancestral Pueblo, whose ruins and rock art are plentiful amidst the colorful sandstone monoliths and canyons. The park straddles the Utah-Arizona state line, but this seems irrelevant in this magical land of the Navajo Nation. Some Navajo families have resided in the valley since the 1800s, and their traditional hogans dot the landscape along with more than a hundred prehistoric Ancestral Pueblo ruins. You can drive the 17-mile loop road through the valley, but to see other parts of the park, including

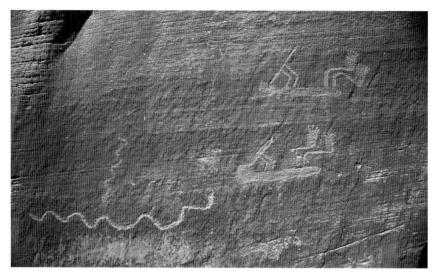

FIGURE 4.19: Petroglyphs of reclining flute players, Monument Valley, Arizona.

any rock art sites, you must hire a Navajo guide, and you will need a four-wheel-drive vehicle to negotiate the rough dirt roads. Inquire at the park headquarters or at Gouldings Ranch about arranging to visit rock art sites. One area that is quite scenic and which contains some fine examples of Kayenta Style petroglyphs is a group of natural arches that are poetically named "Sun's Eye" and "Wind's Ear," but there are many other possible destinations, such as the intriguing petroglyph panel in figure 3.20 that depicts a flute player and an apparent narrative about tracking bighorn sheep. Another site depicts the two reclining flute players shown in figure 4.19. For information about Monument Valley Navajo Tribal Park or to schedule a guide, call 435-727-5870, 435-727-5874, or 435-727-5875.

Petrified Forest National Park

Famous for its petrified wood, fossils, and the Painted Desert, this remarkable park also contains more than 550 archaeological sites. Perhaps the finest collection of petrified wood in the world is preserved here. Two of the many petroglyph sites in the park are easily reached by the main park road: Puerco Ruin and Newspaper Rock. Contact the park at 928-524-6228.

Palatki Heritage Site

The Palatki Heritage Site is located near the town of Sedona in north-central Arizona (fig. 4.20). Managed by the U.S. Forest Service under the Red Rock Pass Program,

the site is open to the general public for visits seven days a week (closed Thanksgiving and Christmas). A small visitor center and bookstore, run by the Arizona Natural History Association, is located a short distance from the parking lot. There are two trails at Palatki Heritage Site, one that takes you to the Sinagua cliff dwellings, and a second that goes to the rock art alcoves.

The rock art site represents a chronology of human occupation in the Verde Valley from the Archaic Period (3,000 to 6,000 years ago), to the Southern Sinagua (AD 650–1300), through the Yavapai and possibly Apache (AD 1400 through the 1800s). Near the end of the rock art trail is an alcove containing examples of all the periods that are represented at Palatki, including a pictograph of a reclining flute player in black (fig. 4.21).

There is another cliff dwelling and rock art site—Honanki ("Bear House")—located nearby; ask for directions at Palatki Heritage Site. Reservations are required. Call Palatki at 928-282-3854 between 9:30 a.m. and 3:00 p.m., 7 days a week. Information is also available at the Red Rock Ranger District at 928-282-4119,

FIGURE 4.20: Map showing access to the Palatki and Honanki Heritage Sites near Sedona, Arizona.

FIGURE **4.21:** Pictograph of a reclining flute player, Palatki ruins near Sedona, Arizona.

Monday through Friday, 8:00 a.m. to 4:30 p.m. The entrance gate is closed about half hour before the site itself closes. Hours are from 9:30 a.m. to 3:30 p.m., 7 days a week (subject to weather conditions). There is an entrance fee of $5 per person.

If it has rained or snowed recently, it is recommended that you contact the South Gateway Visitor Center to learn the condition of the roads to Palatki Heritage Site. If the roads are impassable, Palatki Heritage Site will be closed; signs indicating the closed status normally will be posted at key access points. A Red Rock Pass (or equivalent) is required on all vehicles parked at these sites. This pass can be purchased at these sites during normal hours of operation.

To get to Palatki Heritage Site from Sedona, take 89A south from the Y (away from Oak Creek Canyon). About 1/2 mile south of mile marker 365, at a group of mailboxes, turn right onto a dirt road (FR 525 to FR 795; passable for passenger cars when dry), and drive 8 miles to Palatki Heritage Site and the parking lot.

Alternatively, those with high-clearance vehicles and/or a sense of adventure can turn right on Dry Creek Road off 89A (south of the Y, still in the town of Sedona) and follow the signs for Enchantment Resort/Loy Butte. At the road to the Enchantment Resort, turn left onto Boynton Pass Road (FR 152C), and follow the signs for Loy Butte/Palatki (FR 525 to FR 795, turn right and follow to site). This road is generally passable to passenger cars when dry, but it is not regularly main-

tained by the county and has some rough and rocky stretches. The compensation will be spectacular views of the red rock formations.

To get to Palatki Heritage Site from Cottonwood, take 89A north from Cottonwood. About 1/2 mile north of mile marker 364, at a group of mailboxes, turn left onto a dirt road (FR to FR 795; passable for passenger cars when dry), and drive 8 miles to Palatki Heritage Site and the parking lot.

Colorado

Ute Mountain Tribal Park

Surrounding Mesa Verde National Park to the south is Ute Mountain Tribal Park, a 125,000-acre preserve that is part of the Ute Mountain Ute Reservation. Ute Mountain Tribal Park has been set aside by the tribe to protect the hundreds of spectacular ruins and cliff dwellings similar to those at Mesa Verde. The Ute Mountain Tribal Park, which is centered along a 25-mile stretch of the Mancos River, contains many rock art sites of both Ancestral Pueblo and Ute origin. Many more rock art sites can be seen here than in Mesa Verde National Park. The park is operated mainly as a primitive area to protect the environmental and cultural resources. Emphasis is placed on the visitor experiencing these sites in a remote natural setting—a welcome change from the crowds and restrictive regulations at Mesa Verde National Park. There are no visitor amenities, and all visitors must be accompanied by a Ute guide. Various day hikes as well as backpacking trips are available to explore the many sites in the park.

Both Ancestral Pueblo and Ute rock art are well exhibited in Ute Mountain Tribal Park; often both styles appear together in the same panel. The Mancos River Canyon has a wide floor and permanent water, so it was a prime habitat for the Ancestral Pueblo, who continuously occupied it from Basketmaker to late Pueblo times (approximately AD 550–1250). Early-style Basketmaker rock art in the park occurs as pictographs and petroglyphs, and is similar to Basketmaker art in Grand Gulch, Canyon de Chelly, and at other sites in the San Juan drainage. A Basketmaker petroglyph panel at Kiva Point features more than 200 elements, including the broad-shouldered anthropomorphs typical of Basketmaker art, bighorn sheep, and meandering rows of dots. Also among the Ancestral Pueblo rock art in Mancos Canyon are examples of flute players, including the two shown in Figure 4.22 that are strangely attached to other symbols. More early Ancestral Pueblo flute players are depicted at the Train Rock site on the south side of the Mancos River (fig. 3.39).

Rock art of the Ute Representational Style, from the Reservation Period (AD 1880–1950), is known primarily from examples in Ute Mountain Tribal Park. This recent, realistic Ute rock art differs somewhat from the earlier historic Ute rock art, especially regarding concerns with Euro-American beliefs. A preoccupation with the horse extends throughout. The Ute rock art in Mancos Canyon is particularly interesting because the area was continuously occupied by only one band (the Weeminuche) from 1880 on, and much of it was made by Chief Jack House (1886–1971), the last traditional chief of the Weeminuche. Chief House lived in the Mancos River Canyon most of his life, and for fifty years decorated the canyon walls with petroglyphs and paintings, some of which are dated and initialed. Many of these sites also include Ancestral Pueblo rock art, on which is sometimes superimposed Ute images. Apparently the pigments used in some of the brightly colored Ute paintings were sheep dyes distributed by the United States government.

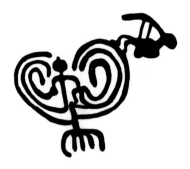

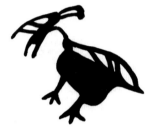

FIGURE *4.22:* Petroglyphs of flute players, Ute Mountain Tribal Park, Colorado.

Full-day tours of Ute Mountain Tribal Park are scheduled daily and leave from the Ute Mountain Pottery Plant, 15 miles south of Cortez, Colorado, on U.S. 666. Visitors must use their own vehicles for transportation (be sure to have a full tank of gas—the main ruins are 40 miles off the highway) and bring their own food and water since there are no facilities. Camping is available at a primitive campground located along the Mancos River. For information and reservations, call the Ute Mountain Tribal Park at 970-565-3751, extension 282. The tribal park is about 1.5 hours from Mesa Verde National Park. For more information and reservations, contact the tribe at 1-800-847-5485 or 970-565-3751.

Bibliography

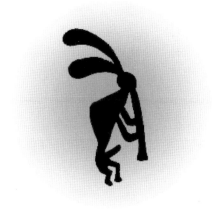

A

Abbey, Edward. *Desert Solitaire: A Season in the Wilderness.* New York: Simon and Schuster, 1990.

——. *The Serpents of Paradise.* New York: Henry Holt and Co., 1995.

Alpert, Joyce M. "Kokopelli, a New Look at the Humpbacked Flute Player in Anasazi Rock Art." *American Indian Art Magazine* (Winter 1991): 49–57.

Anati, Emmanuel. *Valcamonica Rock Art: A New History for Europe.* Valcamonica, Italy: Edizioni del Centro, 1994.

B

Benedict, Ruth. *Patterns of Culture.* New York: Mentor Books, 1953.

——. "Zuni Mythology." *Columbia University Contributions to Anthropology* 21, no. 2 (1969). New York: AMS Press.

Bierhorst, John. *A Cry from the Earth: Music of the North American Indian.* Santa Fe, NM: Ancient City Press, 1979.

Bishop, Clifford. *Sex and Spirit.* Boston: Little, Brown and Company, 1996.

Boyd, Douglas K., and Bobbie Ferguson. *Tewa Rock Art in the Black Mesa Region.* Amarillo, TX: U.S. Department of the Interior, Bureau of Reclamation, Southwest Region, 1988.

Bradley, Bruce A. "Architectural Petroglyphs at Sand Canyon Pueblo (5MT765) Southwestern Colorado." *Kiva* 54, no. 2 (1989): 153–61.

Brill, Lois. "Kokopelli: Analysis of His Alleged Attributes and Suggestions Toward Alternate Identifications." Master's thesis, University of New Mexico, Albuquerque, 1984.

Brody, J. J. *Mimbres Painted Pottery.* Santa Fe and Albuquerque: School of American Research and University of New Mexico Press, 1977.

——. *The Anasazi.* New York: Rizzoli, 1990.

——. *Anasazi and Pueblo Painting.* Albuquerque and Santa Fe: University of New Mexico Press and School of American Research, 1991.

Brown, Emily J. *Instruments of Power: Musical Performance in Rituals of the Ancestral Puebloans of the American Southwest.* PhD dissertation, Columbia University, 2005.

Brown, Donald Nelson. *The Flute in Pueblo and Apache Cultures.* Paper presented at the Colorado-Wyoming Academy of Sciences (unpublished manuscript), 1961.

——. "The Distribution of Sound Instruments in the Prehistoric Southwestern United States." *Ethnomusicology* 15, no. 3 (1967): 363–78.

Bunzel, Ruth L. "Introduction to Zuni Ceremonialism." *47th Annual Report of the American Bureau of Ethnology*, Washington, DC: Government Printing Office, 1932.

C

Cabrera, Roberto Velazquez. *Caral's Aerophones: The Oldest Playable Tubes with a Side Hole and a Stick Inside,* 2002. www.geocities.com/rvelaz.geo/caral/caral.html.

Campbell, Joseph. *Historical Atlas of World Mythology.* Vol. 1, *The Way of the Animal Powers.* New York: Harper and Row, 1988.

——. *Historical Atlas of World Mythology.* Vol. 2, *The Way of the Seeded Earth.* New York: Harper and Row, 1989.

Castleton, Kenneth B. *Petroglyphs and Pictographs of Utah.* Vol. 1, *The East and Northeast.* Salt Lake City: Utah Museum of Natural History, 1978.

——. *Petroglyphs and Pictographs of Utah.* Vol. 2, *The South, Central, West, and Northwest.* Salt Lake City: Utah Museum of Natural History, 1979.

Chaloupka, George. *Journey in Time: The World's Longest Continuing Art Tradition.* Chatswood, Australia: Reed, 1993.

Cole, Sally J. "Iconography and Symbolism in Basketmaker Rock Art." In *Rock Art of the Western Canyons.* Edited by Jane S. Day, Paul D. Friedman, and Marcia J. Tate. Colorado Archaeological Society Memoir 3:59–85. Denver: Denver Museum of Natural History, 1989.

———. *Legacy on Stone: Rock Art of the Colorado Plateau and Four Corners Region.* Boulder, CO: Johnson Books, 1990.

Conn, Richard. *Circles of the World: Traditional Art of the Plains Indians.* Denver: Denver Art Museum, 1982.

Conway, Thor. *Painted Dreams: Native American Rock Art.* Minocqua, WI: Northwood Press, 1993.

Cordell, Linda S. *Prehistory of the Southwest.* New York: Academic Press, 1984.

Cordell, Linda S., and George J. Gumerman, eds. *Dynamics of Southwest Prehistory.* Washington, DC: Smithsonian Institution Press, 1989.

Coulson, David, and Alec Campbell. *African Rock Art.* New York: Harry N. Abrams, 2003.

Cushing, Frank Hamilton. "Outlines of Zuni Creation Myths." *Bureau of American Ethnography Thirteenth Annual Report, 1891–92.* Washington, DC: Government Printing Office, 1896.

———. "Zuni Breadstuff." *Indian Notes and Monographs,* no. 8. New York: Museum of the American Indian, Heye Foundation, 1920.

———. *Zuni.* Lincoln: University of Nebraska Press, 1979.

Cutler, Hugh C. "Medicine Men and the Preservation of a Relict Gene in Maize." *Journal of Heredity* 35 (1944): 291–94.

D

Daniels, Helen Sloan. "Appendix A, Pictographs." In *Basketmaker II Sites near Durango, Colorado,* by Earl H. Morris and Robert F. Burgh. Carnegie Institution of Washington Publication 604, 1954. Pp. 87–88.

Dedrick, Philip. *An Analysis of the Human Figure Motif on North American Prehistoric Painted Pottery.* Master's thesis, University of New Mexico, Albuquerque, 1958.

Di Peso, Charles C. *Casas Grandes: A Fallen Trading Center of the Gran Chichimeca.* Dragoon, AZ: Amerind Foundation, 1974.

Dutton, Bertha P. *Sun Father's Way: The Kiva Murals of Kuaua.* Albuquerque: University of New Mexico Press, 1963.

Draper, Brad. Personal communication, 2002.

E

Eastvold, Isaac. "Ethnographic Background for the Rock Art of the West Mesa Escarpment." In *Las Imagines: The Archaeology of Albuquerque's West Mesa Escarpment.* Albuquerque, NM: Report prepared for Parks and Recreation Department, 1986.

Eliade, Mircea. *Shamanism: Archaic Techniques of Ecstasy.* Bollingen Series 76. Princeton: Princeton University Press, 1964.

Erdoes, Richard, and Alfonso Ortiz. *American Indian Myths and Legends.* New York: Pantheon Books, 1984.

Ewers, John C. *Plains Indian Sculpture: A Traditional Art from America's Homeland.* Washington, DC: Smithsonian Institution Press, 1986.

F

Fallon, Denise P. *An Archaeological Investigation of the Petroglyphs at the Waterflow Site, LA 8970, San Juan County, New Mexico.* Laboratory of Anthropology Note 135. Santa Fe: Museum of New Mexico, 1979.

Faris, Peter K. "A Fertility Ceremony Illustrated in the Cave of Life, Petrified Forest National Park, Arizona." *Southwestern Lore* 52, no. 1 (1986): 4–6.

Fewkes, Jesse W. "A Few Tusayan Pictographs." *American Anthropologist,* o.s., 5 (1892): 9–26.

———. "Hopi Katcinas Drawn by Native Artists." *Bureau of American Ethnology, 21st Annual Report for the Years 1899–1901.* Washington, DC, 1903. Pp. 3–126.

———. "Archaeology of the Lower Mimbres Valley, New Mexico." *Smithsonian Miscellaneous Collections* 63, no. 10 (1914). Washington, DC: Smithsonian Institution.

———. "Designs on Prehistoric Hopi Pottery." *Thirty–third Annual Report of the Bureau of American Ethnography to the Secretary of the Smithsonian Institution 1911–12*. Washington, DC: Government Printing Office, 1919. (Reprinted 1973, New York: Dover Publications.)

———. *The Mimbres: Art and Archaeology*. Albuquerque: Avanyu Publishing, Inc., 1989.

Flood, Josephine. *Rock Art of the Dreamtime*. Sydney, Australia: HarperCollins Publishers, 1997.

Frazer, Sir James. *The Golden Bough*. Hertfordshire, UK: Wordsworth Editions, Ltd., 1993.

Furst, Peter T. "Ethnographic Analogy in the Interpretation of West Mexican Art." In *The Archaeology of West Mexico*, edited by Betty Bell. Ajijic, Jalisco: West Mexican Society for Advanced Study, 1974.

G

Gimbutas, Marija. *The Language of the Goddess*. San Francisco: Harper and Row, 1989.

Goddard, P. E. "Myths and Tales from the San Carlos Apache." *Anthropological Papers, American Museum of Natural History* 24 (1918): 1–86.

Gough, Galal R. *The Shaman's Poro (Sacred Crook) in Native American Rock Art*. Presented at the Utah Rock Art Research Association Symposium on August 31, 1996, Green River, Utah.

———. "Native American Encircled and Enclosed Crosses Having Prehistoric Puberty/Fertility Symbolism." *Rock Art Papers* 13 (1998): 45–51. San Diego Museum Papers No. 35.

Grant, Campbell. *Rock Art of the American Indian*. Dillon, CO: Vistabooks, 1967.

———. *Canyon de Chelly: Its People and Rock Art*. Tucson: University of Arizona Press, 1978.

———, James W. Baird, and J. Kenneth Pringle. *Rock Drawings of the Coso Range*. Ridgecrest, CA: Maturango Press, 1968.

Graves, Robert. *The White Goddess—A Historical Grammar of Poetic Myth*. New York: Farrar, Strauss, and Giroux, 1948.

H

Hadlock, Harry L. "Ganaskidi: The Navajo Humpback Deity of the Largo." *Papers of the Archaeological Society of New Mexico* 5 (1980): 179–210. Santa Fe, NM.

Hamilton, Tyler. *Pueblo Gods and Myths*. Norman: University of Oklahoma Press, 1964.

Hammond, George P., and Agapito Rey. *Narratives of the Coronado Expedition 1540–1542*. Coronado Cuarto Centennial Publications. Albuquerque: University of New Mexico Press, 1940.

Harris, James. "Corn Maidens in Anasazi Rock Art." *American Indian Rock Art* 12 (1993): 123–32. American Rock Art Research Association.

Haury, Emil W. *The Hohokam: Desert Farmers and Craftsmen*. Tucson: University of Arizona Press, 1976.

Hawley, Florence. "Kokopelli of the Prehistoric Southwestern Pueblo Pantheon." *American Anthropologist* 39 (1937): 644–46.

Hayes, Alden C. "The Archaeological Survey of Wetherill Mesa. National Park Service." *Archaeological Research Series* 7–A. Washington, DC, 1964.

Heizer, R. F., and M. A. Baumhoff. *Prehistoric Rock Art of Nevada and Eastern California*. Berkeley: University of California Press, 1962.

Hewett, Edgar L. *Pajarito Plateau and Its Ancient People*. Albuquerque: University of New Mexico Press, 1938.

Hibben, Frank C. *Kiva Art of the Anasazi at Pottery Mound*. Las Vegas, NV: KC Publications, 1975.

Hirschman, Fred, and Scott Thybony. *Rock Art of the American Southwest*. Portland, OR: Graphic Arts Center Publishing Company, 1994.

Hoover, Joanne Sheehy. "Making Prehistoric Music." *American Archaeology* (winter 2004–5).

J

Jimenez, Antonio Nunez. *Petroglyfos del Peru: Panorama del Arte Rupestre.* Havana, Cuba: Ministerio de Cultura, 1986.

Johnson, Clay. "Clay's Tablet (Barrier Canyon)." *Utah Rock Art* 8 (1990): ii, edited by Bonnie L. Morris; Salt Lake City: Utah Rock Art Research Association.

K

Keyser, James D. *Indian Rock Art of the Columbia Plateau.* Seattle: University of Washington Press, 1992.

Kidder, Alfred K. "The Artifacts of Pecos." In *Papers of the Southwestern Expedition 6.* New Haven: Published for Phillips Academy by Yale University Press, 1932.

Kidder, Alfred Vincent, and Samuel J. Guernsey. "Archaeological Explorations in Northeastern Arizona." *Bureau of American Ethnology Bulletin 65.* Washington, DC: Government Printing Office, 1919.

Kluckhohn, Clyde. "The Excavations of Bc 51 Rooms and Kivas." *University of New Mexico Bulletin,* no. 345. Anthropological Series 3, no. 2 (1939): 30–48.

L

Laeberlin, H. K. "The Idea of Fertilization in the Culture of the Pueblo Indians." *The American Anthropological Association, Memoir 3,* 1916.

Laird, Carobeth. *The Chemehuevis.* Banning, CA: Malki Museum Press, 1976.

Lambert, Marjorie F. "Paa–ko, Archaeological Chronicle of an Indian Village in North Central New Mexico." *School of American Research Monograph* 19. Santa Fe, NM: School of American Research, 1954.

———. "A Kokopelli Effigy Pitcher from Northwestern New Mexico." *American Antiquity* 32, no. 3 (1967): 398–401.

Lange, Frederick, et al. *Yellow Jacket: A Four Corners Anasazi Ceremonial Center.* Boulder, CO.: Johnson Publishing Company, 1986.

Lewis-Williams, David, and Thomas Dowson. *Images of Power: Understanding Bushman Rock Art.* Cape Town, South Africa: National Book Printers, 1989.

Linne, S. "Humpbacks in Ancient America." *Ethnos* 8 (1943): 161–86.

M

Magne, Martin P. R., and Michael A. Klassen. "A Possible Flute Player Pictograph Site near Exshaw, Alberta." *Canadian Journal of Archaeology* 26 (2002): 1–24.

Mallery, Garrick. "Picture Writing of the American Indians." *Bureau of American Ethnology, Tenth Annual Report, 1888–89.* Washington, DC: Government Printing Office, 1893.

Malotki, Ekkehart. "The Dragonfly: A Shamanistic Motif in the Archaic Rock Art of the Palavayu Region in Northeastern Arizona." *American Indian Rock Art* 23 (1997): 57–72. American Rock Art Research Association.

———. *Kokopelli: The Making of an Icon.* Lincoln: University of Nebraska Press, 2000.

Manning, Steven J. "The Lobed-Circle Image in the Basketmaker Petroglyphs of Southeastern Utah." *Utah Rock Art* 10 (1990): 149–208. Utah Rock Art Research Association.

———. "An Hypothesis for a Pueblo IV Date for the Barrier Canyon Style." *Utah Rock Art* 1 (1981): 31–42. Utah Rock Art Research Association.

Marshall, Michael P., and Henry J. Walt. *Rio Abajo: Prehistory and History of a Rio Grande Province.* Santa Fe: New Mexico Historic Preservation Division, 1984.

Martineau, La Van. *The Rocks Begin to Speak.* Las Vegas, NV: KC Publications, 1973.

McCreery, Pat, and E. Malotki. *Tapamveni, the Rock Art Galleries of Petrified Forest and Beyond.* Petrified Forest, AZ: Petrified Forest Museum Association, 1994.

McGlone, Bill, Ted Barker, and Phil Leonard. *Petroglyphs of Southeastern Colorado and the Oklahoma Panhandle.* Kamas, UT: Mithras, Inc., 1994.

Miller, Jay. "Kokopelli." In *Collected Papers in Honor of Florence Hawley Ellis*, edited by T. R. Frisbie. Archaeological Society of New Mexico Papers 2 (1975): 371–80.

Miller, Mary. *Music of the Neanderthals*. American Association for the Advancement of Science, Dispatches From the Field, 2000.

Morss, Noel. "Clay Figurines of the American Southwest." *Papers of the Peabody Museum of American Archaeology and Ethnology* 40, no. 1 (1954). Cambridge, MA: Harvard University.

Morris, Ramona and Desmond. *Men and Snakes*. New York: McGraw Hill Book Company, 1965.

Morris, Elizabeth Ann. "Basketmaker Flutes from the Prayer Rock District, Arizona." *American Antiquity* 24, no. 2 (1959): 406–11.

N

Nabhan, Gary. "Kokopelli: The Humpbacked Fluteplayer." *The CoEvolution Quarterly* (Spring 1983): II.

Neary, John. "Kokopelli Kitsch." *Archaeology* (July–August 1992): 76.

Nicholson, Irene. *Mexican and Central American Mythology*. London: Paul Hamlyn, 1967.

O

Opler, Morris E. *An Apache Life–Way: The Economic, Social, and Religious Institutions of the Chiricahua Indians*. Chicago: University of Chicago Press, 1941.

———. "Childhood and Youth in Jicarilla Apache Society." *Publications of the Frederick Ward Hodge Anniversary Publication Fund*, vol. 5. Los Angeles: The Southwest Museum, 1946.

P

Packard, Gar and Maggy. *Suns and Serpents, the Symbolism of Indian Rock Art*. Santa Fe, NM: Packard Publications, 1974.

Parsons, Elsie Clews. "Mothers and Children at Zuni." *Man* 19 (1919): 168.

———. "Some Aztec and Pueblo Parallels." *American Anthropologist* 35 (1933): 611–31.

———. "The Humpbacked Flute Player of the Southwest." *American Anthropologist* 40, no. 2 (1938): 337–38.

———. *Pueblo Indian Religion*. Chicago: University of Chicago Press, 1939.

———. *The Pueblo of Isleta*. University of Albuquerque, Calvin Horn Publishers, 1974.

Payne, R.W. "Indian Flutes of the Southwest." *Journal of the American Musical Instrument Society* 15 (1989): 5–31.

———. "Bone Flutes of the Anasazi." *Kiva* 56, no. 2 (1991): 165–77.

Pepper, George. "The Exploration of a Burial Room in Pueblo Bonito, New Mexico." *Putnam Anniversary Volume, Anthropological Essays Presented to Frederick Ward Putnam In Honor of his Seventieth Birthday*. New York: G. E. Stechert, 1909.

Pilles, Peter J., Jr. "The Sinagua: Ancient People of the Flagstaff Region." *Exploration, Annual Bulletin of the School of American Research*. Santa Fe: School of American Research, 1987.

R

Reichard, Gladys A. *Navajo Religion: A Study of Symbolism*. Vols. 1 and 2, Bollingen Series 18. New York: Stratford Press, 1930.

Reichel-Dolmatoff, Gerardo. *Amazonian Cosmos: The Sexual and Religious Symbolism of the Tukano Indians*. Chicago: University of Chicago Press, 1971.

Renaud, Etienne B. "Kokopelli: A Study in Pueblo Mythology." *Southwestern Lore* 14, no. 2 (1948): 25–40.

Riggs, Aaron D. Jr. "Yellowhouse Crossing Mesa Petroglyphs." *Transactions of the Fifth Regional Archaeological Symposium for Southeastern New Mexico and Western Texas*. Portales, NM: El Llano Archaeological Society, 1969.

Riley, Carroll L. *The Frontier People: The Greater Southwest in the Protohistoric Period*. Albuquerque: University of New Mexico Press, 1987.

Roberts, Frank H. H., Jr. "The Village of the Great Kivas on the Zuni Reservation." *Bureau of American Ethnology, Bulletin 111.* Washington, DC, 1932.

Russell, Sharman Apt. *Songs of the Fluteplayer.* Reading, MA: Addison-Wesley Publishing Co., 1991.

S

Schaafsma, Polly. "The Rock Art of Utah." *Papers of the Peabody Museum of American Archaeology and Ethnology* 65. Cambridge, MA: Harvard University Press, 1971.

———. *Rock Art in New Mexico.* Albuquerque: University of New Mexico Press, 1975.

———. *Indian Rock Art of the Southwest.* Santa Fe and Albuquerque: School of American Research and University of New Mexico Press, 1980.

———. "Kachinas in Rock Art." *Journal of New World Archaeology* 4, no. 2 (1981): 25–32.

———. *Rock Art in New Mexico.* Santa Fe: Museum of New Mexico Press, 1992.

———. "Trance and Transformation in the Canyons: Shamanism and Early Rock Art on the Colorado Plateau." In *Shamanism and Rock Art in North America.* Special Publication No. 1, edited by Solveig Turpin. San Antonio, TX: Rock Art Foundation, 1994.

———, ed. *Kachinas in the Pueblo World.* Albuquerque: University of New Mexico Press, 1994.

Schaafsma, Polly, and Curtis F. Schaafsma. "Origins of the Pueblo Katchina Cult." *American Antiquity* 39, no. 4 (1974): 535–45.

Shady Solis, Ruth, et al. *Las Flautas De Caral-Supe.* N.d. www.ia.csic.es/sea/publicaciones/4375ef002.pdf.

Silver, Constance S. "The Mural Paintings from the Kiva at LA 17360: Report on Initial Treatment for their Preservation." In *Prehistoric Adaptive Strategies in the Chaco Canyon Region, Northwestern New Mexico.* Vol. 2: *Site Reports,* edited by Alan H. Simmons. *Navajo Nation Papers in Anthropology* 9. Window Rock, AZ: Navajo Nation Cultural Resource Management Program, 1982.

Slifer, Dennis, and James Duffield. *Kokopelli: Fluteplayer Images in Rock Art.* Santa Fe, NM: Ancient City Press, 1994.

Slifer, Dennis. *Signs of Life: Rock Art of the Upper Rio Grande.* Santa Fe, NM: Ancient City Press, 1998.

———. *The Serpent and the Sacred Fire: Fertility Images in Southwest Rock Art.* Santa Fe: Museum of New Mexico Press, 2000.

Smith, Bradley. *Mexico: A History in Art.* Garden City, NJ: Doubleday and Company, 1968.

Smith, Watson. "Kiva Mural Decorations at Awatovi and Kawaika-a." *Papers of the Peabody Museum of Archaeology and Ethnology* 37. Cambridge, MA: Harvard University Press, 1952.

Stephen, Alexander M. "Hopi Journal." *Columbia University Contributions to Anthropology,* vol. 23. New York: Columbia University Press, 1936.

Stevenson, Matilda Coxe. "The Zuni Indians: Their Mythology, Esoteric Fraternities and Ceremonies." *Twenty-Third Annual Report of the Bureau of American Ethnology for the Years 1901–1902.* Washington, DC: Government Printing Office, 1904, 1915.

Sutherland, Kay. "A Classification and Preliminary Analysis of Pictographs at Hueco Tanks State Park, Texas." In *American Indian Rock Art—Papers presented at the 1974 Symposium,* edited by Shari T. Grove. Farmington, NM: San Juan County Museum Association, 1975.

Swentzell, Rina. "Mountain Form, Village Form—Unity in the Pueblo World." In *Ancient Land, Ancestral Places in the Pueblo Southwest,* by Paul Logsdon. Santa Fe: Museum of New Mexico Press, 1993.

T

Talayesva, Don C. *Sun Chief: The Autobiography of a Hopi Indian.* Edited by Leo W. Simmons. New Haven, CT: Yale University Press, 1942.

Taube, Karl. "The Breath of Life: The Symbolism of Wind in Mesoamerica and the American Southwest." *The Road to Aztlan: Art from a Mythic Homeland.* Los Angeles: Los Angeles County Museum of Art, 2001.

Tedlock, Dennis. *Finding the Center: Narrative Poetry of the Zuni Indians.* Lincoln: University of Nebraska Press, 1972.

Thomas, J. J. "Rock Art and the Religion of Sky." *American Indian Rock Art* 7 and 8 (1982): 33–37. American Rock Art Research Association.

Titiev, Mischa. *The Hopi Indians of Old Oraibi: Change and Continuity.* Ann Arbor: University of Michigan Press, 1972.

———. "The Story of Kokopele." *American Anthropologist* 4, no. 1 (1939): 91–98.

Trimble, Stephen. *The People: Indians of the American Southwest.* Santa Fe, NM: School of American Research, 1993.

Turner, Christy G., II. *Petrographs of the Glen Canyon Region.* Glen Canyon Series 4, Bulletin 38. Flagstaff: Museum of Northern Arizona, 1963.

Turpin, Solveig A., ed. *Shamanism and Rock Art in North America.* Special Publication 1. San Antonio, TX: Rock Art Foundation, 1994.

Tyler, Hamilton A. *Pueblo Gods and Myths.* Norman: University of Oklahoma Press, 1964.

———. *Pueblo Birds and Myths.* Flagstaff, AZ: Northland Press, 1979.

V

Van Hoek, Maarten. "Biomorphs Playing a Wind Instrument in Andean Rock Art." *Rock Art Research* 22, no. 1 (2005).

Vastokas, Joan and Romas. *Sacred Art of the Algonkians: A Study of the Peterborough Petroglyphs.* Peterborough, ON: Mannard Press, 1973.

W

Wade, Edwin L., and Lea S. McChesney. *America's Great Lost Expedition: The Thomas Keam Collection of Hopi Pottery from the Second Hemenway Expedition, 1890–1894.* Phoenix, AZ: The Heard Museum, 1980.

Walker, Barbara G. *The Woman's Encyclopedia of Myths and Secrets.* San Francisco: Harper and Row, 1983.

Walker, Dave. *Cuckoo for Kokopelli.* Flagstaff, AZ: Northland Press, 1998.

Wallace, Henry D. "Pictures in the Desert: Hohokam Rock Art." In *The Hohokam: Ancient People of the Desert,* edited by David Grant Noble. Santa Fe, NM: School of American Research Press, 1991.

Warner, Jesse E. "Transformation II: Man to Bird." *Utah Rock Art* 9 (1989), edited by Nina Bowen. Utah Rock Art Research Association.

Warner, Judith. "An Intuitive View of Waterflow, New Mexico." *American Indian Rock Art* 10 (1983): 29–39.

Waters, Frank. "Kokopilau: The Humpbacked Flute Player." *Shaman's Drum* 10 (Fall 1987): 17–20.

Webb, G. B. "Tuberculosis." In *Clio Medica,* edited by E. G. Krumbhaar. New York: Paul B. Hoeber, Inc, 1936.

Wellman, Klaus. "Kokopelli of Indian Paleology: Hunchbacked Rain Priest, Hunting Magician, and Don Juan of the Old Southwest." *Journal of the American Medical Association* 212 (1970): 1678–1682.

———. "Some Observations on Human Sexuality in American Indian Rock Art." *Southwestern Lore* 40, no. 1 (1974): 1–12.

———. "The Indomitable Hump-back Returns." *La Pintura* 1, no. 2 (1974). American Rock Art Research Association.

———. "Shades of Dr. Jekyll and Mr. Hyde: Conceptual Dichotomy as Expressed in North American Indian Rock Drawings." *American Indian Rock Art* 6 (1981): 1–10.

White, Leslie A. "The Acoma Indians." *U.S. Bureau of American Ethnology Annual Report 1929–1930* 47 (1932). Washington, DC.

Whitley, David S. "Shamanism, Natural Modeling and the Rock Art of Western North America Hunter-Gatherers." In *Shamanism and Rock Art in North America,* Special Publication No. 1, edited by Solveig Turpin. San Antonio, TX: Rock Art Foundation, Inc., 1994.

———. *A Guide to Rock Art Sites: Southern California and Southern Nevada.* Missoula, MT: Mountain Press, 1996.

Williams, Terry Tempest. "Kokopelli's Return." *From the Canyons* (summer 1989): 17.

Wright, Barton. *Kachinas of the Zuni.* Flagstaff, AZ: Northland Press, 1985.

Y

Young, M. Jane. *Signs from the Ancestors.* Albuquerque: University of New Mexico Press, 1998.

———. "The Interconnection Between Western Puebloan and MesoAmerican Ideology/ Cosmology." In *Kachinas in the Pueblo World*, edited by Polly Schaafsma. Albuquerque: University of New Mexico Press, 1994.

Z

Zhang, Juzhong, Changsui Wang, and Zhaochen Kong. "Oldest Playable Musical Instruments Found at Jiahu Early Neolithic Site in China." *Nature* 401 (1999): 366–68.

Zimmerman, Larry J. *Native North America.* Boston: Little, Brown and Co., 1996.

Zwinger, Anne H. *Wind in the Rock: The Canyonlands of Southeastern Utah.* Tucson: The University of Arizona Press. 1986.

Index

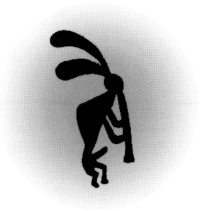

E

Eagles, 113, 157
Ek Chuah, 31
Elk, 4
Energy, 103, 104
Entoptic phenomenon, 57
Eroticism, 40–41
Espanola, New Mexico, 126

F

Feathers, 11, 113, 115
Female flute players, 42–43
Female supernaturals, 125–27
Females, 29
Ferron, Utah, 42
Fertility, 10–11, 21, 27, 38–40, 43–45, 65
 as theme in South American rock art, 135–37
 as worldwide theme, 134
 commercialization and, 48
 dragonflies as symbol of, 120–24
 exaggerated penis and, 109
 humpbacks and, 107–9
 menstrual blood and, 89–90
 of plants and animals, 91–99
 pregnancy and birth and, 87–89
 rain and clouds and, 99–100
 role of flute player in, 81–87
 shamanism and, 103, 105
 snakes as symbol of, 109–12
 spirals and, 119–20
 twinned flute players and, 127–30
Five Mile Draw, Arizona, 114
Flickers, 113
Flight, 105
Flowers, 43–45
Flute ceremony, 23, 24
Flute Clan, 37, 41–42
Flute player(s):
 as sexual deity, xvii
 as trickster archetype, 106–7
 birds and, 112–16
 brings clouds and rain, 99–100
 crook-staffs and, 116–18
 depicted as insects, xix, xx, xxvii, 1, 8, 120–24
 distribution of, in rock art, 33–38
 female, 42–43
 fertility of plants and animals and, 91–99
 fertility role of, 81–87
 geographic range of, xv
 humpbacks of, 107–9
 in Apache rock art, 76
 in Hohokam rock art, 69–70
 in rituals and ceremonies, 130–34
 menstrual blood and, 89–90
 mistaken for Kokopelli, 3–4
 origins and interpretations of, 21–32
 reclining, xxii
 role in pregnancy and birth of, 87–89
 shamanism and, 100–105
 Sharman Apt Russell on, 1
 snakes and, 109–12
 Southwest distribution of, 2
 spirals and, 118–20
 supernaturals and, 125–27
 Terry Tempest Williams on, 79
 twinned, xxiv, 127–30
 various cultures of, xii
 various depictions of, 4
 worldwide rock art images of, 134–42
Flutes:
 as ancient and multi-cultural instruments, 15–20
 dating, 11–12
 love magic and, 4–21
 materials for, 12
Footprints, xxv, 95
Fremont, 33, 37, 71–74, 162–65

G

Galisteo Basin, New Mexico, xxii, xxvii, 22, 24, 82, 87, 97, 115, 117, 118, 125
Gallo Wash, New Mexico, 130
Gallup, New Mexico, xxx
Game, Mother of, 125–26
Garza County, New Mexico, 33–36
Geometric rock art, 57
Ghanaskidi, xxvi, 75–76, 98, 106
Gobernador Phase, 75
Gourd, 26–27
Grand Falls, Arizona, 88
Grand Gulch Primitive Area, Utah, 159–60
Great White Duck, 127
Grotto Canyon, Canada, 36
Guruve, Zimbabwe, 136

Acknowledgments

Foremost I would like to honor the ancient ones who created the rock images we all love and respect. This book is dedicated to their spirits and descendants.

I am grateful to friends and colleagues who have assisted in the creation of this book. Acquisitions editor Ellen Kleiner resurrected this project when it seemed dead, and was encouraging from start to finish. Project editor Linda Nimori was very efficient and a pleasure to work with. Jim Duffield, who co-authored our 1994 book on Kokopelli, reviewed the manuscript and helped in many ways throughout the years, especially with site information. I would like to thank the following anthropologists and archaeologists who peer-reviewed the manuscript and made helpful comments for improving it: Sally Cole, Chris Turnbow, Dick Ford, Donald Brown, Orit Tamir, and Emily Brown. Dick Huelster of High Desert Field Guides graciously allowed the use of some of his maps to public sites. Terri Paul at Edge of the Cedars State Park invited me to participate in creating an exhibit about Kokopelli in partnership with Hopi Pueblo, which provided valuable insight on the Hopi perspective. Photographs and other materials were generously shared with me by Maarten VanHoek, Margert Berrier, Jim Duffield, Marty Magne, and Chris Larsen. Katherine Wells granted access to her property and permission to use photographs taken there.

Others who shared information about sites are Glen Stone, David Noble, Sally Cole, Curt and Polly Schaafsma, Jesse Warner, Hugh Crouse, Charlie DeLorme, Jim

Mullany, Eula Payne, Bill Davis, Jim and Luann Hook, John Young, Betty Lilienthal, Janet Leslie, Joseph Villega, Ellen McGehee, Larry Larason, Brenda Poulos, Dick Ford, and Tony Lutonski.

For company and assistance on field trips, I thank Sara MacFarland, Chip Conway, Dick Habakuk, John Pitts, Chris Larsen, Jim Duffield, Orit Tamir, Brad Draper, Deborah and Jim Cool-Flowers, and Eric and Angela Drew.

The library research at the New Mexico Laboratory of Anthropology would not have been possible without the expert assistance of Mara Yarbrough. David McNeece and Valerie Verzuh at the Museum of Indian Arts and Culture helped me obtain photos, as did photo-archivist Daniel Kosharek at the New Mexico Palace of the Governors.

About the Author

DENNIS SLIFER is the author of five previous books about rock art—*Kokopelli: Flute Player Images in Rock Art* (with James Duffield); *Signs of Life: Rock Art of the Upper Rio Grande; Guide to Rock Art of the Utah Region; The Serpent and the Sacred Fire: Fertility Images in Southwest Rock Art;* and *Rock Art Images of Northern New Mexico.* He is also the author of *The Caves of Maryland.* Slifer leads field trips and gives presentations to archaeological societies, museums, schools, agencies, and other organizations throughout the Southwest. Since 1988, he has worked for New Mexico State government, where he is involved with management and protection of natural and cultural resources. In 2003, he was designated a research associate at the New Mexico Museum of Indian Arts and Culture, where he is involved in activities related to rock art.